MINOR WHITE

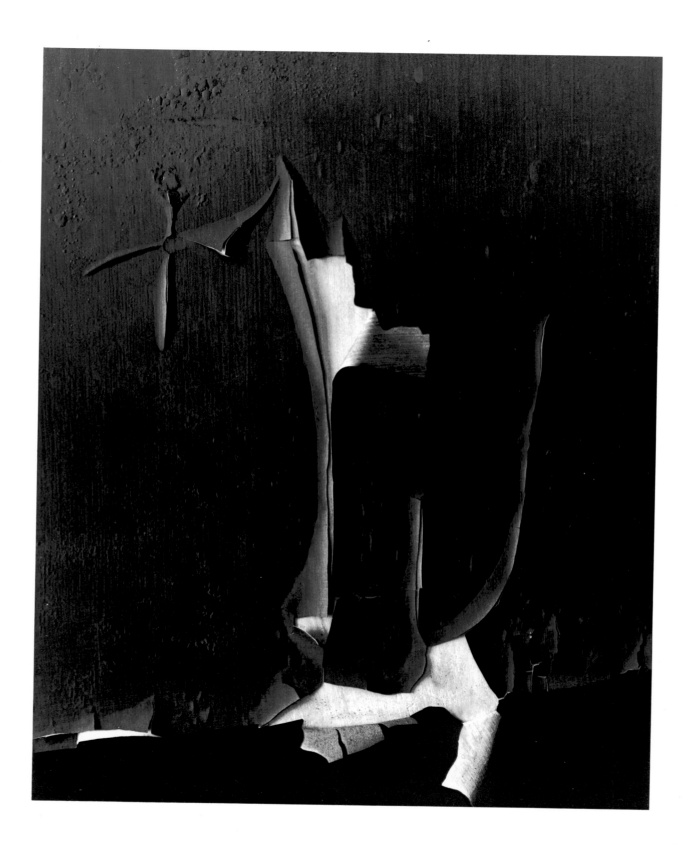

MINOR WHITE

RITES & PASSAGES

HIS PHOTOGRAPHS ACCOMPANIED BY EXCERPTS
FROM HIS DIARIES AND LETTERS

BIOGRAPHICAL ESSAY BY JAMES BAKER HALL

AN APERTURE MONOGRAPH

MINOR WHITE 1908—1976

Aperture, Inc., publishes a periodical, portfolios and books to communicate with serious photographers and creative people everywhere. A complete catalogue is available upon request. Address: Elm Street, Millerton, New York 12546

Library of Congress Catalogue Card No.: 77-80023
ISBN: 0-89381-022-3
Composition by David E. Seham Associates, Metuchen, New Jersey
Printed by Rapoport Printing Corporation, New York City
Bound by Sendor Bindery, New York City
Manufactured in the United States of America

The Minor White Archives, at Princeton University, includes all of the artist's photographic work, as well as his library and papers and his collection of photographs by other artists. Inquiries regarding this material should be addressed to The Minor White Archives, The Art Museum, Princeton University, Princeton, New Jersey 08540.

A limited number of selected prints are available from Minor White's *Jupiter Portfolio,* published in 1975. For further information write Aperture, Inc.

Minor White: Rites and Passages is published as a remembrance and a testament to a visionary whose grace and dignity have inspired this book and all that Aperture has ever accomplished.

Minor White's work as Editor of Aperture from 1952 to 1975, as a teacher at the San Francisco Art Institute, Rochester Institute of Technology, and the Massachusetts Institute of Technology, his workshops given throughout the country for many years—all allowed him little time to publish and exhibit his own photographic work. During the last year of his life, his thoughts turned to the publication of this volume designed to include a representative selection of his most important images and the first text to trace his life and accomplishments.

Minor gave James Baker Hall access to his papers, supplied introductions to friends and associates, and made himself available for interviews. He worked closely with me on the selection of photographs and format for the book. Every attempt has been made to carry out his wishes and his spirit, which continues as a nurturing and guiding force.

Publication of this book has been made possible by contributions from Ansel Adams, whose friendship with Minor White began in San Francisco in 1946 and Shirley C. Burden, whose first meeting with Minor in 1954 established an enduring association.

Michael E. Hoffman

No matter what role we are in—photographer, beholder, critic—inducing silence for seeing in ourselves, we are given to see from a sacred place. From that place the sacredness of everything may be seen.

Amid the static its name lies in the images that have an affinity for one another. Many readings flicker until suddenly one reading is unequivocal—frozen fire.

A sequence of photographs, then,
functions as a little drama
of dreams with a memory.

The spring-tight line between reality and photograph has been stretched relentlessly, but it has not been broken. These abstractions of nature have not left the world of appearances; for to do so is to break the camera's strongest point—its authenticity.

*The path my feet took was lined with images, whole gardens of pictures.
With exposures I picked bouquets, each more vivid than the previous…
finally a gathering of gem-like flames in the low tide…I thought I had
forgotten how to use my camera, so I counted each step of the process
aloud…shutter speed, aperture, cock the shutter.…Though I feared
to lose the sense of beauty, no loss occurred; the sense of rapport was
strong beyond belief.*

*While rocks were photographed, the subject of the sequence is not rocks;
while symbols seem to appear, they are pointers to the significance.
The meaning appears in the space between the images, in the mood they raise
in the beholder. The flow of the sequence eddies in the river of his
associations as he passes from picture to picture. The rocks and the
photographs are only objects upon which significance is spread like sheets
on the ground to dry.*

The photographs may be read without reservation. The accidental has been held back. The transformation of the original material to camera reality was used purposefully; the printing was adjusted to influence the statement; and it was anticipated that as the object was revealed, the Self of the beholder would unfold.

For technical data—the camera was faithfully used.

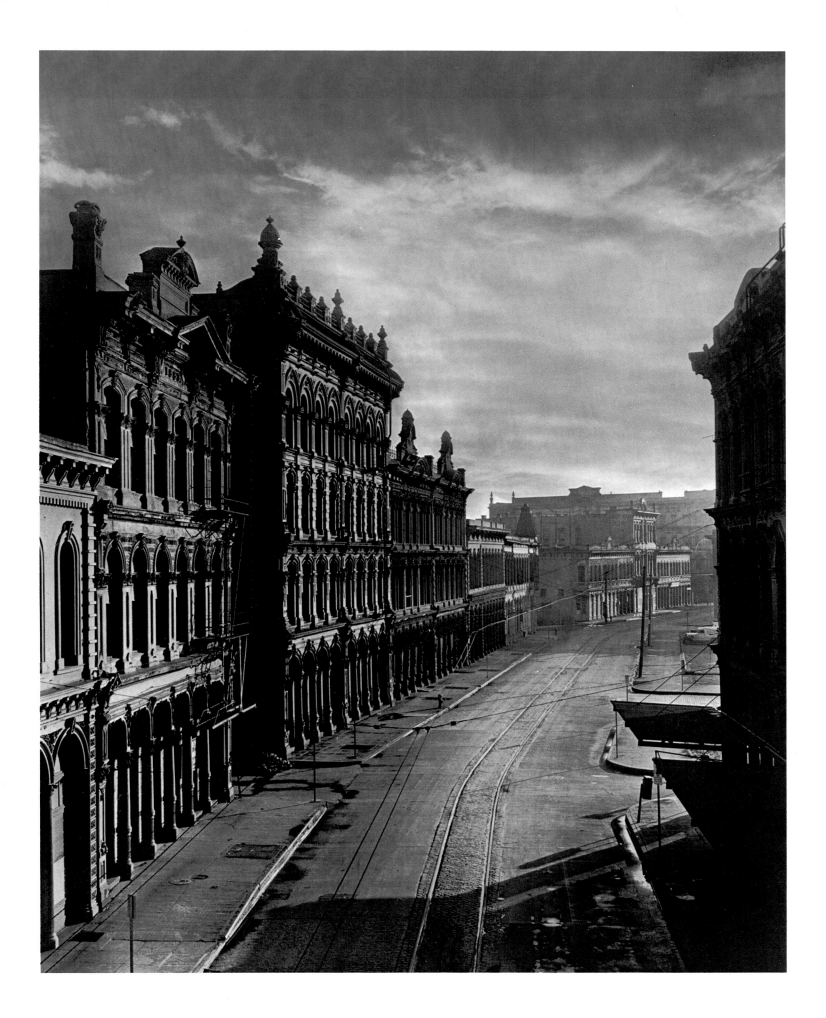

To take photographs. Such was the entry point into photography. Along the creek beds and waterfalls <u>seeing</u> was always possession and <u>camera</u> affirmed ownership. Since then other modes, other doors have superseded, for example, <u>to</u> <u>make</u> photographs. The greed, however, has never really disappeared. Ownership seems to be the force that opens all the other doors. Yet, possession is not all. As I become more in harmony with the world around, through, and in me, the varieties of time weave together. Chronological time, the time my psyche takes, and creative time were once always at odds with each other. Less so now that the manifestations of inner growth are seen to be set in my path as if by an invisible disincarnate friend. When I have sensed his presence, the photographs, afterward, seem like footprints…his or mine is the question!

Early in January of 1946, when Minor White was free of the war to resume his career, he made his pilgrimage to see Alfred Stieglitz. White was a grown man in his late thirties, his first one-man show years behind him, some of his prints already in the permanent collection of New York's Museum of Modern Art, but he was, by his own account, "petrified." Stieglitz was an oracle in the world of modern art, had been for years, and he was *the* oracle for Minor White, and for many other serious photographers. White got off the elevator on the wrong floor, could not find An American Place, Stieglitz's gallery, and fled the building with relief. There would be no escaping the need to go back and face the master, several times in fact, but White knew a message when he got one—messages were his specialty—and on that first day obviously the time was not right.

Twenty-five years later White could recall only in the most general terms what took place in those meetings with Stieglitz—they looked at prints, they talked about what was happening in photography and in modern art—but one of his journals reveals what made the deepest impression on him. Stieglitz asked him, "Have you been in love?" And when White answered that, yes, he had, Stieglitz said, "Then you can photograph." Of all the themes in White's journals and in his other unpublished writings, that is the most recurrent and the most deeply felt: the seminal role that love played in his work, and that work played in the whole of his life.

From many of the people who in increasing numbers sought out Minor White during the last twenty or so years of his life—many of them young and most of them photographers, but not all by any means—I have heard countless stories similar to the one of his pilgrimage to see Stieglitz. Some were petrified at first, others never were, but all who came under his influence testify that there was something extraordinary about him. Not just Minor White the photographer, nor even Minor White the artist-teacher-editor, but what several of them are wont to call "the whole man." It was his refusal to separate his personal life from his work, or his work from the rest of his existence, that gave him such extraordinary power to change people's lives and made him one of the most controversial figures in the history of photography. Virtually everyone agrees that he was a masterful craftsman and a significant artist—the only real question about the photographs is *how* good—but many people interested in photography argue often and with deep feeling about the man, about who he was and what his life was about.

Abe Frajndlich, a young photographer who studied closely with White for several years, tells a typical story of falling under his influence. Frajndlich had only a vague idea what he was doing when he found himself in one of White's workshops in Cleveland. He had just finished an M.A. in English at Northwestern and had dropped out of the Ph.D. program because he "had had it with words. On a lark I decided to go. I didn't really know a whole lot about him. His big book, *Mirrors Messages Manifestations*, had come out the year before. I'd looked at it, and I didn't have too close an affinity with that kind of image-making, but I decided to go and take a look anyhow.

"I remember walking into a big room where there were forty or fifty people. The room was dark, everybody was sitting on the floor, and this low voice was holding a hypnotic spell over everyone. Right away I put up all these blocks—what the *hell's* going on here! But I went on in and sat down and started taking it all in. And I remember in about five minutes I said, All right, get on out of here. But some other part of me said, Just hear it out, see what's going on. And sure enough, by the end of the day I began to experience photographs very differently than I ever had before, than I'd ever anticipated being able to do. I started moving through images, seeing fronts and backs to things, being able to penetrate things. Started throwing me for some loops. I got enticed in. And the next day we got into a conversation. . . . He looked at my pictures, told me pretty much that my photography was rotten. The talk went from there on out into the idea of a life quest. He told me about the live-in workshops at his place, so in the fall I moved up to Arlington [Massachusetts]."

Peter Laytin, another young photographer who worked extensively with White, describes a first encounter that has much the same intensity as White's with Stieglitz. Laytin was a premed student at the University of Wisconsin in the late 1960's; his dissatisfaction with his studies and with American culture as a whole, aggravated by the political climate created by the Vietnam war, led him to enroll in a summer workshop offered by White at the Hotchkiss School. Laytin knew very little about photography, even less about what Minor White stood for, but he was convinced by the time he got from Wisconsin to Connecticut that summer—a trip full of omens—that he was on one of the important journeys of his life. Every impressive-looking gentleman that he saw on the campus he mistook for the man he had come to study under. When Minor White finally appeared, introducing himself with an unassuming, charming smile, he looked, in his wild Hawaiian shirt, more like a groundskeeper than a guru—which only intensified Laytin's anxiety. "I was uptight," he told me, "you won't believe how uptight! I remember stumbling on my name and thinking, Oh, my God, he's probably going to kick me out of the workshop. He thinks he's got a retarded person on his hands!"

Pratfall followed pratfall for the first few days; Laytin was on the verge of packing up and leaving several times. Still tongue-tied and now diarrhetic, he tried at one point to explain himself to the teacher, "It must be something I ate." To which White replied knowingly, "No, it isn't," and walked away, leaving Laytin feeling more than ever a fool. Finally Laytin got up the nerve to ask Minor White for a conference, only to be told cryptically that it was not yet time. For days Laytin was left to stew in his own anxiety and confusion. He was beginning to despair of the possibility of being worthy of even the teacher's attention, let alone capable of learning anything from him—which in many traditions is thought to be a necessary part of spiritual growth. It was then that the breakthrough came. Laytin was down on the floor, knees and elbows, chin in hands, engrossed in a photograph—when White sneaked up behind him and gave him a Zen slap on the ass. Laytin spun around, suddenly free of all that tension, the first spontaneous move he had made since he arrived, and there was Minor White with his boyish, disarming smile. "You look like you're ready to talk," White said. And they did.

Toward the end of the workshop, Laytin had an experience that summed up what he was learning. Lugging a 4 x 5 through the woods, he came upon a waterfall so pristine that he thought he must be the first ever to see it. His initial reaction was to treat it as subject matter for a picture, but something told him to put his camera aside. He waded out and sat quietly on a rock in the middle of the stream. Shortly a yellowjacket landed on his knee, and, quite unlike himself, he let it be: he watched the stinger carefully, ready to brush the wasp away, but he did not interfere with it. Soon there were five of them crawling around on the white skin of his knee and leg. He could hardly believe that he was letting it happen, but indeed he was: he was keeping track of all five stingers, perfectly alert now to what was happening to him, but he was not interfering. And soon the wasps began to hum. It was as though the whole experience were under a magnifying glass, the insects, his skin, the hairs on his leg—a humming microcosm surrounded by rushing water and sunlight. He began to hum with them, and to hear himself humming, as though someone else were doing it. Finally it became too intense he brushed the yellowjackets away and with tears of joy scrambled back to shore. He knew that he was learning what Minor White was trying to teach him, but he had no idea, in his moment of euphoria, that the lesson was only half over. As he emerged from the water to retrieve his camera, he fell, impaling himself on a branch. It penetrated several inches into his back, a sharp, excruciating pain, and no one there to help him. The tears deepened considerably then, and so did his understanding.

Laytin, like Frajndlich and many others, went on to study with Minor White as a live-in student at his home, an arrangement that White began in the mid-1950's and continued virtually without interruption until his death in 1976. White's students were, day to day, his closest associates. When he had a stroke at home in 1973, it was a live-in student who saved his life with mouth-to-mouth

resuscitation, breathing life back into the body that had once breathed it into him. That such a critical moment involved not a friend but a student young enough to be his grandson was no coincidence; it is a fair measure, in fact, of the loneliness and isolation that had him often near despair. Of all the many people who knew him, only a few claim to have known him well; and as one friend put it, echoing a belief held by many, "You're really getting to know Minor when you realize that you don't know much about him at all." Even those who were truly close to him were not truly close for long, though most remained dedicated. As he himself wrote, often and in a variety of ways, "I only have students—no friends—or close ties. I don't seem to belong anywhere." Much of his life was spent emerging joyfully from the world's deep waters, only to fall in pain, no one there to help. He was forever retrieving his camera and attending to his wounds alone.

Some of the parallels between Stieglitz and White are more apparent than others. Much of White's best work, both as a photographer and as an editor, came directly and consciously out of Stieglitz's idea of the Equivalent, the photographic image as a metaphor, as an objective correlative for a particular feeling or state of being associated with something other than the ostensible subject. Each man in his day embodied and promulgated that controlling idea by editing journals of comparable impact, Stieglitz with *Camera Work,* White with *Aperture.* Just as Stieglitz and Edward Weston—the other principal influence on White—fairly dominated a significant portion of the photography world during the second quarter of the century, so White, along with Henri Cartier-Bresson, Ansel Adams and Robert Frank, dominated it during the third. Ideas play a role in the influence of Weston, Cartier-Bresson, Adams and Frank, but not nearly as important a role as they do with Stieglitz and White. Their work as teachers and editors has reached far fewer people than their photographs, and it has been less well understood, but both men's lives testify in no uncertain way to the fact that it was every bit as important to them as their camera work. Stieglitz spent much of his time and energy talking to the people who, like White, came to see him over the years at one or another of his three extraordinarily influential galleries: the pictures on the walls at 291 and at Room 303 and at An American Place were points of departure as well as ends in themselves, and he saw himself, as did White in similar situations, as the vehicle for the next stage of the journey. Obvious dissimilarities notwithstanding, Minor White's homes—in Rochester, New York, from 1953 to 1965 and in Arlington, near Cambridge, from 1965 to his death—served his life's work in many of the ways that Stieglitz's galleries served his.

Minor White's basic commitment was to a way of life, not to photography per se, a fact that generated much of the confusion and controversy that still surrounds his name. "He was always a religious man," says Michael Hoffman, a live-in student at Rochester who went on to take White's place as editor of *Aperture.* "He was basically a contemplative. Everybody knows that, but very few people in photography seem to understand what that really means." It meant and still means, among other

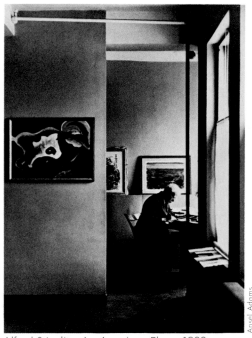

Alfred Stieglitz, An American Place, 1933

things, that there were more important matters in his life than making pictures, and more important goals in photography, as he understood it, than making good ones. In the course of his own spiritual development he discovered, some time in the early 1960's in Rochester, that photography was not only not necessary to him, it was in fact something of an encumbrance. "Working along esoteric or spiritual lines," White told me, "you come to the realization that your medium can't keep up with you, you can go beyond it. And a decision has to be made—or you have to keep your eyes open and see what decisions are being made for you."

Why then did he decide to continue? Why not use the time and energy for goals higher than those he could achieve with photography? It was a crisis similar to that of the Buddhist who experiences enlightenment and must decide whether to go on into the nirvanic One or turn back to the many troubles of this world. In his decision to stay with photography White was not unlike the bodhisattva, who chooses to stay and help his fellow creatures. "I realized that photography was my mouthpiece, this was the way I talked—photography meaning writing about it, editing it, teaching and making it. All of those

things, not just any one of them, the camera is just part of it, including the awareness of audience. . . . I decided to continue, but with a totally different attitude than before—it was a service thing now. And,'' he said, laughing at the fact that it sounded like an afterthought, ''I had to make a living.''

His tireless efforts to communicate what he felt and thought were considerably more successful with his students than with the photography world in general, but even with his students he often had serious problems. Part of the fault was in the intellectual climate, a hermetic world in which photographers talked only to other photographers about photography, suspicious of all but the most matter-of-fact uses of the mind, indifferent, even hostile at times, to all languages other than their own. Only recently have photographers started coming out of the darkroom in any numbers, and many of them are still blinking. His teaching methods were dramatic rather than expository, he showed rather than told what he had in mind, which often required more of his students than they wanted to do. Impatient as he was with that atmosphere, he saw in it a job to be done. ''Poets, actors, musicians, artists,'' unlike photographers, would ''have no trouble'' with what he was saying, but then that was precisely why he had to keep trying to say it to photographers.

And part of the fault was his. For all the writing and talking that he did, for all his reputation as an intellectual and as a spokesman, even as a poet, he was not articulate. Many people were often impatient with what has been called, many times, his ''mumbo jumbo.'' Nor was it simply a failure of language; he was not intellectually equipped for much that he tried to do. He had a fine intuitive intelligence, as his best camera work well testifies, and as anyone fortunate enough to have worked with him on a book or show will tell you; but his mind had none of the rigors of good discursive thought, nor was it well enough informed. For a man who was committed all his adult life to a quest for truth, and to sharing it with others, he was remarkably inattentive to most bodies of knowledge, remarkably narrow in his frame of reference.

All that has to be said, but it must also be said that only a secular intellectual would think that it was particularly important. White's experience told him that intelligence does not necessarily involve learning, that in fact learning, because it can be accomplished with only the head, and because it is so easily confused with understanding, may often be treacherous. Wisdom to him involved the whole being—head, heart and senses—not just a part; enlightenment could come through bootblacking as readily as it could through biophysics.

Some of his trouble in communicating came from the fact that he was forever blurring the necessary distinctions between the ''esoteric'' and the ''spiritual,'' between specific methods (which are often strange to many of us) and general goals (which are usually more or less familiar). What he was always talking about was as old as religion itself—which is not to say that it was easy to communicate, far from it, but rather that it was not nearly so esoteric as he seemed to believe. The essence of what he was saying is this: that the profane is also sacred, that the Creation is being reenacted every moment everywhere, and that salvation lies in the exacting task of keeping those facts alive in one's daily life. Just how and why his preoccupation with the mysteries led him repeatedly into mystification is probably as complex as the man himself. Intellectual amateurishness and inarticulateness were no doubt involved, but so were a lot of deeper and more personal things.

There was something in him that did not want to be known, that was constantly withholding and protecting, that refused, as he so often said, ''to let go.'' He promoted introspection and self-revelation and nakedness—Being Without Clothes, as he put it, the image of paradisal innocence, of shamelessness—because he was constantly struggling with the compulsion to clothe and obscure and hide himself, to cover his shame. What he was ashamed of, and why, are important to a certain kind of understanding of him, but the specifics are perhaps not so important as the role of shame itself in religious experience. If he had not been ashamed of whatever it was he was ashamed of, he would have been ashamed of something else. It is, after all, how the Christian manifestation of *homo religiosus* was conceived, in original sin, the classic predicament of postlapsarian man, strung out on the tightrope between the sacred and the profane.

Minor White was born on July 9, 1908, in Minneapolis, the only child of Charles and Florence White; and was given an old family name that had belonged to his great grandfather. When asked about his childhood, he talked about his maternal grandparents, not his parents. They lived nearby; until he was twelve he saw them nearly every day. ''They had a profound influence on me—in some ways more profound than my parents.'' They had an ordinary little house, but with two lots and a big garden; his grandmother was a superb cook and gardener. ''I became fascinated with the garden—which probably accounts for the fact that I went into botany when I went to college.'' His grandfather was an amateur photographer, had a carbon arc projector and an enormous lantern slide collection, which ultimately Minor White inherited. A good many of those slides had been

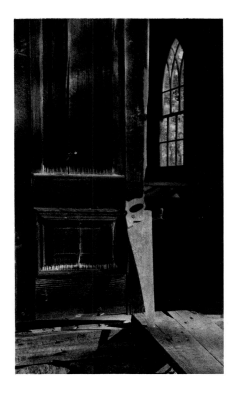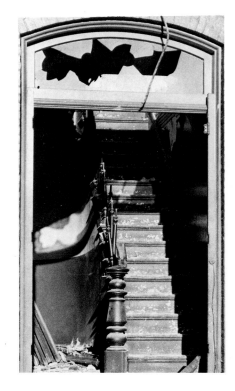

purchased—western landscapes, architectural studies, Civil War pictures, work by Gardner, O'Sullivan, Mathew Brady, "and all those people. . . . I looked at those slides over and over again." White got his first box Brownie when he was nine or ten years old, but it was not until he was at the University of Minnesota that he learned to develop and print photographs, and then in connection with extensive student work in photomicrography.

What he saw through the microscope in those days had a profound effect on much of what he later saw on the ground glass, especially those nature images in which the scale is ambiguous and what is in front of the lens is hard to name. "A lot of times people would show various strange forms in art, modern art, when it came along in the thirties and forties, and I'd say, hell, I've seen all that under a microscope. That wasn't true of all of it, by any means, but there was a familiarity in a lot of it for me where others found strangeness."

Unable to afford photography on his own, and taken with poetry, he found that his creative impulses in those college days went mainly into writing. When he graduated in 1933 in the middle of the Depression with a B.S. in botany and a minor in English, he was embarked on a five-year writing project to train himself as a poet. Despite working twelve hours a day, six days a week, and six hours on Sunday as a houseboy, waiter and bartender at the University Club—the only job he could find—he managed to finish a sequence of 100 sonnets according to plan and to pick up his interest in photography again.

The preoccupations of his life were already evident in his journal entries from that period. "Love is necessary to establish the intenseness from which the spirituality can sprout and then grow with or without love to power and conviction. Power that gives freedom. . . . The four sublimations of love are sex, pleasure, power, jealousy. . . . The contemplation of deity in all its manifestations is the true work of the soul. The work of the body is to provide first: the means to keep alive; second: the means to see all manifestations. . . . If a man makes something that can be loved for its own sake and not its associations he makes great art. The artist creates that he might be loved. The bridging ideas are somewhat as follows: a man works best when doing for another whom he loves, and it is necessary to be loved to do his best work, and the cycle starts; by projection a man can do good work without love expecting love in the future; by continuing this a long time, it seems that a man is working for his own satisfaction alone, but the time comes when he suffers from the realization that he is working alone; an artist carries this projection farthest of all and works for a love he is certain does not exist; and still he works and creates as if his love were near. Maybe it is only himself."

In June, 1938, he bought a 35mm Argus for $12.50 and boarded a bus for the West Coast with a little more than $100 in his pocket. In Portland, Oregon, he got a job as a night clerk in a tiny hotel and lived for months at the Y.M.C.A., where he developed his film at night in his room. With the French poet François Villon as his model, he continued to write, discussing poetry with a dwarf newspaper boy who hung around the hotel desk, but his

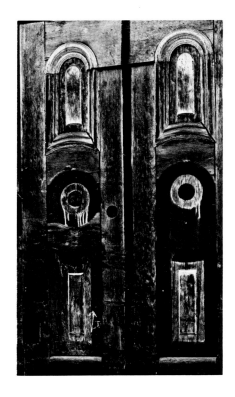 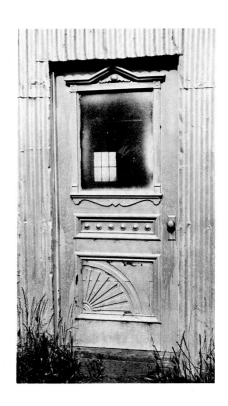

Lately I find at the turn
Of my Self-made keys
Full rooms open

creative energies were turning more and more to photography. He joined the Oregon Camera Club, "a very fine camera club, where then I really did learn the finer techniques of printing, of developing and all the rest of it." A brief involvement in politics, the only such in his life, helped get him a job as a photographer with the WPA, a federal agency set up to relieve unemployment. And from that point on, except for service in the war, he made his living in photography. For the WPA he produced, in 1938–39, a series of pictures of early Portland architecture, and another of the Portland waterfront, two exhibitions that were sent on tour by the agency. And at the same time he did some publicity work for the Portland Civic Theater and for the Y.M.C.A., where he also organized a camera club and taught classes in photography. In 1940 the WPA sent him to eastern Oregon, and he soon became director of the La Grande Art Center there, a job that he held for nearly two years, until shortly before he was drafted at the beginning of the war.

It was in eastern Oregon that "the philosophy of photography that I had soaked up from reading books came to fruit," he noted in a journal. "Edward Weston and the F/64 school dominated" his thinking and his practice. With time and materials now, thanks to the WPA, he was able to pursue in earnest his own camera work. In 1941 several of his photographs were shown in a theme show at New York's Museum of Modern Art, his first exposure nationally, and the Museum purchased some of them for its permanent collection. The next year he had his first one-man show, pictures of the Grande Ronde-

Wallowa Mountain area of northeastern Oregon, which hung both at the Portland Art Museum and at the Y.M.C.A. With that exhibition, his journal says, "a period came to a close."

From April, 1942, through August, 1945, Minor White served in the Army Intelligence Corps, mostly in the South Pacific—"three years, five months bored stiff, one month scared stiff." Except for portraits of fellow soldiers, some of which appear in *Mirrors Messages Manifestations*, he made few photographs during the war; what little time and creative energy he had went into writing. He worked on a book, never published, called *Eight Lessons in Photography*, an attempt, in lieu of being able to photograph, to apply to his own art what he was learning from Boleslavsky's *Acting: The First Six Lessons*. And he wrote poetry, some of which appears with the portraits in *Mirrors*, the "Amputations" sequence—his most successful effort, I think, at combining words and pictures.

While he was in the army, he joined the Roman Catholic Church, "in order," according to one of his journals, "to find out, if possible, what it was all about." He discovered "that praying used the same energies that creativeness did," and that he "enjoyed the services pared down to essentials." But army life "was a series of bottoms dropping out from under bottoms," and before the end of the war his "spiritual life stopped." Back in the States, he found "the Catholic services in domestic churches . . . empty after the bare realities and those helpless army priests, and so slowly stopped going, confessing, and taking communion."

It's all in the mind
Driving the night rain like nails
Into the clouded desert
Frozen with fear at the night wind
If the lightning strikes I am dead
If it doesn't I will not live

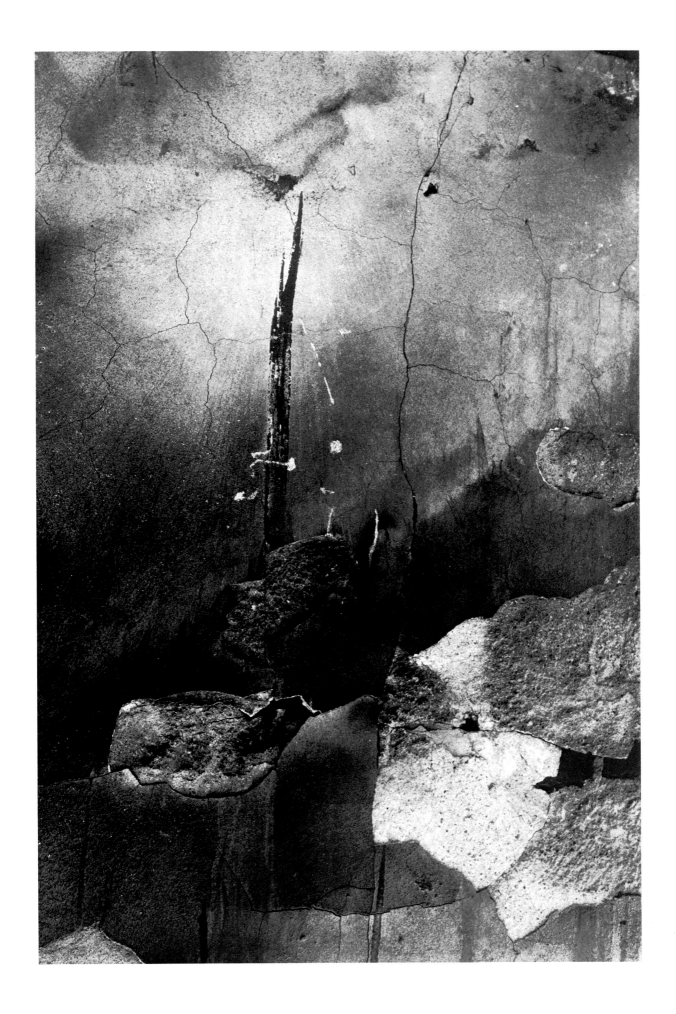

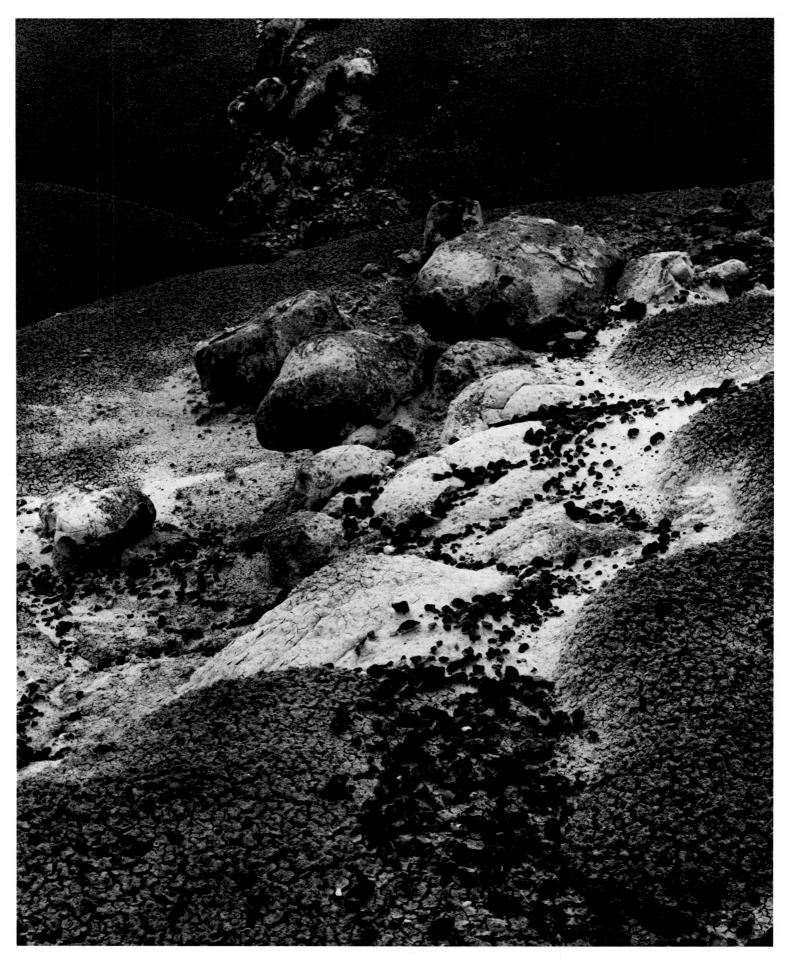

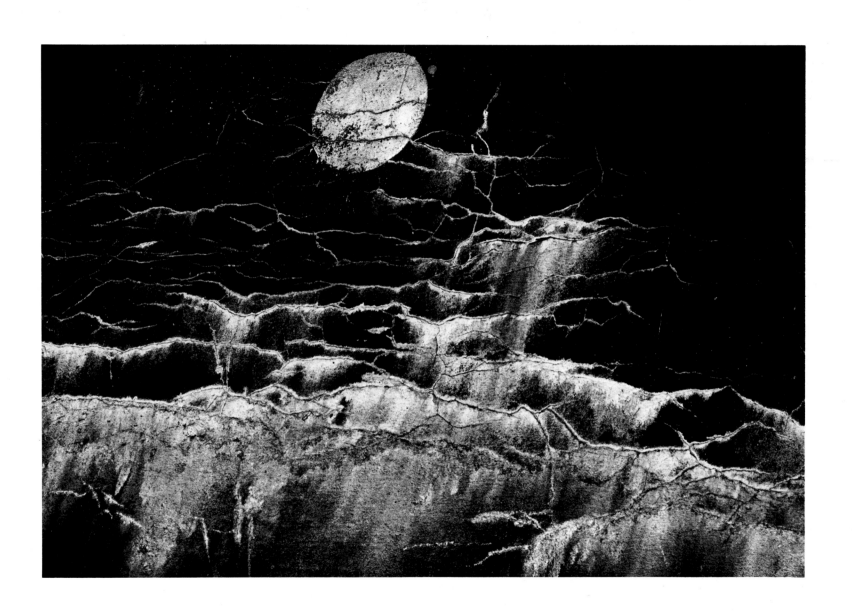

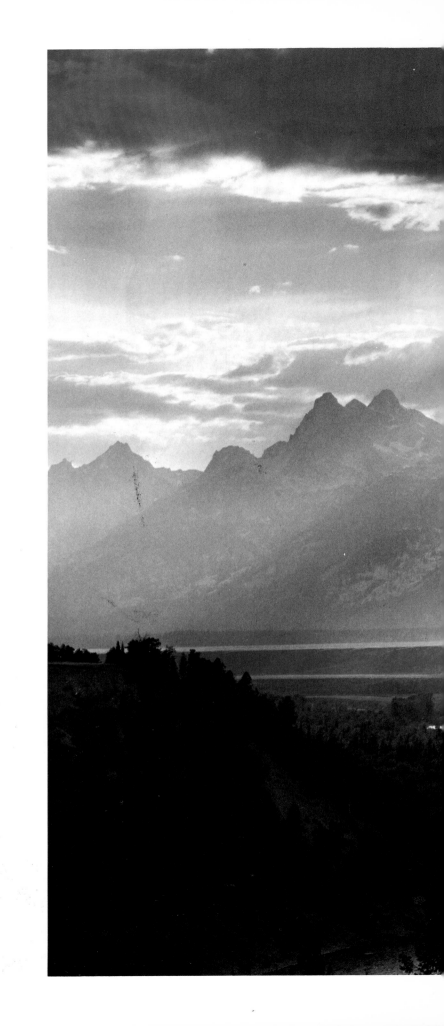

Thunder over earth tips over
The altar of my mind

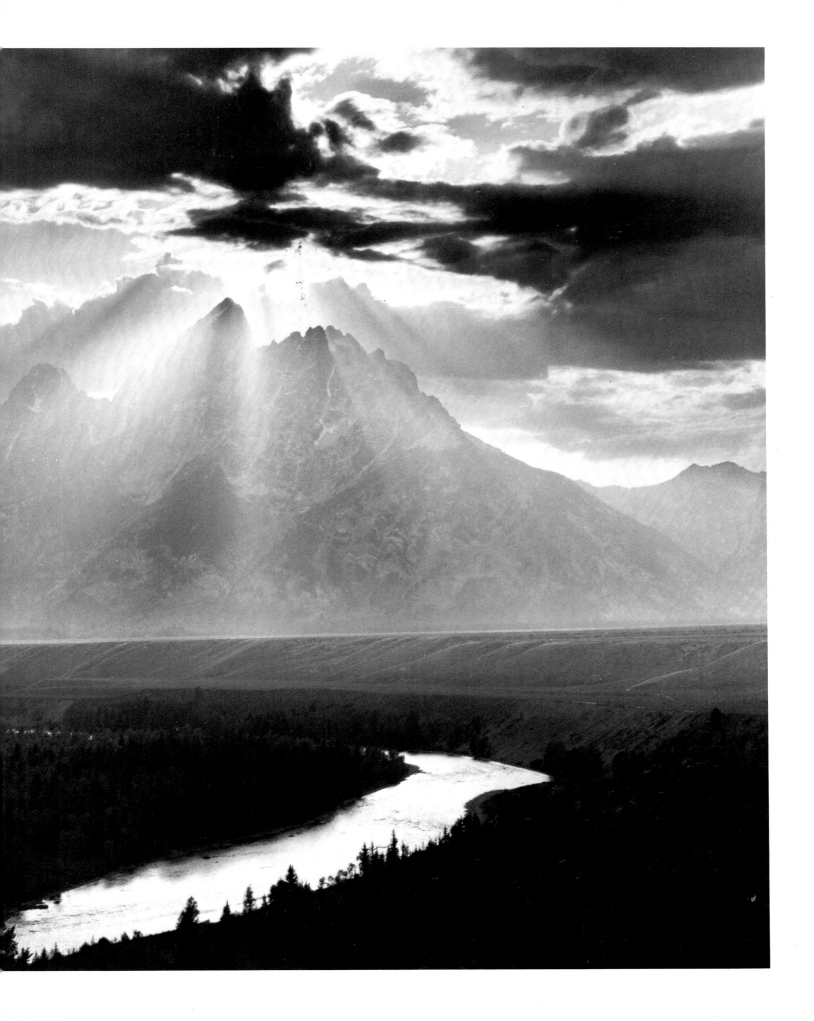

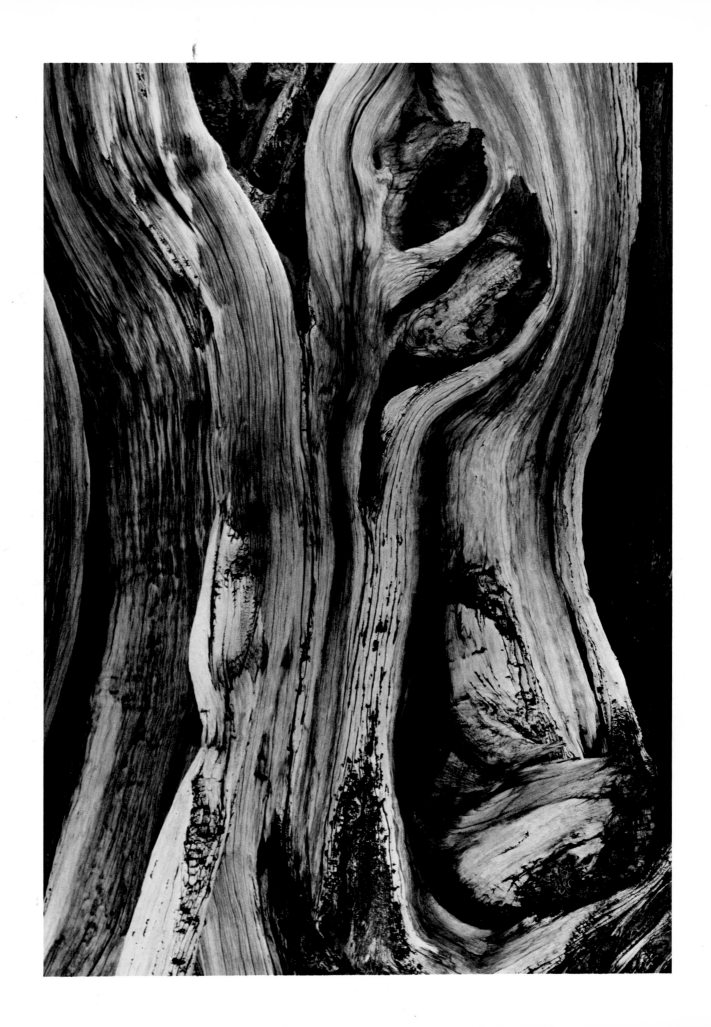

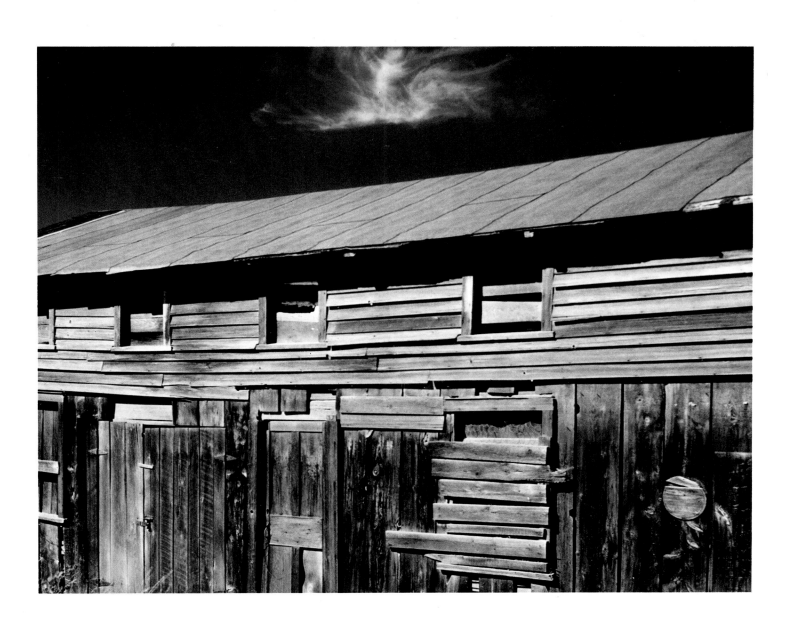

...in the heat-depleted afternoon, we will visit a solemn old cathedral I know, where you find the choir practicing. It is a strange church, the choir is installed behind the altar, and our vision of them is faulty because of a high steep grille of metal in front of them. You will nearly weep here also at the exuberant chants, at the chasened spirit singing, especially as the singer turns and puts his hand on a bar, as if to hold himself, or as if to hold the bar aside and let his voice ring out to the remotest corner where kneel the timid and the sick at heart. The sight of him singing thus is so like a prison you will clap your hands over your eyes to keep from seeing the willful prison surround untrammeled song....

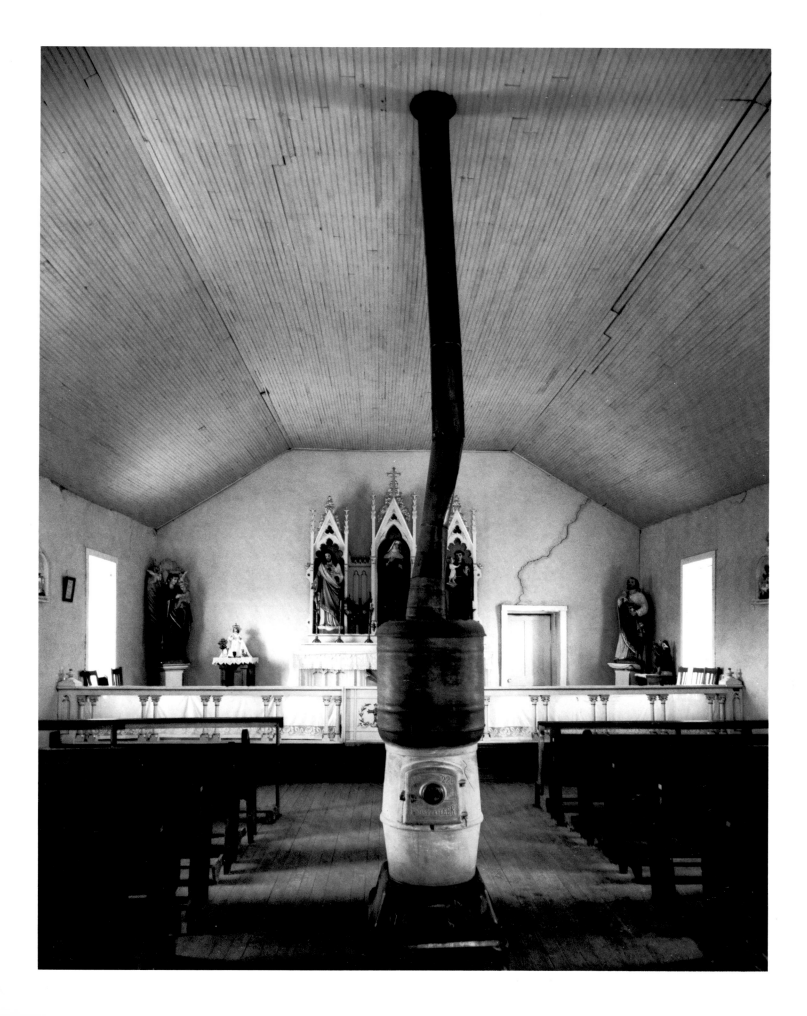

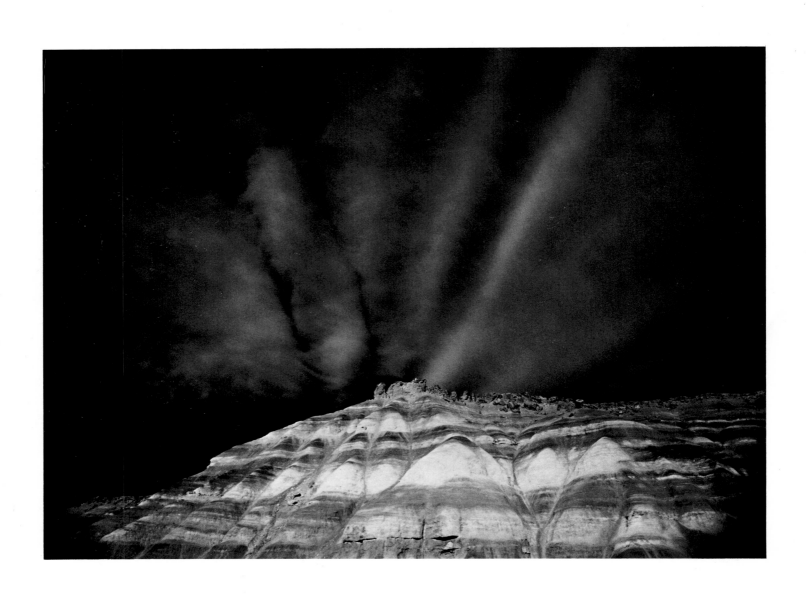

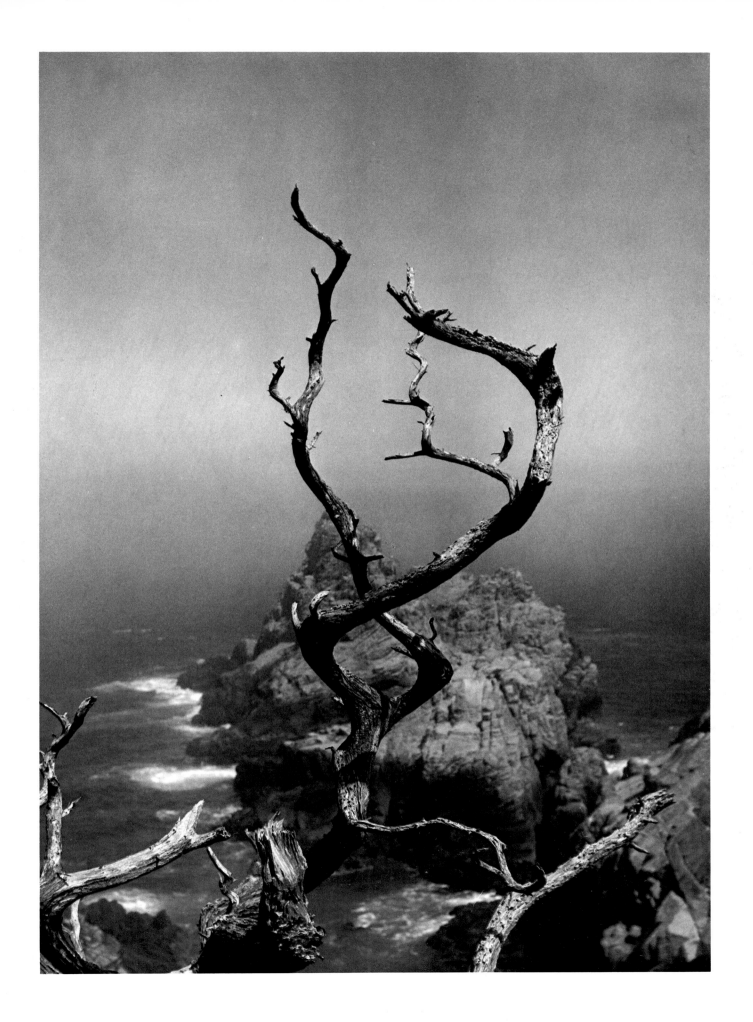

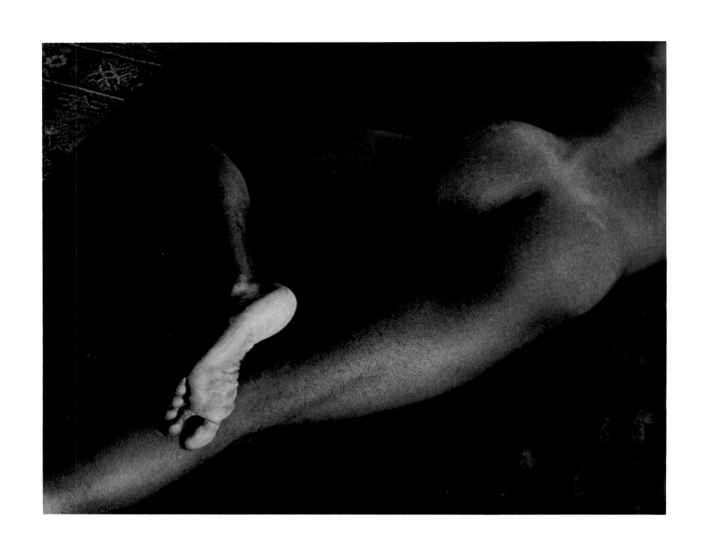

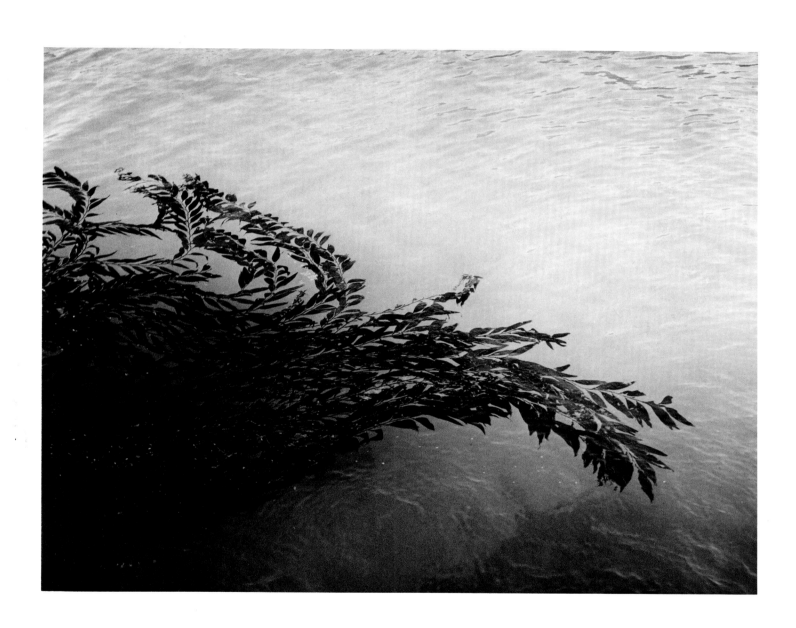

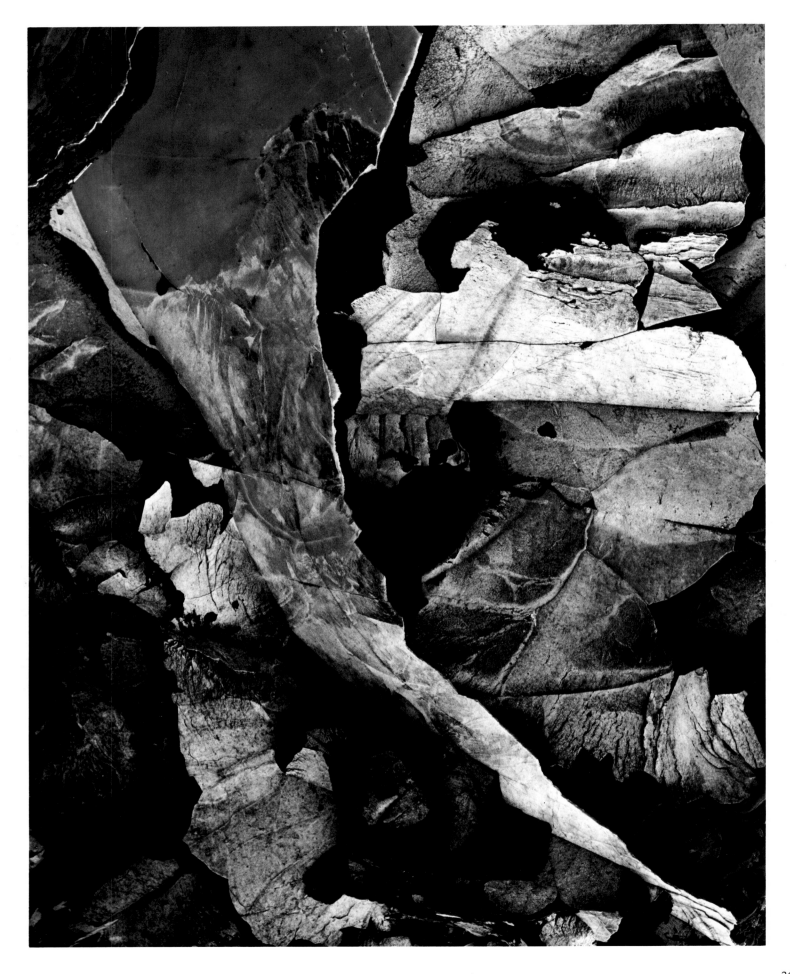

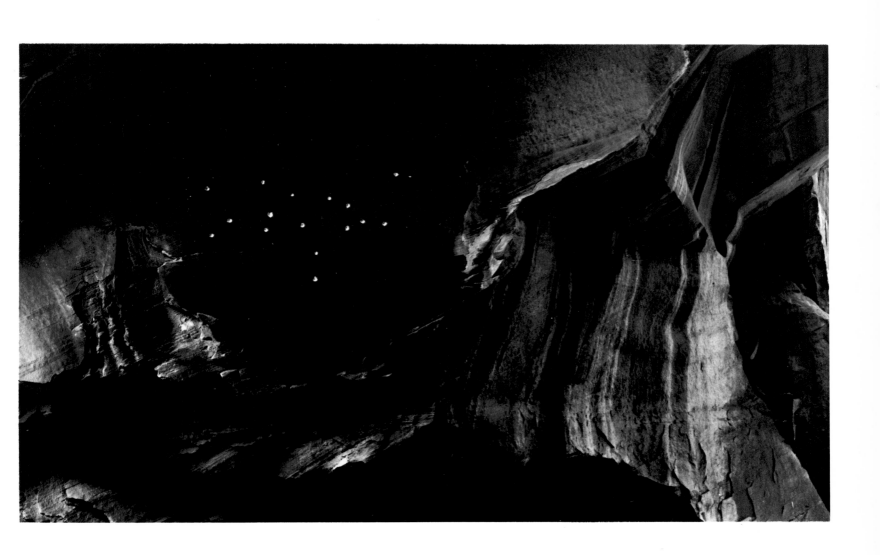

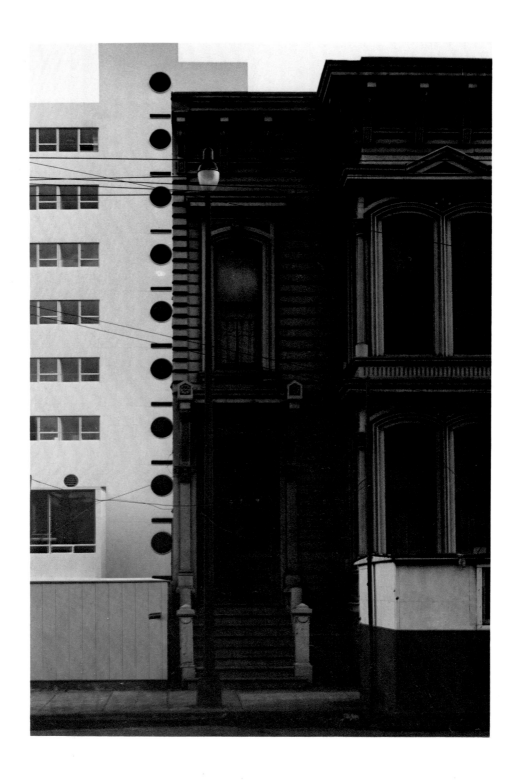

Self-discovery through a camera? I am scared to look for fear
of discovering how shallow my Self is! I will persist however...
because the camera has its eye on the exterior world. Camera will lead
my constant introspection back into the world....

every photograph
A celebration
Every moment of understanding a birthday.

The rest of White's life, after his release from the army in 1945, can be seen as one sustained effort, more and more successful as time went on, to find a spiritual home. He was not seeking a substitute for Catholicism; important as joining the Church was to him at the time (and there is substantial evidence that the experience was far more profound than he was wont to suggest in his journals, interviews and conversations), it was merely the first dramatic move in a quest that would preoccupy him for the next thirty years. Michael Hoffman is on the mark exactly when he says that in order to understand Minor White and his work you must understand what it means that he was essentially a religious man. It does not mean, for instance, that he was a man with a certain set of beliefs —though he was, during his last dozen or so years, that also. It means rather that he was forever experiencing himself and the world, often consciously, in terms of an essential distinction between the sacred and the profane.

For such a man the quotidian world of the body, of work, of rocks, friends, rainbows, houses, love, pictures, meals, the world of the profane, ever-changing many is unequivocally real only insofar as it manifests the eternal and sacred One. No religion offers an experience of God, which by definition is ineffable and profoundly subjective, but merely a way to it. The secular man may look to religion for *what* to believe; the religious man looks to it for *how*. His search is for nothing more or less than a language suited to his own experience of the sacred and the profane, a method of organizing his thoughts and his life so as to stay in touch with what is real.

There was personal instability in White's life, and confusion, indeed plenty; but that sort of thing did not seem to be involved, as it is with so many moderns, in his moves from one quasi-religious discipline to the next. It was not that he had no idea what he was looking for; he had a very good one. His search for an ever more exact language was demanding, and it was restless because it was demanding. Strange as it seems, the religious man, especially if he is a twentieth-century American, may very well find a religion particularly hard to come by.

From the late 1950's to the end of his life in the summer of 1976, Minor White was involved, more deeply all along, with the philosophy of the Russian-Greek-Armenian mystic G. I. Gurdjieff and his followers. Gurdjieff taught that most of us are asleep most of the time, experiencing the world through a disastrously fragmented and deadened intelligence, and that the first order of business is to wake up and stay awake. An arduous undertaking indeed, as Gurdjieff knew only too well, often painful and bewildering, at times terrifying—a path that cannot be traveled alone. "The work," as it is called, is done in small, tightly knit groups, put together around a teacher, and the bonds formed there, where the appeal is to the heart as well as the head, to the body as well as the soul, are often deep. White was profoundly nourished by that involvement, especially during the last dozen or so years of his life. In the end he willed his home to Aperture, to assist in continuing the work he started there; his photographic archives to Princeton University, testimony to his long friendship with Professor Peter

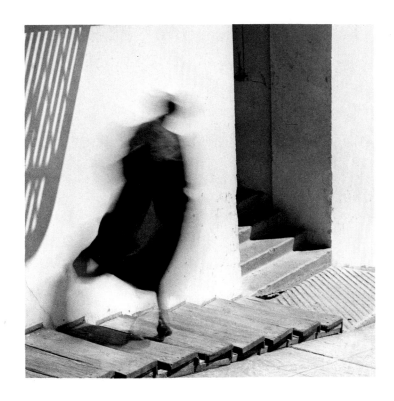

Bunnell, Director of the Art Museum; and his personal effects to his Gurdjieff friends in the Boston area.

The Gurdjieff ideas, the key ones for most followers, are not intellectual constructs, but rather guides to experience; to treat them as integers in White's philosophical development would be not simply to slight them but to falsify them. My principal concern, in any case, is not with the evolution of his thinking, but with the shape of his religious experience, which is the shape of his life. He often thought that he was on a quest and used myths to articulate its nature. Only a few months before his death, he published in *Parabola* (a magazine subtitled "Myth and the Quest for Meaning") a short piece entitled "The Diamond Lens of Fable" in which he associates himself with Gilgamesh, Jason, King Arthur and all the heroes of the old quest tales. And in a journal kept on cross-country trips during the summers of 1960, 1961 and 1962, he identifies himself repeatedly with The Wanderer, that archetypical adventurer from the archetypical myth, the quest for the ultimate boon, the Golden Fleece, the Holy Grail, the Bo Tree, the Commandments—the knowledge that will restore the vital connection between the sacred and the profane, that will reveal all opposites to be in fact merely phases of one continuous process. "As ever the wanderer," he says at one point, somewhat plaintively. But that is the fate of *homo religiosus*, and the very nature of a continuous process: no sooner is the circle completed than it is begun again: the light gives way to darkness, darkness to light once more. That the figure of the wanderer came to him from the *I Ching*, his hexagram for the

summer, is evidence itself of its aptness: his quest was leading him into a variety of mystical teachings and Eastern religions, into symbologies and methodologies from all over the world. In order for such a quest to be successful, as all the myths tell us, the hero must undergo a series of trials, a descent into the underworld, the belly of the whale, the labyrinth, the nightmare, the Id—the images for it vary from story to story and from culture to culture, but the place is always the same—where the powers that be test the adventurer's worth and reward him as they see fit.

For all that was charming and nourishing in his otherworldliness (a colleague once described him as "a delightful bubble wafting through" the bureaucratic fog of MIT), he could be infuriatingly difficult to pin down. What he describes with characteristic brevity in one of his journals as "a series of bottoms dropping out from under bottoms" was just such a descent—his first, it seems, but certainly not his last. A sequence of long letters written when he was in his mid-thirties from the Pacific, copies of which he left, neatly typed, with his papers—nine of them in all, some fifty pages, the first dated November, 1942, the last April, 1944—document in some detail what was happening to him at that time and what would happen again and again. Repeatedly over the next thirty years or so, he would find himself, as he did at the end of the war, hurt, detached and lonely, uncertain of his capacity to love and be loved, his life a burden. I want to quote at length from these letters, for not only are they intrinsically interesting and valuable (they tell a profound

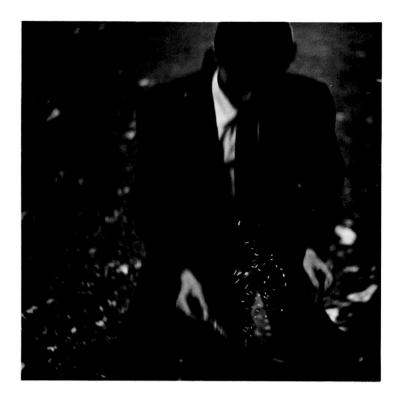

Each artist going
in his own direction
At some time
Walks on water.

story, and tell it quite well—far and away the best writing he ever did, the most clearly thought, the most richly detailed and deeply felt), they also define, in his own words and actions, the "religious man" at the center of his life and work. Some of the simpler information in them is not to be trusted, but even if that were not the case I would suggest reading them the way good fiction wants reading, or the *Diaries* of Anaïs Nin, not for facts but for authenticities. The preoccupations that we see in these letters, with transcendental experience, with the relationships among love, work and God, are the preoccupations that he would sustain and be sustained by for the rest of his life; and the habits of mind, not *what* he thought about but *how*, are even more revealing. He was more interested in the meaning than in the experience itself; for him—and his best photographs thrive on this—the world was full of things communicating more than themselves: signs, symbols and examples of general principles.

Not only, then, do these letters particularize much that needs particularizing; they often reveal, quite vividly, much of White's personality. Witness the tenderness, the gentleness, humility, solicitousness, generosity; and the shyness, the awkwardness (especially about his sexuality) that led him often into a stiff formality. Witness the vulnerability, the caution, the circumspection that made him such an enigma to so many; the innocence and romanticism; the self-consciousness with which he was forever struggling; and the richness and profundity of his spiritual life, its undeniable authenticity. All these things were very much a part of him, day in and day out, experi-

enced most fully of course by his intimates, but known more or less clearly by all who dealt with him.

As I read them, these letters embody the essence of Minor White. (The ellipses are mine; the spelling has been corrected. Otherwise the letters appear as White left them.)

My Dear:
It was delightful today, extra delightful to be handed a whole stack of letters from you. I was overjoyed because yours, which I longed for the most, were the first to reach me out here. You know how you feel when a blackboard full of your horrible mistakes is erased and you can start over again fresh? It was like that moment I felt the weight of them in my hands. All the bitterness and uneasiness of many letterless weeks were erased like magic. The middle of the Company street was the only place I could find to be alone, so there it was that I lined the letters up by dates and settled myself for a much needed talk with you. The first one was just what I wanted; newsy, affectionate, endearing. Consequently, I was most surprised to read in the next letter of your decision to join the Women's Army. Then, as the days dropped from my fingers page by page and you recounted the interviews, the induction party, the trip to your first army camp; each protest as it rose to my lips was stopped by another development.

There are so many reasons why you should join that it is hard for me to understand my feeling of

confusion at your doing so. We have shared many things together, perhaps you wished to share the service also. While I am getting used to it, you can pretend that I am very proud of you, for by the time this letter reaches you, I probably shall be.

I suppose this new experience is still very exciting to you, and I hope that it is, at least until my sage little lecture reaches you. You may already have noticed how irksome it is to be but a single drop in that vast sea of nonentity that recruit training seems to be. And if you have, you will be ready for my advice; for your needing comfort is as certain as the fact that it is all I can do for you.

The time will come when you will be troubled as to where you will be placed in the service and whether or not your particular talents will be put to use. My suggestion is simply to forget it. . . . (As an unusually round peg in an extra square hole, I speak with about the only authority I have.) Surprisingly enough what you gain is in a large measure spiritual.

One thing that will be a real pain to you will be the cutting off of your creative activity. You will miss fiercely not being able to design new dances and new music.

On the whole this new experience is not very pleasant, but then, being jarred loose from old habits has never been very pleasant. You will discover that going back to kindergarten and taking instruction from persons obviously your inferior in most things except their information on drill regulations requires

a higher order of patience than you have exhibited in years. The result, once the habits have become formed, is a freedom of spirituality quite beyond what at first seems possible. It is like writing verse in some strict form, the sonnet, for instance, whose rules are enslaving till they become second nature. Then by some miracle of adjustment the manacles themselves become the wings of expression. . . .

Hardships in the army take a variety of diminutive forms which grow out of all proportion by sheer repetition. You may not mind standing in line now and then; in fact, you may enjoy the chance to talk to strangers. But as a matter of routine—pardon me while I am ill! Boredom, unchosen companions, petty apple dusting, vagaries of which only an army is capable; regulations, the soundness of which no one bothers to explain to the recruit; officers, whose human failings are usually greater than their professional ability—the list is as endless as it is trivial, as annoying as it is inescapable. However, there are hours, sometimes days at a time when it does not bother you at all. . . .

Now there is another point that I am not altogether happy about. I am just starting to face it myself and I do not find it easy to take. You see, a soldier has to learn to dislike his enemy very much. This is so that he will be a more efficient killer. Somehow the thought of you learning to dislike anyone does violence to my thoughts of you. It is quite enough just now to get used to your deserting my

The image or sequence that holds the mirror to the man scares the fearful and stimulates the joyous. Sometimes a spiritual one sees his Self.

most pleasant memories of our life together in order to live and serve, as much like I am as you can, without having to get used to you going through the world hating anyone in it. That is not at all like you, nor like what I love in you, or want you to be. . . .

Being a soldier will mean to you someday the hating of an enemy. You must hate, for the moment, just enemy, blindly till you find out which race you will be pitted against. Then you must hate a particular race blindly, brutally, or exquisitely, as your nature determines. Much as I dislike bringing it to your attention, I do so because, like me, you have so far to go in hate that you can not begin soon enough. Hating your enemy must be constant, deliberate, till it becomes instinctive. And believe it or not, concentrating on murder until killing becomes satisfying, deeply satisfying, will depend exclusively on your inner resources. You, an artist, whose whole instinct is to create, have a long way to go, and luckily a great deal more to go with than most. You may have to become a mystic to do it; or take into yourself that remoteness of mind which is the creative state of mind, and which you already know. You will then discover it is akin to, if not the same thing, as the state of prayer. . . . Only in that state of remoteness can you commit the necessary murders without remorse or responsibility. . . .

Why do I say these things to you, when I know they can only make you uneasy? Is there to be more to our separation than an infinity of horizons between us? Must it include a change deep inside of us far beyond the physical appearances? . . .

As for myself, I shall always be a rotten soldier because I can not live by revenge. Yet, even this early, I know I must. I have an inkling of a way I might do it—by a deep regard for the men in my outfit. A regard that must be as deep as love at least. I am told that seeing your mates hurt makes a man blistering mad, but that is a little late. This rage of retaliation must be present early, so that I will eagerly destroy whatever threatens them long before a hair of their heads has been damaged. I am fairly certain that the only way I can acquire a semblance of hatred is by the backdoor method of learning a love for my mates. Already I am learning the bitterness of harboring no bitterness against any man about me. . . .

Will the hatred we learn be as hard to unlearn? . . . In my prayers for you I shall ask, not that your troubles be lessened, but that you be given strength to take them in your stride.

· · · · · ·

I was prepared for your not being willing to accept my belief that the creative artist is fundamentally a deeply religious person, because I was not very sure of it myself, then. It was a point with me I was keeping in storage till it was proven one way or the other. I think I realized that your unwillingness to accept the idea probably came from the hint of sacrilege in saying that man's creativeness is divinity in him. I hope your rather questioning attitude was nothing more

than getting used to an unfamiliar idea. I could hardly blame you for hesitating, considering the many artists of our acquaintance who claim to be indifferent to religion or atheists. In the arts too, "many are called." Now I think that even these lesser men of art are more in error than I am, when I claim that no man can create without being an imitation of creation.

Such a positive statement as the above is based on the solid foundation of doubt. It has been proven for me, right down to my own satisfaction. It is a much more important concept to me than perhaps you realize, because it almost amounts to a statement of faith.

Through your own eagerness to understand what I was doing, you also learned to know the all pervading interest I had in the creating of pictures. Your patience with me when the love of my work seemed greater than my love for you is all that I needed to convince me of your faith in my work. It convinces me also that I do not understand you very well. I expected you to be jealous of my art; perhaps you were. Is it that you thought that by encouraging my work you could gain my love? I tend to believe more firmly that your love is so compassionate that it encompasses both my love for you and my love for creating pictures; that you encourage my work because you would have me grow to your own stature, and know that the discipline of making pictures will let me grow the best of all. I like to remember the

times after breakfast in the mountains when you dismissed me to look for pictures. You smiled most knowingly and busied yourself with the dishes in a manner that implied that you would rather be entertained by your own thoughts today.

Maybe then, your insight has prepared you for the admission I am about to make. For a while when I was first in the army, the pain, like pressure, I felt in not being able to create or to have art close at hand became so great that I actually denied art. I said over and over again, "art is useless, it's a waste of time, it's just something to keep leisure from being a bore; nothing that reality needs, something that reality only tolerates." And I was bored. I was bored furious. I could see no sense in making me live on a level with men who had never even wanted to live better than animals. The standard was set for the least of men which was harder on me than a higher standard would have been on them. . . . In such conditions, I was constantly denied the praise which I craved, and, of course, I could not shine as a soldier. There is no counting the times that some frightful blunder occurred, which when untangled, found me the unmistakable cause of it all. . . .

When the time came that I had been just as unhappy as possible, and had finally fallen exhausted from beating my hands and head against the cobwebs that divide sanity from insanity, I started to climb out of my private pocket of self-pity by myself. No, my sweet, I do not think I am being too hard on

By night prophetic telegrams pass through me By day arrow-headed photographs.

myself calling it "self-pity." True, the army had not, at the time, provided me with its substitute for the high-seriousness of art which I missed so painfully, and which it was to do later. Nevertheless, I am ashamed of myself for not having the wisdom to see through the calculated breaking of the spirit our training included. And more ashamed that my inner resources could not weather a single little storm. Perhaps that process of rounding out the full circle of doubt concerning art had never before been completed. Thus, the opportunity was forced upon me that once more my will had to be broken before it could be made to do, instead of denying, what it wanted to do most of all—create. I found at the bottom of my denial that I could not live without creating. . . .

The first indication that the turning point had been passed came as I found myself explaining the many stupidities of the army way to my companions who were worse off than myself . . . even though it was difficult for me to see any logical sense in most of it. I started creating in my companions an attitude of tolerance and understanding which made me much more content. Of course, I did not know right off why I felt better, and it was only through analysis that I discovered I was creating again. The discovery made me very happy. It also sobered me with the thought of how narrow my concepts of human creation had been before. Creating is an absolute thing and it is the medium which we use to create with that is the

variable. I used to be able to exercise my creative desire with a camera, and now I am able to accomplish the same creative result in people by being a halfway cheerful individual. Sounds incredible, does it not, my trying to be cheerful when I don't have to be. Be assured I have enough lapses. It is interesting—I used to try to create an emotion in people by means of an intermediary, pictures, and now I have learned it is possible to create an emotion in people directly. I was doubting and I was denying finally as hard as I could. I turned my back . . . and endured the sight of unreflecting walls as long as I could. I endured the thought of walking in crowds of people wrapped alone in a great coat on a hot summer night, till I could no longer. I came back to admitting art again in a roundabout way, that is true, and I took a long time. The something more profound than reason does not seem to act quickly in me. It took quite a time for me to formulate into words a phrase to set me free. "The only seriousness higher than war is the creative demand in men and its controlled expression as art."

Your understanding of me is great enough to know how happy I was to emerge from that experience with full faith in art restored. If it were not as much an instinct in human nature as is conflict, and to my way of thinking a lot more endurable, it would never have survived that trial by negation.

I hope you do not get the notion, my dear, that I envision a world of aesthetes. I could never see how

an artist could be an aesthete any more than I can imagine a world of soldiers. Man does not live by spirit alone. . . .

There was an advantage to thinking my return to sanity was due to a return to faith in art, instead of a growth of soul in me which it really was. This you may not understand very well, because you are accustomed to speaking to Him quite unabashed. At the time I was uncertain and a little shy. Then, too, when the thought derailed me, as it frequently did, that I was hypnotizing myself into a belief in God, I could circumvent the doubt by casting my faith in terms of art. It has been easier to explain my faith to others than yourself by claiming that through the broadening experiences of art I climbed back to assurances that made life bearable and death unimportant. I know, and you know, that only faith can do that.

Well, such is my tale for tonight. The doubts are dispelled again, and the problem seems settled once and for all. It is a fine relief to be free again and let my love for you take hold of me once more. It reminds me of our days in the Wallowas when I had returned at dusk, purged of the lust for pictures, and could devote my full attention to yourself.

Do you remember the night we climbed out on a rock in Hurricane Creek? There was a fragrant moon and the water coursed by with inexhaustible fervor, cold and clear and full of white, lapping at the low sweeping pine boughs and often dragging them under. In the uncertain light you remember that eerie spirit came eddying up the stream and caught up the white stuff of our souls in its whirlpool of air, and the three of us ascended the stream to the high valleys above where snow lay beneath the scattered trees and lined the waterfalls, and where we ascended the air over the peaks like a thin white flame so in love with the world it danced and danced out of sight.

Of all the fires
Clear lucidity
None so clear
As those that redistill
The brilliant night;
The black and jetting flames
That elucidate with ice.

Now do you remember the kiss that broke one spell with another?

.

Perhaps you do not know how much I love you, nor my despair in trying to tell you. . . .

You may not have forgotten the weekend we drove to the ocean and found a cottage that hung over the sea so that living in it was like leaning on the rail of a liner washed ashore. It was early in the year, you remember, and cold. The wood fire smelled good and felt better, and the long talk of deeply personal matters after dark felt good too, like the fire. I recall watching, as I told you about myself and things I had forgotten for years, the new moon sink through a troubled sky, though hardly as troubled as my words. When it had sunk in the ocean I was through with my words; and you, my model of patience, were through with wisdom for my ears.

The next morning there was a rainbow where the moon had set. I don't know whether I pointed it out to you or not. I most likely did, for there seemed nothing that I would not share with you. It was a funny little rainbow, just one end of one, with scarcely any curve at all. I did not give it any more attention than all the other bright events, like the fresh seaweed, the green stones, and the foam on the sand which we found that day. Still it reminded me of a kind of a benediction to my first confession in years. . . .

Now, as then, my inadequacy in telling or showing you how much I depended on you must be all too clear to you. So much you must remember. From there on, I have been alone for that was our last time together.

It was shortly afterwards that I was given my uniform and began my life of standing in line. What I never told you was that in the course of a few days in the army, the full impact of how trapped I was struck me. I ran out of the Post Library one night choking at a chance remark which intimated that I would be sent overseas at once. The inescapable trap from which there was no appeal had closed in on me. The only way out was self-destruction, suicide. And God, Himself, stood in the way of that. It was as if I had been shut in a steel room with the only door barred by flaming angels. Nor could I stand and shout my defiance, for I had done that before and banged my head against the wall too. Instead, for once, I prayed. The words of the ancient prayer I learned from my grandmother, "Thy Will be Done," over and over till I went right on past the chagrin of turning to Him only in trouble; past the hypocrisy till I knelt as a naked soul before love. . . .

You may be curious, and you have a right to ask, why I reached these profound depths of discouragement and how I knew it was God that stood in the way of my killing myself. It is easy enough. There has always been a belief in me that moves on its own, walks in its own paths, and to whom there is no doubt of its own existence. It may very well be my

soul—what we call it is clumsy—whereas itself is perfectly conscious of itself, of considerably more which is exterior to itself which is not me. It is this that now and then leads the rest of me into what seem like fits of despair and leads me to contemplate suicide, knowing it is perfectly safe for me to do so because itself has no such intention, nor that of which it is conscious outside of itself has any intention either. It is a kind of method of reminding the rest of me of its continued existence. Flaming angels—they make good reading, though of course, I never really saw such things. The utterly confident soul is quite well acquainted with angels of all kinds in itself, though my mind, as I say, has never seen them. Again, it is no matter to it; angels are not important except to speak of them to help you understand.

And that which seemed a trap became a stepping stone to accomplish a purpose. It seemed to me that once I had said, "Thy will be done," I could not revoke my contract simply because the time was quiet, and the grass growing unharmed about me. It seemed a lull for learning, the time really set aside to see the white altar at Easter. It was at this feast that I *was accepted by the Church*. It is late to tell you of this, though its aspect as a gift for you was one I could hardly send you so far overseas before it happened. Perhaps grace for you that day was multiplied.

In a way, which is not quite clear to me, the whole crucial moment of baptism seemed more full of people far away than those who saw me and touched me. Father made all the necessary arrangements. The evening of the event came as penetratingly as only they come on an island that is always too beautiful. We took off in a jeep, and drove past mountains and towering cane fields and pineapple fields in ordered rows to the Chapel of the Rifles. The sun's last rays were sweeping across the wide cloudscapes overhead, and all had the clean dusted feeling that recent showers leave behind. In the back of my mind there was a faint question as to the propriety of what I was about to do. Mother, you know, had not given her consent to my baptism in your church, and furthermore this was her birthday.

As we unloaded ourselves in front of the Chapel I glanced across the vast lawn beside it and there was my answer. For there was one of my special rainbows in plain sight. Without thinking at all, I knew He was nodding to me that it was all right. I went into the chapel feeling that mother approved. I felt also that you were closer now than you had been in a year. This was the first fine fruit of your love. . . .

In this life of mine which has become one of

possible last things, here was a first thing, a beginning of something that death, instead of terminating, would commence. Death instead of cutting off forever the stream of my efforts before full tide is reached, or stealing like a frost the first fruit before the flowering is done, is only the quick sharp crisis of another just as it breaks into a burst of golden petals.

Yes, I think the promise of the rainbows has been fully kept. Do I presume too much to think they were all for me? I think I do really; yet the ways of Him are not very clear to me. If they were there for me to see, I saw; if not—but that is out of the question. The first promise of our visit to the ocean was kept. And now, my love, I think there are other things in store for me. . . .

.

You remember I mentioned mother's approval of my joining the Church had not reached me when I was actually baptized that evening. Also, that my faintest fear of disobeying her evaporated as I walked up the chapel steps. I know this is belated for you; it was for me also. Shall we just call such inconveniences as time and space impose on us the least of our sacrifice? First let me repeat for you, to the best of my memory, a letter or so I wrote her just before I was baptized.

"But mom, you surprise me greatly to even suggest that my joining the Church would lead me to disavow my family. That is the furthest thing possible from my intent or any teaching of the Church. In fact, it is because of things I have learned in the Mass that I have renewed my responsibility to you. It was very much because of the teaching in the Mass that I requested your approval of my joining. There have been so many years and so many plains and hills between us that our ties were in danger of breaking. And now, that there are thousands of miles of ocean between us also, and many nations, it is the influence of the Church that has set our relations thriving again."

Mom, for a while, seemed to think that I no longer loved her. Such a thought ever entering her head is completely out of my understanding. In answering, I assumed that she was jealous in some way of Our Lady—apparently that was the trouble.

"How else, mother, do you suppose I have known the nature of Our Lady but from what I know of you? From what other source could I have learned of Her kindness but from remembering your kindness, which was so great that you could punish my misdeeds? I recall your worry when I was learning for myself that living was very much what you had told

me it would be; and from so remembering, I could measure a little of Her concern for Her struggling children. Why, mom, all I know of Our Lady came from my knowledge of you. And all I feel about Her comes from my love of you. Are you satisfied now, my sweet, enduring Mother, that I love you more than ever before in my life?

"I like to think, and maybe you do too, that you can be a mother for life. Perhaps that is as much as a mortal can bear, and that is why Our Lady went to heaven to be our Mother for eternity."

The letter must have reached her only a few days before her birthday, though I am not sure. She is not always definite about dates, and no letter of mine is necessary for her to change her mind. Now your impatience can be rewarded with a paragraph from her last letter.

"Yes, my son, you have my approval. Do you know how I spent my birthday this year? You were the only one to remember it. I passed the day very peacefully thinking of you. It seemed so strange to think of you without any trace of worry. The whole day was so charmed it did not seem quite of this earth, and it even lasted into the second day. Is this the bounty and generous nature of Our Lady, of whom you speak? I am sure she must have answered your prayers. Your baptism was the nicest birthday gift I have ever had. It makes me feel as if I had been a good Mother to you."

Oh, I wish I was as demonstrative as you. This letter of Mother's deserved more than inward exaltation. An instant prayer satisfies some part of me; still I wish I were not so shy but what I could dance and shout with joy. . . .

.

Somehow watching the water and hours flow past the plunging ship, any soldier crowded beside me is very much like you standing with me, each of us lulled by the monotony into a secret cell of our own.

It is even more wondrous at night with the phosphorus in the water making the ship appear to be sailing through nothing more solid than space across the ramparts of heaven. These warm nights in the tropics are things not quite of this world. Last night I was on deck long after most of the troops had been driven below by a squall of rain. The warmth and the dampness were such that one became unconscious of one's body. I was little more than a disembodied thought when the moon escaped its clouds for a moment and cast a faint shadow of the liner on the lacy foam below. Life can never be that ephemeral again.

Some soldier stopped a moment and spoke. "It's indescribably rich in the dark, isn't it?" Without waiting for an answer he continued, a little unlike a soldier. "This soft mist, the dark outlines of the boats in the convoy make it seem as if the long strong limbs of my woman are what cause the rhythmic heaving of this bloody ship. And the wind is like her hair in my face. And the foam and blue-green glints of light are like her fleeting expressions of smile and seduction. Can you see that faint red gleam on the water like flesh in the moonlight is red from your memory of flesh?"

I could not, so I laid his faulty vision to the hot red blood of him who spoke. He must have been full of the dreams the endless ocean engenders to talk so freely and so expressively of his feelings, instead of using the vulgar language we usually use to hide the tenderness of our passion. I had been dreaming of love, myself, I guess, though you were not consciously in my thoughts. . . .

The soldier rubbed his hand briskly across my close-cropped head and whispered, "It feels good—like a brush." He laughed quietly and went on his way to the black deck below, though maybe he wanted to stay—I don't know, and like it better not knowing. His stopping had the effect of twisting the revolving river of my thought further backward than ever on myself.

On liberty once I met a sailor at a bar whose frank little eyes made him look like a son of ours might look someday. That alone was enough to tug mightily at my very weakest spot. Then when our talk turned quickly to books, music, art, and photography, and we found that the same things roused us, I was helpless. He entered that deep down place where I live and before long had stirred there the memory of an old, old, love, one even longer ago than yours; that of a golden lad who used to sit in my window at the end of day when the feathered clouds turned to wings of gold and rose in a throaty, blue-green sky. And he would read to me from those self-same books, or show me a Falhael he had become enamored of, or fill the room with the sound of Brahms, or tempt me with splendid pictures of the mountains he had climbed in the glittering Rockies. Yes, the image the sailor let loose was greater by far than the man himself.

When he had gone, quickly, like spray on your face which leaves the taste of salt, I found that sorrow and lonesomeness threatened me. It was only by praying to Our Lady that he, and the lad of long ago, be led to Christ as I had been, that I could remember him kindly. . . .

The soldier's hand on my shorn head set going other thoughts, one of which I could not dispose of by simply forgetting. I began to notice also a red glint on the water like the red we remember of flesh in the dark. There is much of unallayed lust among men without women, that fine bodies in close proximity and lads with limbs as smooth as a woman's does nothing to lessen. Already has started that process of separating love from desire in us. There will come the time when the degradation of our bodies by pain, hunger, privations, and annoyances, will be so great that our minds will stand aside like a disembodied thing obedient only to its own ideals, rather than acknowledge the beastly thing it lives in. Our bodies will go on slaking their desires, not of love, but of disgust in the bowels of one another. And it will be unimportant. Some will seem thus to punish the body for being subject to so much pain.

I have watched many men while watching myself and it seems to me that it is only our Priest who can love all men with purity of purpose. . . .

You have remarked before that I am oversensitive on this point of love for men. It was one of the things that opened the way to our understanding of one another. You became a confidante, a leader in the way I must go if I were to earn your love. Would you believe it, but, for a long time, I was fearful of loving Christ because of being shy of loving men. And that, mind you, after you had told me that the way to Him was by love here on earth, in any way we might experience it or abuse it. Oh, I knew it, and knew how, but I was such a doubter that I must have an incident, a sign, if you will. The wonder is the incident was awarded me.

I had gone to St. Sebastian's by the Sea to share for a few moments with Him my happiness to be on leave. Kneeling in this tiny chapel with walls of open lattice work instead of solid stone, was one of the things I loved to do. The sound of the surge and the beat on the beach coming through the perforated walls; the wind blowing through it, and the birds of St. Francis nesting in the rafters, made it seem as if He shed His rays beneath a spreading banyan tree. He was no longer hidden in a deep cave like a jewel repository. The open chapel always seemed friendly and loving, as if it cared more that the Light within it should reach far; as if it thought its keeping safe the Light would deprive the men far away at sea of His strength.

Kneeling there that dawn was uneasy, for the flesh had sorted out all the apologies—loneliness, need for affection, a reward for prolonged attention to duty—and had taken the only satisfaction it would recognize in the embrace of strong and supple arms. I was especially uneasy because the full afterglow was still upon me and I was in love with the whole world with that detached Olympian regard the flesh rewards us after orgasm. In this state my love went out to Him from the bottom of the very act against Him. I prayed forgiveness with all the solemnity I could muster, and by some miracle of understanding, knew I was penitent for once instead of just ashamed. I was sorry the flesh was stronger than my will, but I could not be ashamed of any work His hand had made.

In the silence afterwards, listening for His voice, I felt the love of Christ envelop me with the sound of surging waves, and I praised again the open walls. There were no words formed for me to hear as I was spoken to. I felt I had been forgiven for going beyond the bounds of purity into lust; I was forgiven because I had loved.

From Sequence, *Temptation of St. Anthony,* 1948

In that moment I would have willingly died for this world beyond good and evil, for love beyond male and female, and the vagaries and poor separations thereof. . . .

I left the miraculous church most assuredly on air. The love that I had determined to commit, and which had often left me bewildered and hurt, and which too many times was disgusting and sterile, had proved that it also led to Christ. I went away inwardly praising Him for inclining my decision, quite unknown to me, towards seeking love no matter how badly I might fare. . . .

I went out of the church and sat down on the rocks above the water, and listened to it pound and roar, deep-throated, like men singing novenas from the remotest depths of themselves. So gloriously I listened, so gloriously I determined to love all men in purity—needless to say I fell.

It was thus I learned I must have some way of control, some conscious way of keeping the lust which always seems to follow after the spirit as it loves from devouring the spirit with its own kind of love. I know the easier way is to turn away from all temptation, build me a shell and occupy my time drawing designs of the sea in it; easier, and also less abundant. I prefer to live in the world. . . .

I looked about the deck, darker from blackout than anything else in the visible world. Each black mound of a man that had returned to sleep on deck contained a being smouldering like a lamp in an underground room. They were the only light I could see. . . . With your love to anchor mine and His to aspire to, how can I hesitate to love my companions.

A passing chill touched me and in a few moments I started back to my bunk, being very careful not to stumble over anyone, and being quite unprepared for any startling decision. Maybe I made a decision, maybe it was made for me, I incline to the latter. As I was walking away from ecstasy towards sleep, which is a very necessary thing, so would I soon turn away from seeking Him in some faraway beyond, to seeking Christ in men. To turn somewhat from creating meditations to showing men His presence in them. In the only way I know how, preferably by making pictures, but now when that is impossible by working for their benefit.

If now I turn my thoughts from Heaven
To creating imitations of creation
Think not I have deserted.
It's rather all the flesh can do . . .

.

The feeling of being too far from home, that I first felt on the ship as I saw the North Star go down into the ocean and watched the Great Dipper set another star in the water each night, is only now leaving me. Losing them was plenty tough, because walking about under the stars is the only thing like home I have left any more.

The first few nights I spent in this camp I spent plotting new courses in the sky. I was so empty that I could find nothing to say, even to you. Briefly though, while the first few nights were unfriendly, the old glittering magic of the stars was soon at work, and now there is something very important to write to you about. You remember I mentioned before we left the islands that I was on the verge of understanding something?

Walking in the dark with scarce a star
To line the sky like notes of simple song.
Yet the darkness is as full of light
As if love itself could do no wrong.

The something is about the experience of war. I believe I used the word "clarity" when I spoke of it before. "That a clarity could come, must come sometime." It did come—beginning as I was walking, then during the night as I slept. I did not know it had arrived till I stumbled on it somewhere in the daylight hours. It was simple, and not simple; as lucid in thought as it's going to be murky in words. Because it was present when I awoke one morning, I came upon it quietly, and knew it quietly, and left it quietly. . . .

The clarity, as we might call it, has to do with war in its most intimate sense, those moments when the man himself is hopelessly enmeshed in the accidents war weaves about him. The clarity came to me more as if I were remembering things than envisioning them, though some of them have not happened yet. First the old fear of the unknown, which has overly frightened me too many times, was in men; then it faded away more completely than it has ever done in reality. Then it was replaced by a kind of serious satisfaction as of surviving a grim wreck. I know you do not know what I mean, so let me enlarge.

The feeling of memory persisted into the future, till the moment of serious danger was at hand, and as we say, "somebody was writing my name on it." There was no surprise now at the fact that there was no fear present—I did not expect to be afraid. There was a fullness, an overflowing even, instead of any gnawing emptiness. It was as if the hurt and pain were kept at a distance, though the moment was certain. I walked in an aura of expectance, as if in the middle of a host of friends—in the center of a ring of protecting friends. The blundering moment, loud and howling when it comes, must first of all penetrate the circle, and become quiet, become silent, become full of purpose. With purpose it does its deadly work as delicately as the closing of my eyes; or as if I had touched ever so lightly a hand, and with vision, knew the whole bright being of the man. Or as if someone had struck me a violent blow, and all I felt was a gentle tap.

Yes, I remembered that I would come upon a feeling as of being surrounded by love. I was surrounded because the critical release of death was

near. I did not mind at all because the love did not come from the pity for my startling end. It came from, it was the beginning of the love I would know when I was freed of my anchor of flesh. There could be no pity for the surprise of a promise kept, or the joy of a gift opened.

The clarity passed as peacefully as it had been known and became the tenuous material of memory. As it did, so I knew one more thing. It made me wonder. I wondered if I might meet this love in days to come and live beyond its length. Death might hesitate about my case—and pass on. What would happen then to this love? I was disheartened for a little time, for I knew the hardest of all would then come to me, to step from that peace into the embittering turmoil again. It will be like having a golden promise sealed away for seasons without end. It will become increasingly difficult to swell that secret moment of love always till it fills all my days and nights with a love as if love itself could do no wrong. It was only because there was much of the clarity still in me that I was not utterly discouraged. . . .

Please do not think I am being bitter or regretful when I thank you for all the things we have done together, because we can not do them now, and maybe never can. It is really the fulfillment of what you have taught me that I have no regrets.

It might be well to preserve this letter against the time when they become irrelevant, or much too long apart. I am pleased that I can write you this now or before it happens, because when the time does come, I'll probably be too weary to make sense. . . .

.

Of late all days have been so near the last that we envied the day's dead their unknowing. Once, many hundreds of years ago, I used to treat last things with respect and gave them their due and was restless and frustrated if I had to do them over again. I did not like saying good-by at stations to persons who missed trains. Today, however, I am ready to greet another day and hope there are many more to come. While the world is deep and wide and has mauled me, I guess it is not quite enough. Perhaps I am offending you; something tells me that I am. Be not offended, my dear, it is enough to turn hysteria, like a wolf, on any even course of thought.

Something I wrote you once to help explain the army comes back to me now—"think to accomplish nothing for yourself." It is the word, "accomplish" which wreaks my fancy. A dozen or more blasted men, as innocent as myself, on my list of accomplishments! I did not ask for anything like that.

There are no knots of reasoning my logic has not tied, untied, and retied; its contortions are as vain as they are varied. Their innocent blood—their innocent blood—I had better stop for a moment.

I was about to say the death of them was on your hands as well as mine. There is more than reason which makes me say this, I am sure. You are one of the many people who form the indistinguishable line of men whose ultimate end is the one of us who shoots it out with the enemy. I am no more guilty than you are, though it was my grenade which ripped some of them apart. I would rather not think you guilty, but I am too frightened to live alone with it. . . .

I was lying in the jungle stalking snipers and had become occupied with the delight of an orchid. In this stinking green jungle it was the first thing of beauty I had seen in days. It soon became something to love. Its purple petals were as crystalline as juice dripping from wine vats; its veins of green interior lace more tender than spring. And on it were spots of red as cruel as dried blood. It seemed the only thing alive—till something moved beyond it. I was instantly alert, I fired where I had seen two eyes.

My blossom of delight was shattered, its stem broken, its petals hung like flames of destruction destroyed. I was considerably angered. Later when I had crawled to the place where I had fired, there was a dead soldier. The round that had murdered my flower had left only a neat little hole in his monkey-ugly, slant-eyed face. I was furious. I swore eternal retaliation—because my flower had been lost. You see, I never could learn to hate the little beast.

Now, it is one more day after the last, and they say that death has taken his bloody bones out of my bed. I don't have to be indifferent to their fate anymore—that is, the dead ones. Hope with me, beloved, that their souls were as shining as my orchid. Pray with me it was to heaven I started these souls, and did not start a single ruined soul's descent. Forgive me, dearly beloved, I am very tired; and pray with me that henceforth His will be along more peaceful lines. . . .

.

The many questions you have asked, the natural ones about my recovery, my well being—why, they make me well. The other ones, the ones you have been hesitant to mention—for instance, asking of the moment of destruction, the moment I might have died, when it came was it as I had visioned it would be; or if, now that the moment had come and gone, I still loved you, these make me well to answer. My

sweet, it makes me smile to read your letters for it is like looking up through the ocean in which I am immersed, and seeing your searching face dip beneath the surface and be seen clearly, distinctly for fleeting moments—the sight of you draws me upward briefly.

The illustration of being in a sunken world is more apt than you think, so great are the changes that have occurred in me. I live like a bell tolling through the cold clear water of a deep well. No, I am not unhappy here, though, as I look up at your shining face, I wonder if I will ever be able to return to being the man you remember. I wonder if you can, and hope strongly that you will, join me here in this great solemn sea. When now I smile as you delicately question how it goes with me, I formerly would have wept. It is a matter for tears that I have somehow gotten so far from you—you recall I asked you once if this was going to separate us with more than a multitude of horizons? It has. It is a matter for no smiles at all when I smile at you. It is not that I do not appreciate the incipient tragedy, or have become the one who loves the less, and would therefore be relatively unhurt; it is only that tragedy has become the natural way of things. I do not think I would feel comfortable in a shockless life anymore.

I know you are mystified, for dipping into my world from time to time is not enough to understand it. The natural way, or perhaps I mean the supernatural way, is to be separated from near things, and parted from distant ones. It is to be devoid of positive things and deleted of negative ones. It is to lose; to be stripped. The tragedy of losing you, if that should happen, is only one of the things that has been dropping away ever since I came into this army. First it was clothes, then a sense of freedom, then memories, then the leisure time to accomplish my being, which is my work. Each loss seemed as if the end had been reached, that I was finally naked, unprotected, at the mercy of any stinging insect. It never was. Sheets, then beds, then cots, then wet ground for warm, over and over again, things dropped away. Now I know there never is an end to it. I go on meekly losing little by little, absorbed in the losing for I think that nothing is ever reached. Like the bell broken from its boat drops upon a ledge where its rope is rotted away, then is swept off into the endless ocean, loses the light of day, sinking deeper forever, sounding its drowned note deeper and deeper. However, there is a bright suggestion, too, it sinks away into new water. . . .

You ask if that love which is beyond pity for the event of death, actually came at the time I was hurt. I am sorry to say I don't know. I was too hungry at the time to think of anything else. My thoughts were bounded on one side by a steak and on the other side with eggs, and lighted by occasional flashes of ice cream. It would have surprised me too, had I not been told that my only thought in combat would be food.

The soldier who told me also had other advice, which, contrary to my usual custom, I heeded. On the strength of his recommendation I took the next free hour I had for meditation and prayer. I don't quite understand why I should have prayed differently than I usually do. Ordinarily I speak in adoration, or repentance, or duty. This time I did some down-to-earth explaining. I told Him that no matter what I said in the days to follow He was not to believe it if it was contrary to what I was going to then state. I was saying, "Thy will be done" now and forever and without interruption. That was my intention, and it was to continue unbroken as my belief. I had no idea what my tormented mouth might say, or my battered brain think up in the days to come. The precaution was not amiss. My flesh blasphemed with impunity and was consequently confident and strong. All its little power was directed to its work—oh, I murdered cunningly; whereas, if I had had to add restraint to its torment I would have failed. Perhaps for all my cursing I was not speaking in vain.

But, as for the love, I do not know. There is not a scrap of evidence to prove it, no incident, no feeling, only a residue of solemnity. One which I am at a loss to explain, one which is solemn like all the dead forsaken. I am afraid, my dear, it has gone; His love has retreated. I have lost it. Once I knew my timid approach to Him, then a fullness of love, then the prosaicness of a contract, then as I fell in the stinking mad[?], an absence of love so deep it was itself a kind of vision. . . .

Do not mistake me, beloved, I am not frantic; this body is too sick for frenzy. The deep unmoving of the sinking bell is the most like my spirit. I contemplate this loss as one more thing taken away; probably the one I thought I could never lose.

I am reminded in my loss of a story one of the saints told, St. John, I believe it was. The first time the vision visited him the crown of thorns bore flowers much more wondrous than the roses they seemed to be. With each succeeding vision the flowers diminished more and more into the pitiful stature of reality; they became subject to wilting, to falling away. These must have been the most cruel of all

experiences, for they became a patent for comparison with mankind. At last the visions sank into the wonderful again, and the final one, St. John reports, was the unadorned crown of honest bloody thorns. I am told the Saint was saddened that his visions ran counter to expectation and turned from joy to sorrow.

We are all accorded visions it seems to me, though in these days, it does not seem the fashion to recognize them. . . . I have had the fullness of the days of my entry into the Church, the grace of the rainbows. There has been the slackening of love, the final withdrawing. I have known these, though at no time could I report the rapture of vision-smitten eyes. And at last, the honest bloody thorns, when I witnessed their innocent blood, the blood of those I had killed. While the running out of glory evokes in me a sadness, it is not eager, it is not a tearful way of adoration. What eagerness is present is of something quite different. As little as I know of visions, their progression has been as the saint's, and I should be as sorrowful. Why is it that secretly I am not? . . .

The passage of the visions from glory to suffering is according to our feeble erroneous accounting akin to a well going dry, a sweet orange drained of juice, whereas really it is like the wise teacher who looks where we are, and starts where we are to teach us her difficult lessons. The progression is really the turning of greatness to the great; it is the spiritual becoming the spirit—nothing less.

If there is any frenzy in me, it is because I can not seem to explain to you how I know this. How can I explain visions I have not seen. All I have is a moment so empty of love, it must have been full of meaning. A moment whose only record is that St. John's story illustrates it. Perhaps the saint could not explain it either, and so told with high hopes what happened as it occurred to him; or perhaps the many misgivings as to how well he would be understood inspired him to make up a story. It may be well for me to imitate him and tell the facts I know and let your fancy knit them into the vision of solemnity. . . .

We will walk down by the beach I can hear from my cot. It will be necessary to take you there for your ears are not as opened as mine. You will almost weep as you listen to the going and the coming of the waves during the hot still noons. It is not a very loud sound; the delicate touch of the oppressive heat will be ample to hold you still enough to hear the speech the waves wash up from the middle of the world. If you catch the sound of voices for a moment; that is enough. I would not ask you to hear it as I do for all

the long hours of all day and all night.

Then, in the heat-depleted afternoon, we will visit a solemn old cathedral I know, where you find the choir practicing. It is a strange church, the choir is installed behind the altar, and our vision of them is faulty because of a high steep grille of metal in front of them. You will nearly weep here also at the ecuperant [exuberant?] chants, at the chastened spirit singing, especially as the singer turns and puts his hand on a bar, as if to hold himself, or as if to hold the bar aside and let his voice ring out to the remotest corner where kneel the timid and the sick at heart. The sight of his singing thus is so like a prison you will clap your hands over your eyes to keep from seeing the willful prison surround untrammeled song. . . .

Somehow it is as the man becomes meek the whole earth is his.

You have certainly seen by now that there is little gaiety in me. And before you have gone too far afield, let me urge you there is nothing of despair either. Despair is impossible to me now because that is something the poets invented to pass the time when the spirit is asleep. There is something in this solemnity that is pleasurable. There is pleasure in it such as melancholy has despaired of knowing and joy has never noticed. Joy is too much like foam on the spring-flooded stream, and melancholy too much like shallow water that any rough stream bed can break into a thousand aching voices. In the realm of my emotions, this other is more like a river turning into a powerful column as it rolls over the edge of a cliff. This solemnity is nearer to the serious pleasure we have in learning. . . .

There is a sailor's town in the States, and in it a sailor's street which I used to walk along now and then looking for sailors' women. I would get a little drunk, or quite a little drunk, would envy each and every man who had found a woman; would sit in the taverns and bars and watch them dance, the sailor all male in his lonely legs, and the girl all female in her utter confidence. My longing and despair would keep sticking daggers in my throat. I would go outside and pace the streets again, a bundle of potential eagerness, and probably looking like a starved stick of a thing. On a few occasions the feeling lifted and I relaxed. I would lean up against a lamp post and watch them coming and going with something of delight instead of hunger. The drunken ones who staggered were funny, and I felt sorry for their heads in the morning. The still-searching ones that passed with near despair in their eyes, I pitied and to myself

wished them luck, though it might mean a crippling disease in the morning. The brawls I eagerly attended, shouting with the rest, not counting the wagon in the least. Then when the wagon came and packed them in, their white caps bloody and black, I was sullenly defiant like all the others, sorry they had been caught.

I remember once folding myself up on a bridge rail after my despair had passed in a kind of ecstasy at the passing sailors who by now were louder in their cursing, more voluble in their desires, and I kept saying to myself, "Live, you bastards, love, fight, hate, curse and swear, but live! Your virtues will drag you to hell, and your faults will snatch you to heaven." And I was almost merry. "Your faults will bring you to suffering." And I loved them all. I would not change a thing. Sitting on the bridge rail I was not a part of the stream of persons, no longer an atom staggered by its own desires, but a man observing currents, or charting the drift, the banks, the stagnant places, unmindful of the local tragedies in seeing how the stream progressed. Unmindful of the suffering because it was only by pain that the stream moved at all. I would not want to stop the movement or stop the suffering, because then all would die.

In another city is a restaurant for the poor. At meal times when it is crowded you are not at all sure how clean the dishes are, often there is still lipstick on the cups. After midnight, however, it is better. The roaches are bolder and frequently poke inquisitive heads out of cracks, and the rats, of course, go determinedly about their business. It is a place that never seems to lack life. The men are loud or sullen; the women tired or cranky. Once a small woman fluttered in as if a strong wind propelled her. She slipped noiselessly into a seat in the corner. More ragged than most, in a shawl, a shapeless coat, when others displayed a flashy version of the current style, she stood out unexpectedly. When she slipped off her shawl there was a cloud of no-color hair let loose. Her face had a pathetic sweetness that was of a woman with an innocent mind, one who would never understand why circumstance had destroyed her innocence and subjected her body always to insufficiency. Not that I ever understood myself, why. She was not the drooping flower-girl out of an opera, the young Match-girl dying in the snow, who had somehow reached middle age. My pity went out to her; I held pity in the palm of my hand, and crushed it in my fist. There was something of my solemnity prepared in that.

I have lain in the past few weeks next to my best friend, Danyon. And while I nearly wept at the sun-

light falling on his bed, I have nearly smiled watching his face in torment as waves of pain rose higher and higher over his head. He and I used to talk in the jungle before we were hurt, to encourage understanding of one another. We rarely talked about our weapons, or our filthy clothes, or the food, or about anything in the past. Neither of us had regrets concerning these. He was a man who had overcome the concentric power of original sin. He had come to love those around him nearly as well as himself, and his love was slowly reaching out to God. In fact, in all our conversation we never used very many words. We would just sit in the respective ends of our trench and like to have each other around, or go out on a patrol and feel secure because the other was present, and it would feel just as if we were talking.

When he first came to the hospital I never asked him, but I understood he came because he was lonely. He could not have come to get out of anything; he sacrificed too much for that. At first he would turn his face away so I could not watch him suffering. I did not tell him I did not want to be spared, though soon he no longer turned away. I think he took some comfort from our wordless talk that there was no reason for remorse. He seemed to find my steady gaze all he wanted. I know that emerging from some sick coma of my own and seeing him looking at me was all I wanted. His face was always fine.

He seems more beautiful than ever now. Yet there is no beauty in pain, neither is there anything ugly. It is quite aside from either of these that we have no regrets. When I smile watching him, there are no questions that perhaps his wound was needless, a blunder of his commander, an accident of witless circumstances; these things are trivial to the solemnity.

As the bloody sweat oozes out he would die, but for his spirit lying there alive. I contemplate his pain without pity. Why should I? I see his spirit but thinly veiled by flesh. He sinks so low sometimes his spirit is almost visible. When thus I have often smiled at him, he has understood why, and has not been offended. He was pleased and would acknowledge that I should smile at my Christ in greeting.

He often lay there, eyes closed, never moving; his arm hanging over the side of his cot, its hand lying on the floor like a peeling. Somehow in Danyon the last vision of St. John is reenacted—the honest, bloody thorns. I am humble before it—more humble than I have ever been before, more so than when I kneeled before Him and felt Him love me because of

my sin. I am humble because He suffers in the man beside me.

This morning as Christ rose from his body Danyon died.

One more thing taken away. . . .

There has come a greater capacity for losing and losing and losing. You will not think that is joy, I am sure. Yet of a sort it is, a solemn sort, as I have said. Solemnity is not all ice, nor all fire; there is swelling and growing in it. . . .

I believe it is this humility that the sun warms in me, that I hear down on the grating beach, and smell in this deathly air. I believe it is this which destroys despair, takes up the slack of remorse, cancels sorrow, and determines the accumulation which losing again and again accrues. It is humility that moves in me. . . .

I used to associate humility with meekness. I may not have been mistaken, but I was not fully enlightened. It has become the only eagerness in me, that which moves without haste, without slowness, and whose joy is not joy, and whose beauty is not beauty, but is secret.

As I watched Danyon's spirit I found out that fainting before the face of suffering is all there is of courage, and that steadily gazing there is all that there can be of humility.

.

Well, the war is not over, and we are back again. Once more it's these pagan palms, and jungle so energetic, it invades the sea. . . .

This jungle always seems much too foreign to fight for. I would be more willing to sacrifice my life in country which at least resembles home. Here, we sacrifice even a reminder of home in order to risk our lives.

There you have, in all its prosaicness, the almost irrelevant thought that set me thinking further that humility is not the final outpost of the spirit. In the moment the thought crossed my mind that I would rather fight on a more familiar shore, it also occurred to me that humility was an invisible force that was in need of some way of being seen, or of being noticed somehow by other people.

As usual it happened without effort, quite simply, when I found out that the way to make known that humility is at work, is by an act. This act has a name, and this name is "sacrifice."

It's that old; that well known in human affairs, it has a name. I, myself, can not recall when I first heard the word. As a word, it is very simple, one a child might use, and believe, and even do. Yet, when I stop

to remember the number of years I have not understood it, the thousands of experiences I must have had, any one of which was ample to open my eyes to the meaning of sacrifice, I am convinced all over again that man never learns anything simple. He has to earn it. . . .

You do not know what a glow it gives me when you indicate you have caught my meanings, nor what a joy it gives me when you add to my own understanding—as in one of your recent letters when you explained simplicity to me with neatness and finesse. Could it be that it was your explanation that aided my conviction that we earn simplicity? Allow me then to quote you a few paragraphs from one of your letters. . . .

"You will feel a tear in your heart someday when your little son will say 'Daddy, I saw an angel today; he had blue wings and said that you were very strong.'

"You will want to believe what he says whole, just as your son says it and just as he believes it. Yet you can not believe this easily. You, nor I, can't even remember what it is like to have such implicit faith. It will be years before we can believe as our son will do and even then, it will not be quite the same. You and I will have gone full circle first, not because we wish to, but there is no other way back to faith like that of children.

"He can say, 'This is the Basilica.' And it is eternally confirmed for him. You will go inside and look at all the windows, and ask all the questions about its heating system and its cooling; its cost and upkeep. When done, your knowledge will be greater, but your faith no stronger nor any simpler than your son's. The full circle is more like a spiral returning to simplicity as well as ever increasing knowledge."

It is so simply stated I feel you know more about this matter than I do. . . .

You know, my dear, it was much in the same manner that I learned to my surprise one night, that in spite of all my saying, "Thy will be done," I had never given a thought to what His will with me might be. It was much in this manner that I learned that humility should have an act. And much as I discovered that a lot of thought and effort was required to discover the nature of His will. So did I discover that sacrifice is the act needed by humility. When you come right down to it, there is probably more than just a parallel as to how the discoveries occurred. I suspect that any attempt to discern what He would of me or any effort to carry my decision out, and the act

of sacrifice are about the same thing, like two stalks of corn out of the same field. Consequently, the simplicity and richness that filled my mind as I understood about sacrifice occurred because one full revolution of your "spiral" had taken place. . . .

Inasmuch as the humility of which I have written is a force and not a submission; is a motive power not a negation; a growth like roots submitting to stones continues to grow between the stones, and sometimes in cracks of rocks, they will split the solid stuff apart—so sacrifice is not a degradation either; neither of body or soul, willful or imposed; nor is it a subtle means of feeling sorry for oneself; nor a lopping off of a finger to see the blood flow. It is not unhealthy, or morbid, or the bent desire of any psychosis. It is something like a woman who not only bears healthy children, but bears troubles healthfully as well.

In the few seconds I thought I would rather fight on a more familiar shore and understood about sacrifice, I did not comprehend it as a clap of catastrophe—I have become too detached from this world for that. No, it occurred to me that sacrifice is a kind of gift—a giving of something that is of the substance of our being and giving it with the same ease and cheerfulness as we give of our surplus.

Sacrifice is not drifting helplessly doing without necessities because it is out of our ability to change the circumstances. It is a purposeful doing without. . . .

It is faith that purpose still exists. If there is strength left, we shall try to find out that purpose for us; if none is left we shall acknowledge that purpose, no matter how senseless everything seems.

There was a battle once, and in it a battle line, and I looked up and down that line for as long as it existed. I saw several men die more suddenly than Danyon. In a brief spell of violence, only a few moans were left, and the side-men, when they came by, had little work to do.

I don't know how many of the men were prepared to give their lives, nor how many were not. In my own peculiar detachment, which looked on as if it made no difference, was of no importance, I saw only the indifferent destruction. It was as if a wrathful god had grown impatient with men to acknowledge Him and thus forced them to know. His will would be known. He took them to Himself in bold strong hands as loving as the violence these men had loosed on one another. In that time, they were fighting mad and were giving without reluctance. Even the most reluctant of them was giving freely at last. The act of giving freely was made—and then it was that they could receive.

As usual I looked on quietly. If it is His will we be brought to understanding of Him by compulsion, so be it. His love—great enough to forgive us still.

The sacrifice of a soldier is also something like this. . . .

Purposes in peacetime are different, and the sacrifice of money and comforts and advantages necessary to pursue [the life of an artist] can, in time of war, in order to become sacrifice, be the giving up of [art]. The important subject is humility and its act of sacrifice, not the fulfillment of abilities. The act must be made within the irrevocable vagaries of circumstance, because in circumstance, which we frequently label "witless," there is purpose which is beyond our understanding.

I can say with utter conviction that though [the artist's] talent may be lost to himself and to the world, and his possible contributions deeply missed, there would be no tragedy to him or to the world, if thereby he finds a means of expressing his humility. Through his talent he will be able to find his way to the spirit and to the deity; that is certain. He can also reach the same end in his present position—digging foxholes and throwing grenades. If there is any possibility of tragedy, it would be in his not reaching the spirit and the spirit not reaching him.

The history of the world and its evidences of progress suggest it is possible that progress, which may be more apparent than actual, is actually incidental to the fact that men have found their faith while living on it. At times, History seems like a beach that the tides leave traces on for a while, then wash away. It is to be observed that the beaches do not widen. A man can go only so far on his way to God and then must wait patiently till death.

Don't scold, my dear, a man having gone as far as he can turns back to men and lives with them. He knows very well he is one of them and in his humility, he knows that the least of them is part of himself and that his gift is to love in such a way he makes up a little for the sins of all. He makes up for those like the lad we lost, and like those who have not yet learned all they will, and most of all, for those who have refused to give at all. . . .

There is one more story you will want to know before I go. In one of my classes in sniping the other day, one of the men—he had a few drinks from somewhere—got into an outburst of anger with one of the Sergeants. It was no offense to me; I knew he was drunk, nevertheless he apologized later. Then at

noon he came to me and asked if he could borrow my civilian shoes to go on pass. I deliberated my answer and asked him if he knew any good reason why I should. He was quite frank, answered, "no." I deliberated further, apparently, although I was only thinking quickly how often I had been ashamed to turn to my Father and ask forgiveness immediately after an offense. The lad went away happy when I said he could. He was happy enough; I was too happy. For here was a taste of forgiveness. . . .

Many times now I have read these letters, and each time I am more deeply moved and impressed. For all they tell us about Minor White, their deepest power comes from the disappearance of his personality into the universal nature of the experience he relates. A writer of fiction would be hard put to imagine a purer embodiment of what James Joyce called "the monomyth." This is no occasion to point out all the parallels between the story told in these letters and the many old myths that follow the same pattern—separation, initiation, return, as Joseph Campbell defines it in *The Hero with a Thousand Faces*— some of which are obvious anyway; but there are a few key moments that perhaps are not so apparent and that measure the depth and subtlety of his war experience.

When he talks about achieving "a great clarity" and feeling as though he were surrounded by love when death seemed at hand, "in the center of a ring of protecting friends," he says that he was without fear and it was "more as if I were remembering things than envisioning them, as though some of them have not happened yet." How far that is from the superficial notion of religion that says there are no atheists in foxholes! Obviously it was a very powerful experience, and he wants to say more about it, but he seems mystified and does not know quite what to make of it. I am reminded of "East Coker," a poem by T. S. Eliot which opens, "In my beginning is my end," and closes, "In my end is my beginning," of the beautiful image midway of couples dancing in a circle around a fire. For *homo religiosus*, the Fall was into forgetfulness, the great sin his inability to remember where he came from. With death at hand, White was recollecting his sacred origins in the Creation, re-collecting the power—"a fullness, an overflowing even"—of the Creator within him. He felt that he was inside the magic circle, as indeed he was, for at such moments, as W. B. Yeats says, you cannot tell the dancer from the dance—time intersects eternity, all things are known to be present everywhere all the time, each moment a reenactment of the cosmogony.

When White spoke in retrospect after the war of "bottoms dropping out from under bottoms," he was remembering the despair of loss after loss but forgetting, it seems, what loss taught him. The profundity of the experience and the wisdom embodied in these letters, especially those written from the hospital, is equaled only by the cumulative statement of his greatest photographs. The quest leads down, and down, and farther down, into a dark night of the soul, where the Wanderer who would know illusion from reality is torn to pieces, sometimes physically but always psychically. He experiences meaninglessness: "the world is deep and wide and has mauled me. . . . I [am] so empty I [can] find nothing to say. . . . His love has retreated. I have lost it. . . . All I have is a moment so empty of love, it must [be] full of meaning. . . . an absence so deep it [is] itself a kind of vision." And if he proves worthy, he begins to understand that the gods take you not to "the final outpost of spirit" but to the final transfer, the jumping-off place: they awaken the mind to the void out of which the world came and into which it will return.

Lying there in the hospital bed next to his dying friend, beyond joy and despair, beyond pity, White embodies the deepest and most godlike of all responses to the situation (what he calls "solemnity," more commonly known as compassion), the wisdom of he who bears witness and knows that he can do no more; that, in fact, there is no more to be done. Elsewhere he identifies that state of mind as "the artist's peculiar detachment." In Tibetan Buddhism it is the *paramita* of the fifth *bhumi*, what Chögyam Trungpa in *The Myth of Freedom* calls *panoramic awareness*. In the Indian tradition it is called *dhyana*, in the Chinese, *ch'an*, in the Japanese, *zen*. Gurdjieff called it *objective consciousness*. "I would not change a thing," White wrote. "Joy is too much like shallow water that any rough stream bed can break into a thousand aching voices. In the realm of my emotions, this other is more like a river turning into a powerful column as it rolls over the edge of a cliff. This solemnity is nearer to the serious pleasure we have in learning." The end of man, as Aristotle says, is knowledge, and it was to such "serious pleasure" that Minor White returned after the war; and also to the "embittering turmoil" of his flesh.

The struggle with his sexuality which can be seen in the letters must have reached some sort of crisis upon his return to civilian life. What happened exactly between him and the woman of these letters, I do not know, but within a few years he seems to have given up forever the possibility of a sustained heterosexual relationship. By the early 1960's he is writing in a journal, "I wonder about my reaction to women—fear? They revolt my flesh. I do not want to look at them"; and later he notices "his total loss of interest in an interesting chap because of his mention of women." Psychologists would no doubt trace such reactions to a locked relationship with his mother, a famil-

iar interpretation of male homosexuality—there is plenty of evidence for it, some in the letters quoted here. But that is certainly no more than a partial understanding. Implicated in White's sexual problems is the very mode of Western dualistic thought, which sets flesh apart from spirit, man apart from woman, life apart from death, and implicit in those divisions is struggle. When the Western mind asks, What is the solution? the Eastern mind replies, What is the problem? It is no wonder that White was so drawn to Oriental thought, for he suffered profoundly all his life from Western dualism and its consequences.

White resolved the conflict between the sacred and the profane easily enough in his mind, but his feelings had an old way of their own. The descent into hell and the dismemberment that we witness in the war letters were repeated over and over again in his private life: dark nights of the body led him invariably into dark nights of the soul. As in *Beowulf*, on the other side of Grendel was the more monstrous Grendel's mother, and on the other side of her, the dragon. "Suicide, self-destruction, self-depreciation, self-pity," he wrote to an ex-lover, "all go whizzing around in my head for hours on end. I don't like people, I don't like myself, my friends bore me. . . . I [realize] that the pattern of every affair I [have] known [has] always been the same—a pacing back and forth in the dark at the end. . . . I think the best thing to do is to go quietly insane and get it over with. . . . I don't seem to be able to see the bottom, it's as if one sinks deeper and deeper and with unknown death to sink into. . . . And what would fix it all is a good fuck. God how stupid can

people get. Somehow life has become a sheer terror. . . . In a secret corner is the thought that someday I will die—that is the one that keeps me alive—when I get bored and too frustrated I can quit."

There were times when he "resented the feminine in [himself] with a violence," and he was often preoccupied with what he called "the wasteland of homosexuality" and the suffering it caused him, the shame and disgust. There were times when it seemed to distort entirely too much, to compromise him far too often. "I have looked at many human beings only to find their desirability blinding me to their worth. . . . without sex blindness in my eyes the beauty of man is clear."

The basic conflict was deeper even than his sexuality, and more pervasive. Repeatedly we find him—a man who longed to be able to "dance and shout with joy"—"ashamed of [his] own body," as he put it in a journal, "its impotence, awkwardness," anguished over such things as being unable to "get a tan" and being terrified "of bugs—heat—sun, etc." The problem was not what to do with the flesh, but the flesh itself, the very fact of corporeality. It would seem that his homosexuality, the pleasures and satisfactions that it did give him notwithstanding, was a way finally of torturing the body for its claims on him. And the final torture was an awareness, at least from time to time, that this was indeed what he was doing.

For the religious man, being trapped in suffering is no simple matter, for he knows the nature of traps—what Christianity articulates in the concept of the *fortunate* fall.

58

"The manacles themselves," as White put it in the letters, can become "the wings of expression." Elsewhere he wrote, "When there is no further/Down to go/The bottom/Drops out on up." His homosexuality seemed to him at times "a kind of koan," a spiritual conundrum, his cross to bear for salvation. When he longed in those letters to be free of his "anchor of flesh," he was expressing much more than a reaction to his circumstances there in the hospital: a profound longing for a "world beyond good and evil, for love beyond male and female, and the vagaries and poor separations there."

For all such longings he remained committed, as he was at the end of the war, to living in this world, to helping others by embodying as best he could the life of the spirit. The message of all great myths is essentially the same: if you want the whole picture, you must expose for the shadows and develop for the highlights—Persephone, the Greek goddess of spring and rebirth, spent one-third of the year in the underworld, married to the god of darkness. Minor White's triumphs as an artist, and perhaps even as an educator, are intimately tied to the suffering in his private life. Many of his images deal with that suffering, and the best of them transcend it, provide the purification that a high art can offer.

Look at the photographs he made of Robinson Jeffers' play *Dear Judas*, especially the one in which the masked man, entwined in bandages, walks blindly toward you with his arms outstretched while a distraught woman on her knees prays in the background. And at the two male nudes in the "Amputations" sequence, both headless, one thrusting his incredible bellybutton at you; the other perched like a great bird with a piece of driftwood between his legs. And at the richly ambiguous sexual imagery in "Sequence 4": clefts in rocks look simultaneously like vaginas and penises split down the middle—compelling images, at once beautiful and uncannily disturbing, threatening.

Then look again at the prison song image from the letters: we are called into a strange old church, deserted except for the choir practicing; chastened spirits sing in the heat-depleted afternoon; they are behind the altar, separated from us by metal grillwork; the chants are beautiful, mesmerizing; one of the singers reaches out and takes hold of the grille—and suddenly we see that he is in a prison, that he is holding himself up by the bars so that he can sing, or perhaps he is trying to spread them, better to let the song out. It is, that image, a mirror, a message, and a manifestation. Imprisonment proves to be "a stepping stone to accomplish a purpose."

In White's best work the message in the profane mirror is always the same, a manifestation of the sacred—"things for what they are," as he puts it, "and what else they are." For *homo religiosus* every moment is potentially numinous; he makes of his life a kind of ritual, keeping himself alive to the possibility of transcendental experience, of revitalizing the spirit within him. All artists, perhaps even all iconographers, experience more or less deeply, more or less consciously, the excitement of reiterating the original business of the gods: working with the void of formless materials, they create micro-

cosms. The photographer goes into the dark, works his magic, and comes out with little worlds. Watching a print come up in the developer, no matter how many times one has seen it happen, is always potentially exciting, for it can touch something very deep in us, and very old. As with all creative acts it can provide spiritual nourishment. What we too often and too glibly write off to the marvels of science is, in fact, as with giving life to anything, right at the heart of religious experience. Whether we know it or not, we are saying let there be light, we are naming the creatures yet again.

Minor White understood all that as well as any artist, better than most. The seminal role it played is proclaimed in the photograph chosen for the dust jacket of *Mirrors*, the most quintessential and explicit of all his cosmogonic images, that picture of the moon/sun hovering over the primordial landscape. As an artist he aspired to be radical, working with the root sense of creativity, the model the cosmogony itself. As an educator he tried to do nothing more or less than explain, to a world long dead or nearly so to religious experience, what it means to create.

But White had to settle most of the time for something far less than what he aspired to. He believed that "the artist had only one thing to say—himself," and when there was no manifestation, the message was a profane hall of mirrors. "I talk to myself all the time," he noted in a journal. "To still the mind I cannot." Traps that do not turn into the way out are likely to turn into worse traps. The saving grace of camera work for him was that it led his "constant introspection back into the world." He was forever devising "ways to get away from Self," as a journal entry has it. "To photograph till my ego is destroyed or overcome. . . . to feel the egotistical go down before the image out there."

Nothing that he ever said testifies to the prison so conclusively as what he did not say; in his journals, letters and essays he was preoccupied, almost exclusively, with himself and his private world. Were it not for the references to photography, you would be hard put to know even what century he lived in. Except for education, he showed little or no interest in any of the things that go to make up what we call social consciousness. In the war letters, for instance, there is no mention of fascism or any of the political issues involved, no mention in the later journals or other writings of McCarthyism, the cold war, the Cuban missile crisis, the assassinations, civil rights, Vietnam, conservation—none of it—no mention even of his friends except in relation to himself.

The profane world in its own terms was simply not real enough to sustain his attention, much less offer him a way out of the maze. Had he not been preoccupied with spiritual concerns, he would have been, most likely, a small person, perhaps insufferable. As a religious man and an artist, he had an expansive and impersonal sense of identity that kept his self-absorption from being narcissistic. Difficult as he sometimes was, he was always humble and generous, remarkably generous. And he was loved by many.

It was not, however, the love that he most deeply wanted. Since he was the common denominator, the failures in his love life were probably more often than not his own. He was certainly not in the habit of blaming others. Committed as he was to self-exploration, by principle as well as instinct, he was involved willy-nilly, both as an artist and as a teacher, in self-exposure. But what he revealed with one hand, he was likely to cover up with the other. Witness *Mirrors:* is there another book anywhere so personally personal? That manages to hide so much of what it so earnestly tries to reveal? This sort of ambivalence, together with the manipulation that inevitably comes of intense self-consciousness, defined the limits, I would guess, of most of his intimacies.

Struggle as he did to overcome his shyness and his fear of vulnerability, he left many of his friends, even some who were close to him, with little sense of his inner life. Certainly he hid his suffering from most of them, the extent and intensity of it—and who could blame him, if to reveal it was only (or so he thought) to suffer more? He seems to have shared with many of us a deep feeling that there is some failure of character in being unhappy—as though we could choose *what* to feel as easily as *whether*. I have talked to any number of his friends and acquaintances, and I am amazed by how deeply so many of them feel about him and how little most of them seem to know. In some cases I was dealing with a simple inarticulateness, in others with a more complex withholding, but in most cases, if not all, I was seeing the limits of what White had let them know. He was relatively forthcoming with me (giving me access, directly or indirectly, to most of the information here) because, I think, he knew that he did not have long to live; years of frustration, loneliness and emotional deprivation chastened his longing to be known, but never destroyed it.

Before sketching out his last thirty years, I want to speak briefly to the fact that there are many more or less obvious discrepancies between the public and the private records that White made of his life. What are we to make of the fact, for instance, that in an interview (published in *Camera* after his death) he said that he never saw combat during the war? "I was close to front lines but . . . I didn't have to shoot somebody or get shot at." As a general rule I tend to trust the private record—keeping in mind that letters, and even journals, can be every bit as tricky as remarks made in public—but in this case I do not.

The orchid in the jungle passage does not ring true: it seems too well staged, too symbolic. I am convinced by the details and by the writing in these letters that White was a man deeply wounded by recent experience. That he was there in the hospital next to Danyon I do not doubt, but I suspect he was playing some kind of game with his friend about how he got there. Either that, or the whole episode was reconceived years later. These letters, which show clear signs of careful revision, perhaps even the help of another writer or a good critic, often seem more a literary device than memorabilia.[1] They are absolutely trustworthy as spiritual autobiography, which is how I read them and how I am using them here, but they cannot always be trusted as a source of other information.

Contradictions of fact, however difficult to resolve, are still resolvable, a simple truth somewhere that can be determined. That is not where the problem lies. Minor White aspired to be straightforward because, try as he did, he often was not. The boyish innocence and the enthusiasm for life that charmed so many tended to obscure the complexity of the man. The real problem one has with the record he made is in the more subtle discrepancies, in the omissions and the shifting emphases. Some reveal nothing more than changes of mind or mood, and others are perfectly innocuous responses to the limits of a given situation—no one in his right mind, for instance, takes an ordinary interview very seriously more than once. Still other discrepancies reveal a perfectly respectable sense of privacy, both his own and that of his friends. But too often to ignore, I have seen him involved in manipulations and demonstrable falsifications (some of which I am sure he was not aware of himself) that embodied a greater concern for the impression given than for the truth. For instance, the list he gave me of people he wanted me to talk to was, I see now, full of guile. But then the journals,

which he also wanted me to consult, were not. It would be naive, indeed, to assume that anyone can be trusted implicitly, even the freest of us, especially when we are talking about ourselves, but White was more manipulative and defensive than most.

As is the case with all powerful and influential people, any number of quite different men are loose in the world under Minor White's name. For many who knew him, he seemed to be an occasion for defining themselves, either by identifying with him or separating themselves from him, and often his life has been obscured and distorted in the process. Because he taught people that the world was, among other things, a mirror, he could hardly object when they treated him like one. Because he was starved for intimacy, he found any relationship charged with feeling hard to reject. He was often trapped, both philosophically and emotionally, unwilling and unable to dissociate himself from any attention that was paid to him, however ill-conceived.

He was not, as some have him, a dirty old Hollywood Hindu playing housemother to unsuspecting youth, smiling his time and great talent away on the wrong side of the camera; nor was he, as others have it, a kind of deep-voiced John Wayne of the gentle Way, the hero of the high-noon drama of spiritual awareness in which the fastest Super XX koan in the West lets you have It, the Zone System as mantra. But even in the grossest oversimplification there is often some element of the truth—that is, in fact, how and why they survive.[2]

[1]White kept copies of many of the letters he wrote, but only these are neatly retyped. And only these are written, characteristically, like fiction, intent on rendering the experience instead of merely naming it.

Both William E. Parker (who worked with White on several projects) and Stevan Baron (Aperture's long-time production manager and former student who became a close friend) have confirmed my belief that the letters cannot be taken always at face value. Parker is convinced that Minor White of the late 1950's is revealed in both phrasing and thought. Baron came to much the same assessment I make: the letters, he wrote, "touch me as few things do, and, on one level or another, explain much."

Reality in the letters is where it always is: all mixed up with actuality but not to be confused with it. If I were to find out that White had never been in the army or in the South Pacific or had a girl friend, it would change radically my perception of him, but not of the letters. To my mind you cannot ask more of words on a page than that they read like good fiction—to ask for more is to set yourself up to settle for a lot less. The letters are a metaphor for his entire life: everything he said and did can be read as the love letters of a man deeply involved, more or less consciously, in a serious struggle, revising as he goes along.

[2]There is no need to go into the details of White's sex life, but a few further general remarks are in order. Although most of his relationships were sexual in the broadest sense—something that he was acutely aware of—very few were physical, or explicit in any way. Throughout most of his life he was preoccupied with sexual energies and excitements, but he was remarkably sensitive to the wants of others in these matters, and he was respectful of limits. Stieglitz said that when he photographed, he made love, and White said the same thing many times, in many different ways. He found great pleasure in simply being with men, especially young men, in working with them and teaching them and photographing them. Most of the time, that is all there was to it.

Professor Parker, a former consulting editor for Aperture who has been most generous and astute in his help, suggests that *homoerotic* would be more precise than *homosexual* for what is being discussed here. His thinking, very much to a point that should be made, is as follows: "Since [this profile] depends on an essentially Jungian system of archetypal parallels, Jung's own words may prove the point: 'In distinguishing the homoerotic from the homosexual, the former is always associated with an etiology that involves a religious crisis or is accompanied by a religious quest; the latter refers merely to a matter of choice or practice in sexual behavior.' Homoerotic Jungian/Homosexual Freudian. The former is not a euphemism, but the correct term for a type of psychology and behavior in certain persons, of which Minor White is an 'on target' example. By the way, it is considered positive insofar as the issue of shame is eventually resolved in the process. . . . This, I think, Minor [accomplished] exquisitely—even by abstinence and by association with Gurdjieffian principles."

Sequence 17

Is it you or I who says
out of my love for you
I will give you back to yourself

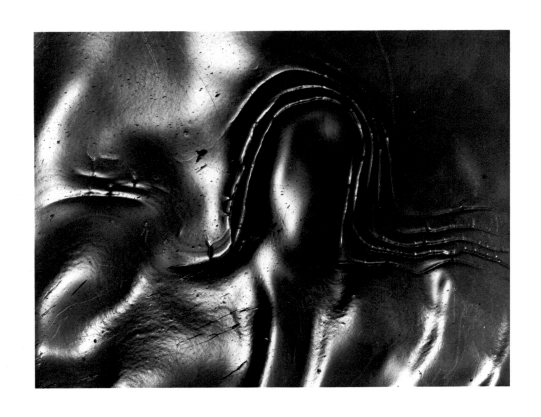

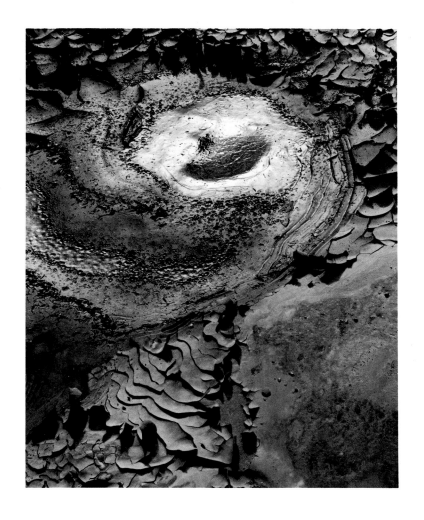

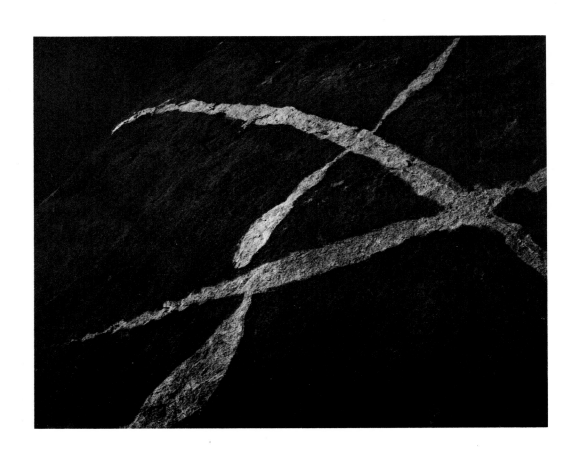

I think that we have two ends of a stick here…
a stick too long for anyone to grasp both
vibrant ends of at once.
 Celebration of the Birthday of Jesus, 1955

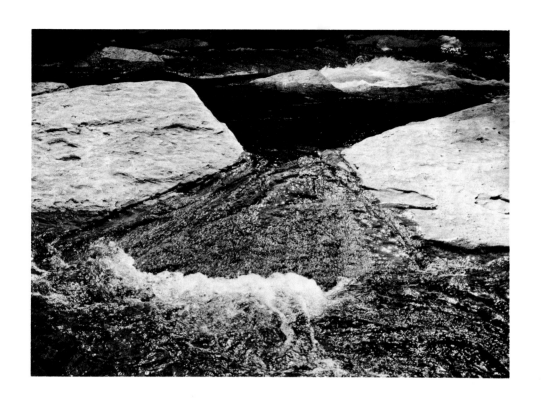

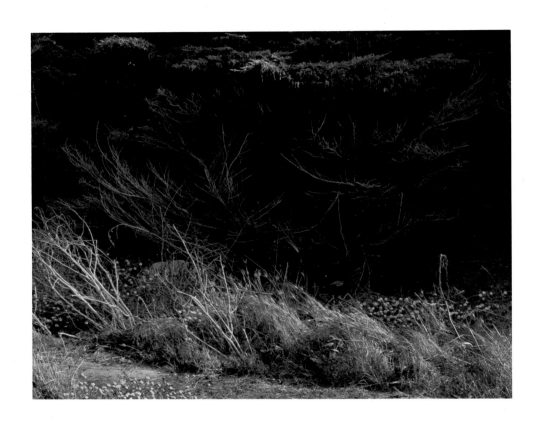

The joy of photographing in the light of the sun is,
and the joy of editing in the light of my mind is.

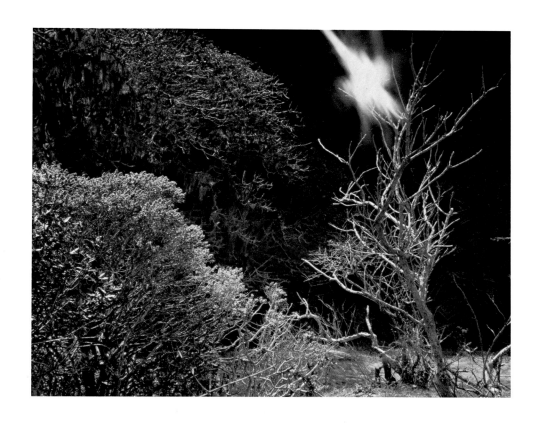

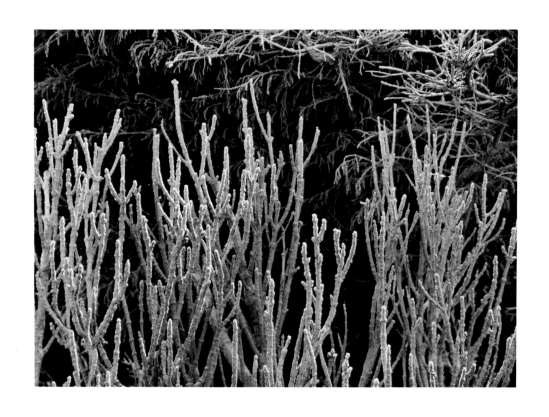

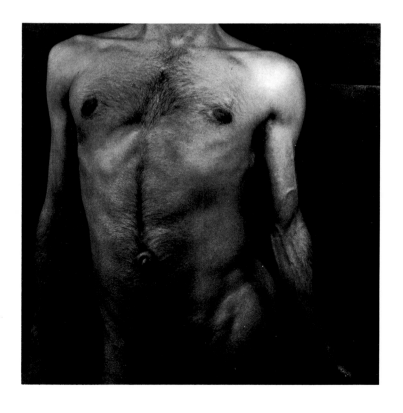

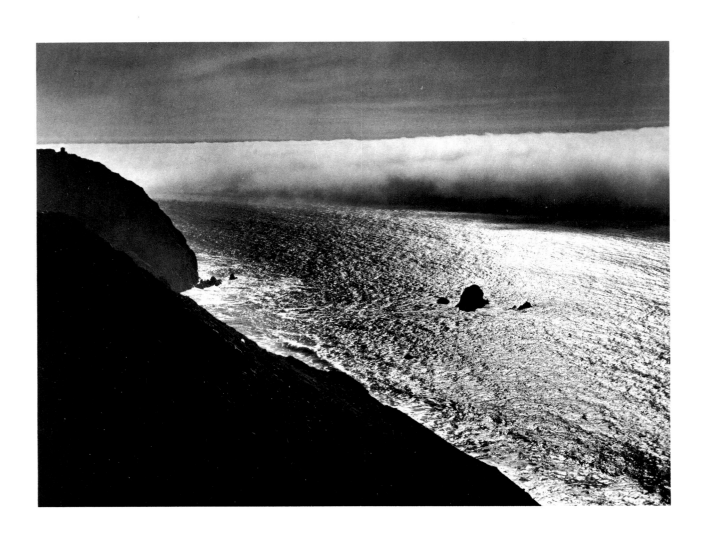

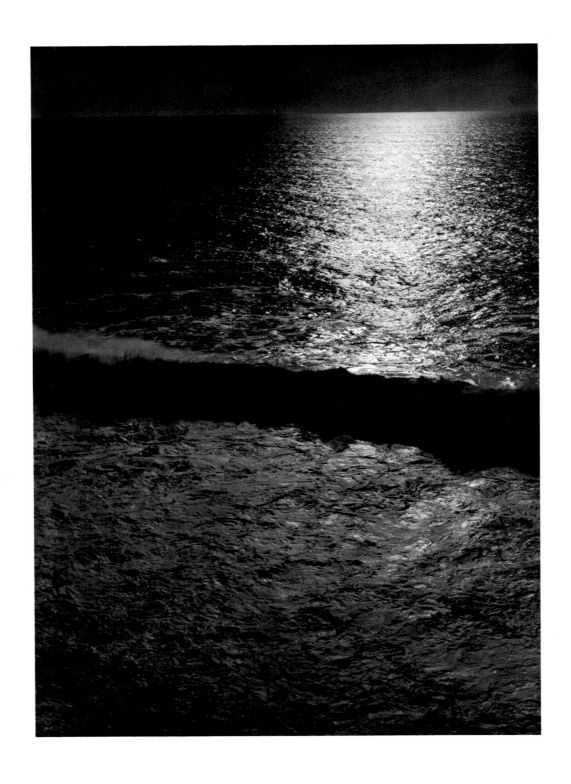

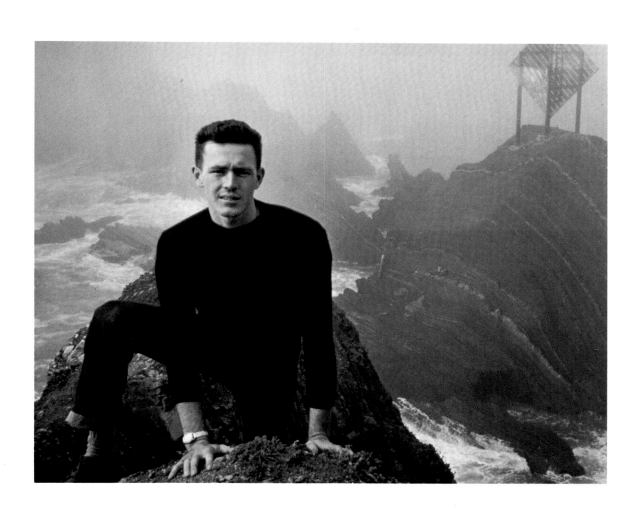

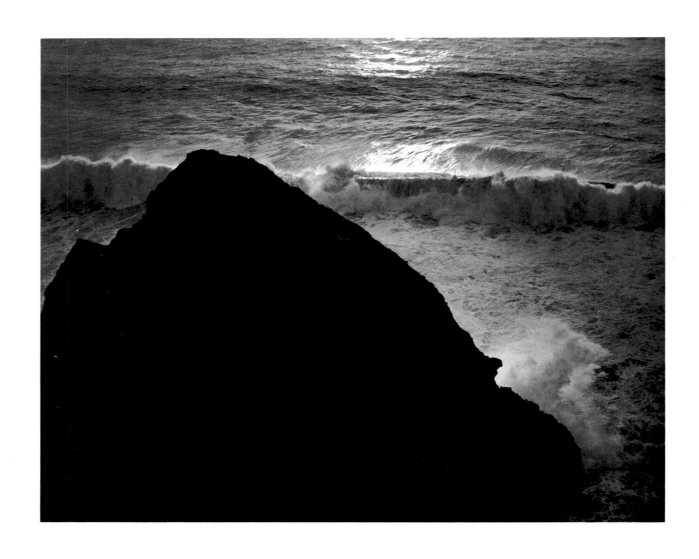

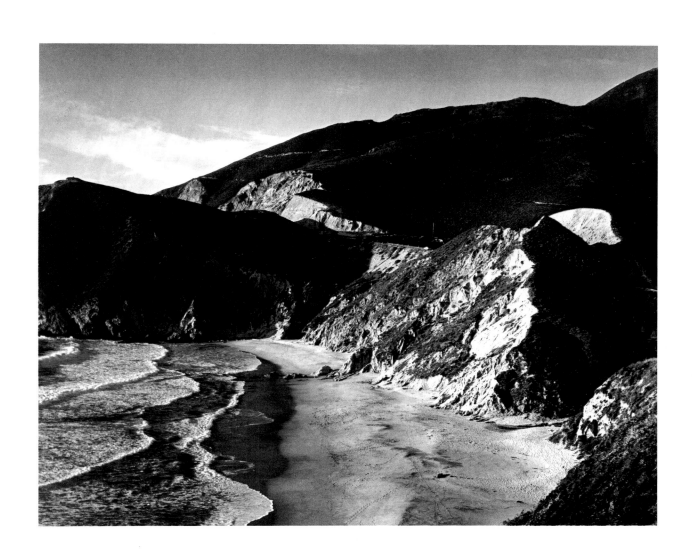

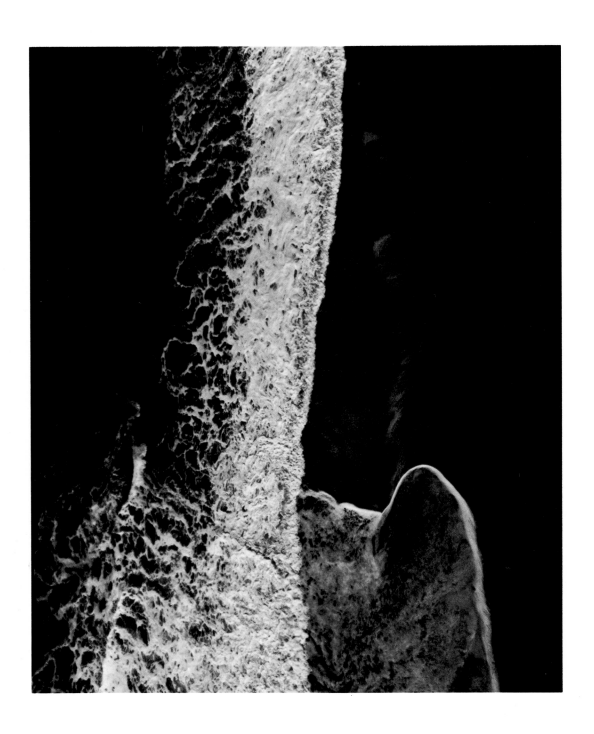

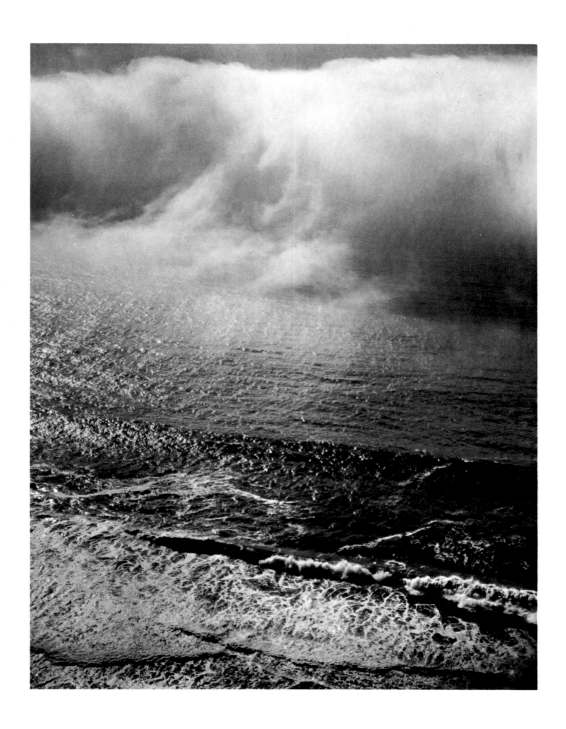

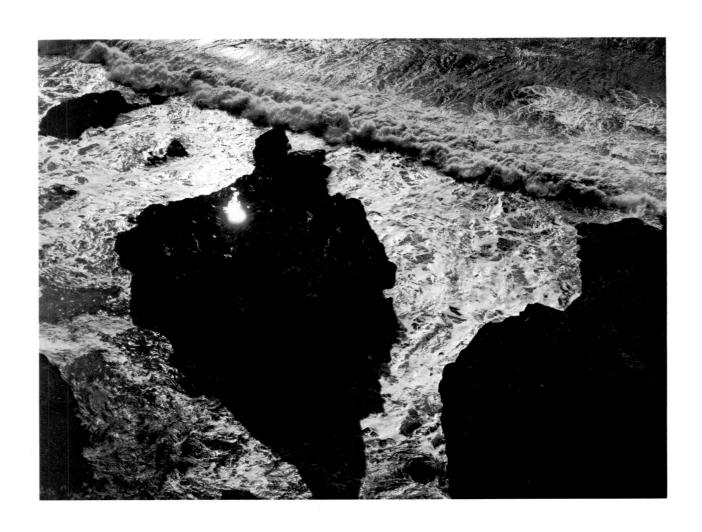

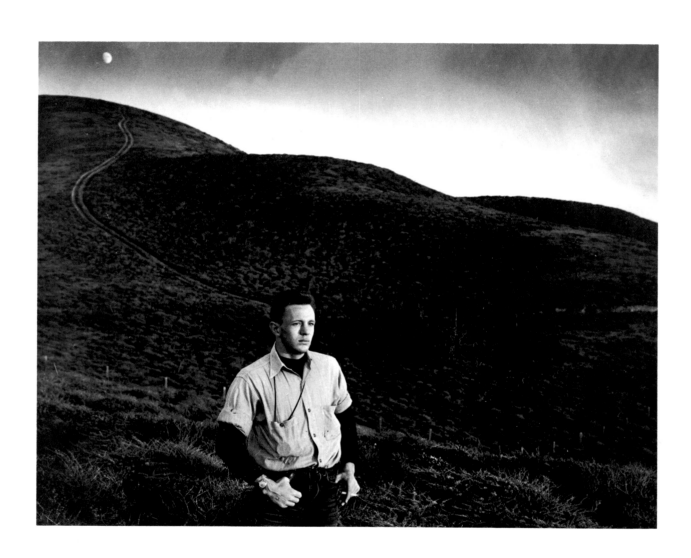

There must have been a long pause.
A thought broke through.
I don't know the words anymore.
What must animate my pictures
from now on, I want no name for.

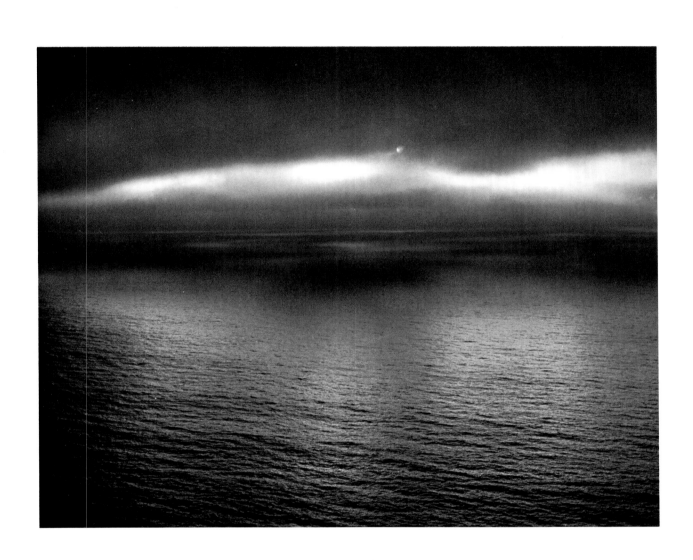

Ansel met me at the train yesterday. This morning in his class at the old California School of Fine Arts the whole muddled business of exposure and development fell into place. This afternoon I started to teach his Zone System. Ansel did not know it, but his gift of photographic craftsmanship was the celebration of a birthday. San Francisco, July 9, 1946

The roots are up again. Fortunately I know how to live floating—for I shall never put them down here. That old business of photographing as an anchor to reality can be used again. The roots float freely getting nourishment out of the air. Rochester, November 1, 1955

Exploring the depth and breadth of the words <u>Equivalent</u> and <u>Equivalence</u>
I have found a craftsmanship of feeling, a technique, an art, a psychology
of feeling, and best of all, freedom from the tyranny of ecstasy.

Monhegan Island, 1966

When White was discharged from the army, he went to New York, "into the embittering turmoil again," no less "an unusually round peg in an extra square hole," but "a man who had overcome the concentric power of original sin," or who at least was determined to act like it. With "a greater capacity now for losing and losing," he was considerably more mature and resourceful, full of a veteran's eagerness to get on with his life, "to climb out of [his] private pocket" and join his ambition to be an artist of the spirit.

The first order of business was to find out what had happened in photography during his absence. He met not only Stieglitz at that time, but also Beaumont and Nancy Newhall, beginning an important and lifelong friendship, and he met many others—Paul Strand, Brett Weston, Gene Smith, Barbara Morgan, Harry Callahan, Edward Steichen, Todd Webb. He studied museum methods with the Newhalls at The Museum of Modern Art, art history and aesthetics with Meyer Schapiro at Columbia University. And he was elected to the Photo League. He "photographed very little in New York," one of his journals says, because he "really was not ready" and found the city "fundamentally dreadful." He had come there "to study . . . and knew that if [he] started to make pictures all else would be forsaken." When Stieglitz told him that if he had been in love then he could photograph, he felt that a "lump of creativeness and spirituality" had suddenly broken out of "its poured concrete strait-jacket." He accepted and then turned down a curator's job under Edward Steichen at The Museum of Modern Art, which

pleased Stieglitz ("Your first decision was good, your second better!") as much as it irritated Steichen, and finally took a teaching position under Ansel Adams at the California School of Fine Arts.

He arrived in San Francisco on his birthday in 1946, "home at last," his journal says, though he had spent very little time there previously. It was again "more as if [he] were remembering things than envisioning them, though some of them [had] not happened yet." For the first two years at CSFA (now the San Francisco Art Institute) he taught five days and three nights a week, leaving little time for his own camera work. His assignments had students photographing the city, section by section, and he came to know it that way. "All the background of science, art, teaching, photographing, living with people, writing, traveling was suddenly channeled into teaching. . . . The lessons learned from the Boleslavsky went into effect. The principles of art history were converted to use by photographers; the psychological approach learned from Schapiro went into effect, the idea of the equivalent from Stieglitz went into the curriculum; technique was learned from Ansel at a high rate of speed and his Zone System became my staple." After only six months, he and Adams worked out a new three-year program of study for the photography students, and Adams turned the department over to him. "He was an important teacher," Adams says. "His influence was tremendous. . . . He was a great craftsman and, perhaps, his greatest contribution (apart from his own photography) was to enhance the importance of craft in the practice of art."

In December he visited Edward Weston for the first time at Point Lobos, the scene of many of Weston's great photographs. According to Peter Bunnell, who wrote the biographical chronology in *Mirrors*, White thus began "a profound attachment to the man, his ideals, and the place." For the next few years, he took his students on field trips to Lobos, where they met and talked photographs with Weston. In class, according to Bay Area photographers Pirkle Jones and Ruth Bernhard, it was not uncommon for him to spend an hour on one photograph, probing always for deeper, more personal responses. At parties and around school he and Adams, who was just as deeply committed to an objective approach to photography, dealt with their differences at times by baiting one another affectionately, to the students' delight.

Minor White and Edward Weston, Point Lobos, c 1947-52

White's first one-man show since before the war was hung in 1948 at the San Francisco Museum of Art, many of the pictures made on field trips with his students. Included in that show were the magnificent seascapes in the sequence "Song Without Words," reminiscent of his experience on the South Seas beach during the war, where he sat "on the rocks above the water, and listened to it pound and roar . . . [heard] the speech the waves wash up from the middle of the world . . . deep-throated, like men singing novenas from the remotest depths of themselves." He fretted less now about being unable to "explain visions I have not seen," for he was seeing them, and bringing them back to be seen—and doing everything he could to teach others how to look.

In 1952, out of a growing dissatisfaction on the part of many serious photographers with existing publications,

Aperture, The Quarterly of Photography, was formed, and Minor White became its editor, a job he took with him everywhere he went, without pay, for the next twenty years. Conceived and executed around several themes—Stieglitz's idea of the Equivalent; "reading" photographs carefully and analytically (according to the principles of the influential New Criticism in poetry); the need for a sophisticated literature in the field—*Aperture* became yet another way, along with his teaching and his own camera work, for him to discover and promulgate his deepening understanding of his life and his art.

His approach to photography during those years was more intensely personal, introspective, psychological than at any other time in his life. He believed, as he put it in a journal, that one who desires technical perfection "is like the grinder of knives who sharpens but never gets to cut with them. . . . Credo: That through consciousness of one's self one grasps the means to express oneself. Understand only yourself. The camera is first a means of self-discovery and a means of self-growth. The artist has one thing to say—himself. If that self is not large, or intense, he need not give up art. The camera and the technique of observation will broaden him, deepen him immeasurably. . . . In my recent photos there is frequently a penis between tall things. Wish for intercourse? Who doesn't? Also a feeling of being alone expressed? Who isn't alone? . . . Expressiveness is thus connected with sexual practice. A conclusion that is in accord with conscious and formulated thought of my own, namely that photography is sublimation of my inability to have the sex I want. Interest in self-exploration in photography may be a reflection of my continual masturbation. Or photography is my equivalent of living. . . . Sex is the basis, but not the ultimate expression, merely the foundation upon which the cathedral is built." He believed that "a substantially introverted person" should be "allowed to remain in his dream world" only if he is "strong enough to explore himself. . . . willing to explore himself rather than hide in himself. . . . If a man lives his frustration to the hilt he will lead a full life."

When some of his students expressed their hostility to his approach openly by bringing in pictures with obvious sex symbols, "for you, White," he was shocked and hurt. It caused him to revise his teaching methods. He was by then in his middle years, more capable than ever of dealing with his life, but his growing strength seemed only to keep up at best with his deepening sense of isolation and loneliness. It was his fate, "an unusually round peg in an extra square hole." He knew, perhaps better than ever, the "love [he] would know when [he] was freed of [his] anchor of flesh," but that freedom was a long way off. Time and again he had to face the need to "climb out

of [his] private pocket of self-pity by [himself].'' In a journal he wrote, ''The knotholes and doorknobs mood is uppermost again. Life all around me and I can only observe and never enter. I think a discipline is in order now (as before) to keep observing all of life and not fall into the rut of expressing only the feeling of lack. . . . It is not surprising I have discovered camera is both a way of life and not enough to live by. . . . I find that my photographs are reflecting the frustrations, the loneliness, the search for intimacy without embarrassment and not much more. I am merely letting the camera visualize my inner wishes—a lazy way of working. Thus I have not really made it a way of life. The challenge has only been recognized, not tried. It still remains to make it a way of creating what I want to happen to both myself and to others. I hardly expect the impossible of creating so that my personal life is invisible—but let the mirror be clouded . . . or two mirror images away at least.'' That ''personal life,'' long full of the confusions, misunderstandings and heartaches of unrequited love, aggravated by society's disapproval of his homosexuality, weighed more heavily all the time now with its accumulated frustrations.

It was the war years all over again: periods of ''purposeful doing without'' followed by boredom, furious boredom, followed by periods in which, according to his journals, he sought ''love no matter how badly [he] might fare.'' The trap became the stepping stone, which in turn became the trap again. ''The pain and anguish are plain enough—whether it's a lad or lassie with china blue eyes I am troubled over should have no bearing,'' he wrote to himself. ''My loves have taken the same pattern of disappointment so long and so many times I no longer know whether it is Spring, a new love, or the memory of an old, old, old one that causes my heart to regret its loneliness.'' And then in letters to a loved one, ''It's a sad commentary on myself that I am more comfortable when you are a letter to be written to. . . . It is something of a shock to be made to realize that one has been writing to a figment of the imagination for months.'' Shortly before leaving the California School of Fine Arts, he wrote to Nancy Newhall, ''Somehow I no longer want to turn to Lobos to lose myself, to express my little hurts—let's do it with those faces that hurt me, with those bits of buildings that break my heart because they visualize an intimacy that I never seem to touch. . . . Christ I have to be the faith my students look to—and always feel that I could be, if I had no students.''

When he discovered machinations at the California School of Fine Arts to get him ''fired,'' so one of his journals says, he ''did nothing'' to stop them, figuring that he needed to get away from teaching, at least for a while. In 1953 he left San Francisco to take a job as assistant curator

under Beaumont Newhall at George Eastman House in Rochester. The adjustments were slow and difficult; after five months he wrote that he had been tired, bored, angry at the weather and homesick most of the time, ''quite violently so. . . . What I have not found here is the sense of touching spirit beyond. No Lobos, no fog, no ships, no mood of communion anywhere.'' The whole move seemed to him to coincide with a drying up of the spirit, a

Minor White with workshop students

time yet again when he was ''so empty that [he] could find nothing to say.''

Compared with San Francisco, Rochester was cold and dreary, and it was dull, unremittingly dull; even in the people he found an undercurrent of depression. After having had control over his comings and goings for so long, he found living with his dear friends the Newhalls, which he did for the first few months, something of a strain. Though he was learning a lot in his new job, he found it ''the least new of all new things,'' and he was convinced, pretty much from the start, that Eastman House was being run by philistines. Before leaving California, he had consulted the *I Ching* and had come away with the distinct impression that he was being told that the move, timely for sure, had to do with leaving the boy behind and entering ''the man's world.'' ''That is the string on which all manner of beads have been strung,'' he wrote, trying to understand what was happening to him, ready for change but determined not to falsify his experience to himself. ''In one sense, of course, teaching no longer fulfills that image completely; then there seem to be other implications: maturity in thinking, in writing, in meeting the men who are mature in their fields instead of the beginners—that has been done, but I miss the student and am not comfortable with the professional. . . . I am a little bored with the documentary school for that matter. The viewpoint is definitely shortsighted only to make pictures *of* people. To make pictures *for* people

opens the entire world of subject matter and limits the photographer only to what he is big enough to find in it. . . . With the obsession of the image of the young in mind, I tend to be bored with people my own age—they are no longer beautiful to look at, and often their ideas have lost any sparkle as well. Though not always—whatever sparkle there is, it is in the depth of their ideas, not in the enthusiasm.''

After six months with the Newhalls, White moved into an apartment of his own, a small but necessary step in coming to terms with the changes that were taking place in his life. Surrounded by the history of photography at Eastman House, he learned much, but he had serious doubts about its effect on his own camera work. "If the sense of discovery is necessary to the vitality of feeling in an artist's work, then too much knowledge of art of the past may work the artist more harm than good." The more he had to do with "the man's world" of his job, the less nourished he was by it. His fondness and respect for Beaumont Newhall, the curator and his immediate boss, only complicated his reactions to George Eastman House. "The Director . . . has no respect for anything but money and refuses to pay his staff but the most pitiful wages. He does not mind piling on responsibility but will not pay accordingly. Consequently, since there is no other recompense for living in this stupid city, I feel absolutely no loyalty or responsibility to GEH." The compromises involved in his job exacted an enormous price. "There is a naiveté that I have lost that was germane to making photographs. And so far," he wrote after having been in Rochester many months, "nothing has supplanted it that will give me the drive. . . .''

In the past, the natural world had always replenished and inspired him, but desire that now as he might he could no longer make those connections. The rainbow was there but not the "promise of the rainbow." Upstate New York reminded him too much of his childhood in Minnesota, a heritage that he felt was alien to the life of the spirit. "This land is comfortable, cultivated, cramped and inhibited. How many times have I looked at a Strand photograph, admired the picture qualities and hated the subject—this land. This rich farmland that goes soft and pretty and spiritually flat. . . . Perhaps I will give in and search for spirit here, doubtless if I get enough starved I cannot help myself. But I resent this place." He seems to have been working through a lot of old resentments and hurts during those first years in Rochester, some of them reaching far back. On a night "filled with an especially bitter mood," the anguished text for a sequence of pictures associated with the death of his father came to him; and it is followed in his journal by this poem: "Of all the bastards/These are the most beautiful ones;/The ones I call my sons./Conceived in dust/Seed spread on ground/To the ends of the earth./Unborn sons have mounted in my memory/As strong as a son who dies but yesterday.'' And then there was the omnipresent loneliness and the desire to be loved. "I have known the loneliness at the end of the day, at the end of the road, and the end of the night. I have expressed its poetry often enough. Perhaps I have willfully sought it because I know poetry is there, having once discovered it, I often return to it as to security. I

72 N. Union Street, Rochester, c 1956-58

should like to know the oneness that comes because two have merged now. I know that oneness that comes from one alone.''

It took him two years after his arrival in Rochester to send to San Francisco for all his books, photographs and darkroom equipment, to abandon the hope of getting back there soon. What he knew about traps told him he had to test the possibility of a stepping stone. "This is a sad day," he wrote, "and it was a very hard decision." He still had no intention of putting down roots in Rochester, but "a new direction—or a new resurgence—seems forming. Just what it is, is not easy to say. The roots are up again. Fortunately I know how to live floating—for I shall never put them down here. That old business of photographing as an anchor to reality can be used again. The roots float freely getting nourishment out of the air. And in this godforsaken country, where even the clouds are out of focus, air is about as close as I want to get.''

At Eastman House, responsible for current exhibitions, he hung several important shows conceived around themes. At home he continued to edit and write for *Aperture*, whose influence was now being felt among those interested in the art of photography. And he traveled from time to time all over the country, giving lectures and workshops and participating in conferences. But the sort of maturation he was looking for declared itself to him most clearly in his thinking. Several years before, writing

to Nancy Newhall from San Francisco, he had said, in connection with a book that he was finishing entitled *How to Look at Photographs,* that after fifteen years of photography his "Ph.D. thesis is done. . . . I can start out to be a photographer—I think I am ready." Five years later in Rochester he was back where he had started, with the "thesis" to be done all over again. "I have been in, around and about photography for twenty years. And perhaps I know enough about it now to start to consider what photography is." He had no classes to teach at Eastman House, but students still occupied many of the front-row seats in his psyche. "Looking over what is taking place since I left CSFA it appears that I am writing the books and articles that I need to teach that full time, three year course."

In a journal he outlined the material for "four or so books," which he figured would take probably three years to write. Ideas that had been with him for years were deepening into finer distinctions, emphases were shifting: the exploration of self, so long the controlling idea of his thought and work, was giving way to the need to communicate general truths. Attention was shifting ever more consciously from the photographer to the audience, from the medium of the particular man to the message of the world at large, from Freudian to Jungian and Buddhist psychology. "I know enough of spirit now to try to bring others, through photographs, some knowledge of it for themselves. . . . Whatever has happened has me looking at everything, but everything, with new eyes." His humanity was beginning to come into focus; he had started that long, arduous struggle with the fetters of his individuality. "It seems to me that this is quite in keeping, quite in line with what is happening all over the world. Among those that have only to suffer by the atomic bombs, a turning to things of the spirit is a natural thing. In one large sense it seems to me that I am of my times for all [my] rejection . . . of the current world we live in." Books and ideas had more influence on him during those years than people—Herrigel's *Zen and the Art of Archery,* Huxley's *Doors of Perception,* and especially Evelyn Underhill's *Mysticism.* Clearly the most important and lasting influence came from the work of Gurdjieff and his followers. White was quite taken with a Gurdjieff group in Rochester, and deeply impressed with the leader, Louise March, who had studied with Gurdjieff and had been his secretary.

In the summer of 1956, his patience with Eastman House finally exhausted, Minor White left his job. For the next nine years he supported himself, and often helped to support those who were living with him, largely by teaching part-time at the Rochester Institute of Technology and by offering workshops around the country. It was during

this period, freer and more capable than he had ever been to pursue his personal goals, that his home at 72 North Union Street began to take on (much as 291 and Room 303 and An American Place had for Stieglitz) important significance in his life's work. The Institute for the Harmonious Development of Man, a château near Fontainebleau where Gurdjieff's students lived and worked with him, probably influenced the shape of things at 72 North Union, but the ultimate model for what was happening there is as old as the distinction between the sacred and the profane. For the religious man, settling into a place is a ritual reenactment of the creation; the earthly house, taking shape in the *imago mundi,* becomes a spiritual home, a psychic center of the universe.

72 N. Union Street, Rochester, 1956

When White turned his full attention to 72 North Union—a large apartment above a store, with a darkroom in the basement—John Upton was already a student in residence. And soon there were others, among them Paul Caponigro, Michael Hoffman, Stevan Baron, George Gambsky, Herbert Hamilton and Ron MacNeil. From the mid-1950's at 72 North Union right on through to his next and last home at 203 Park Avenue in Arlington, Massachusetts, there were students living with him, sharing the day-to-day responsibilities. That situation worked by serendipity or it did not work at all; White never advertised it, as he did the workshops, and only once did he ask for money; each student had to find his own way there and, if he belonged, his own way to contribute. White created thus, in his late forties, a kind of family for himself, the bloodline photography. "Man seems to

thrive on small doses of conflicting poisons," he wrote in a journal. "Solitude is wonderful, too much is stagnating. Gregariousness is healthy, too much scatters the forces." The live-in students not only filled an emotional need, some of them became in effect his children for a while, but they also supplied energy—helped him, as Herbert Hamilton says, "to form a gestalt which vitalized everyone involved." They also provided, according to another student, "the tensions necessary for him to deal with himself," which in turn became a kind of pedagogical device. "You saw him constantly working on himself.

Still life, Rochester, 1958

It was right there in front of you, what he was talking about, right there in his life." All the ideas and methods involved here are traceable to Gurdjieff and his followers, but White was also under the deep influence of similar thought in Zen, gestalt psychology and other philosophies.

Cultural history is full of 72 North Unions, small and unofficial and extraordinary configurations of energy and talent—often with a key figure involved. In addition to those in residence, a steady stream of other people came and went, many of them photographers, Walter Chappell, Peter Bunnell, Nathan Lyons, Ansel Adams, the Newhalls, Jerry Uelsmann, Arnold Gassan, some on business, others on friendship. Chappell in particular, whose friendship with White went all the way back to the days in Portland, had a deep influence on him and on the house. It was Chappell who introduced White to the *I Ching*, Zen and the philosophy of Gurdjieff; and it was Chappell who collaborated with him on some of the finest work in the early years of *Aperture*. Nathan Lyons, whose

intellectual maturity and subtlety White respected, was also an important presence. Within a more or less strict routine geared to efficient and continuing creative work, which effected a kind of isolation, the life of the house at 72 North Union breathed, constantly being nourished by, and in turn nourishing, the outside.

From all reports it was a heady, life-changing experience for everyone who lived there, especially the young people, most of whom had sprung full-grown out of the conventional head of middle-class America. In 1964 Michael Hoffman—who soon became the managing editor of *Aperture*—slept in the attic, which doubled at times as a meditation room. He remembers waking up many mornings with snow on his blanket from a broken window, an exhilarating emblem of his escape from the bourgeois, of the pared-back purity of the life at 72 North Union. There was very little money, but with careful shopping and inventive cooking—ginger chicken from tough old birds, Indian squash, lots of Japanese and Chinese dishes—White and his students always managed to make something of a ceremony of meals, which were eaten with chopsticks. The whole apartment had a spare Oriental atmosphere, low tables, lanternlike lamps; White made a picture of the kitchen, a big paper fish hanging from the ceiling, that conveys something of the austere atmosphere. Collapsible tables made of three-quarter-inch plywood were moved around to fit the project of the moment, and there was always a show in the works, or a book, or a conference, or an issue of *Aperture*, or a critique—White would be engrossed and remember only at the last possible minute that he had a class to meet at RIT—or people just sitting around after dinner, drinking and laughing and talking, Berlioz's *Symphonie Fantastique* turned up loud. White loved to cook and he loved to play host, but everyone understood that he was as poor as they were and would bring food or wine when they came to eat. He had floodlights set up to illuminate the roof outside the bay windows, and he loved to sit there silently at night and watch the snow fall, watch the ice form on the windowpanes and re-form, watch wax build up drop by drop on the large, beautiful brass candlesticks.

His prize possession, a 4 x 5 Sinar view camera—which Peter Bunnell says "was the only material thing he ever *really* wanted"—was often there on a tripod in front of the window, as much a presence in the place at times as White himself. Bunnell says that "you could actually *feel* Minor's relationship with that camera," the way it danced him. "Watching him handle anything was an education in respect and attention," Bunnell says, "prints, a soup ladle, anything—but there was something special about the Sinar. He couldn't pass it by without stopping to touch it and look in the groundglass."

When he was a few minutes late at RIT, the students knew that he was coming to them from some labor of love, and even those wired in their souls to credits and grades and bells were intrigued. The typical RIT student, Bunnell says, had his mind on the nurse he had waiting down in the parking lot. At the start of each class, when White told them to relax, to sit there with their eyes shut and their hands on their knees and relax, most of them could not begin to imagine—what with the writing arm of the desk around their waists, never mind the nurse—what in this world they were being asked to do. When they opened their eyes, they would be looking at a photograph, and White would tell them to look at it until they saw it. A long silence would follow. They were looking at work that was properly printed and mounted, that much everyone saw, and the same standards were applied to all aspects of the craft—even those who could not stand the long silences found themselves sitting still for him in one way or another. Finally someone would say, Well? And White would say, Well? Jerry Uelsmann—who went on to become nearly as well known a photographer as White, hardly your ordinary institute of technology student—was in one of those classes, and even he, according to Bunnell, fought White every step of the way, at least at first. Well *what?* Uelsmann would say. What do you feel? White would say. It's a picture of snow—do you feel cold? And Uelsmann would say, No. Am I supposed to? And White would say, Let's not talk about what you're *supposed* to feel, let's talk about what you feel. When the bell rang and they were asked to remember exactly where they were so that they could pick up there several days later, some of them, after a while, found this suggestion not so crazy as it sounded.

Even the students who resisted being put in touch explicitly with their feelings could not escape the other ways he taught. White went into the field with them, and when he was not working with them on their groundglass, he was working with himself on his own. They *saw* what he was talking about, even if they could not hear it—they saw it again and again when he put his own prints up next to theirs.

Field trips loom large in most of the accounts of those years. Paul Caponigro says he often became impatient with all the talk, then suddenly, the minute White picked up his camera, everything was all right again. "To watch him work," Caponigro says, "now that was a pleasure. It was *more* than a pleasure." In an old Volkswagen bus, pressure doubled in the bald tires to increase gas mileage, the pedal to the floor, White and someone else from 72 North Union would drive for hours through the countryside with their cameras; there was no radio, there was no talking, just the sound of wind chimes which hung

from the roof inside the van. Many of the barns and doors and graveyards from *Mirrors*, most of the eastern landscapes, in fact, were made on such outings.

"They were meditations," Hoffman says about those trips. "They had a good deal to do with concentration, with not falling asleep. . . . There was always the feeling of attention when you were with him. That he was attending to what was happening, and by comparison you weren't. It was embarrassing sometimes. Many people were put off by him because they felt that he was criticizing them—which wasn't true, not in the way they were thinking. The only criticism he ever made was just by the way he himself was."

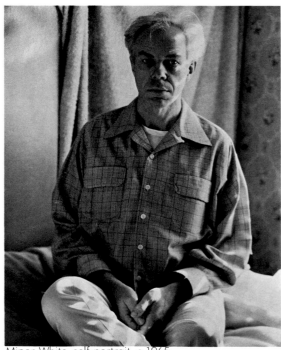

Minor White, self-portrait, c 1965

Bunnell says that White seemed to be able to remember every image he had ever made. During the year-long preparation of a retrospective exhibition—*Sequence 13/Return to the Bud,* which hung at Eastman House and in Portland in 1959, the first manifestation of *Mirrors*—Bunnell worked closely with him on the selection of the pictures and the sequencing. Whenever a hole appeared in the evolving scheme, White would study for a minute, go to the file, and come back with a contact. Sometimes it was a picture he had never printed, often one he had not seen in years. If it did not work, he would remember another one that did.

Everything around 72 North Union was imbued with the spirit of those field trips. Not only were the meals ceremonial, so was virtually everything else—shopping, laying out an issue of the magazine, keeping the house in order, spooning the fat off the soup stock. Each summer, while White was off photographing and teaching work-

shops, Bunnell would prepare the house for the next year: take the floors back down to wood, oil them, take the candlesticks back down to brass, take the typewriter in for its yearly tune-up—all according to very particular instructions. As White's assistant at RIT, Bunnell was coached and tested for hours before each class that he taught. There was a right way to do everything.

Bunnell insists that we not let the shy, sensitive White keep us from seeing White the impresario. When he was hosting or teaching or hanging a show, "he was in his element," Bunnell says. "He loved to take charge, and he did it magnificently. By the time he got around to telling you how to clean the floors, you really didn't mind listening. When he walked into one of those classrooms, it was perfectly obvious to everyone that he wasn't going to let the bells and the desks and all the rest of it keep him from getting down to business—immediately. Even the hecklers would shut up—for a while, anyway."

For all his high seriousness, White was rarely solemn when around others, and I have talked to any number of people who put a strong emphasis on his love of play. When he was on the road, he liked to send goofy post cards from places that struck his fancy. Bunnell got one once from Interior, South Dakota, that said simply, "Clouds in focus all the time." Much of White's correspondence is signed "Cheerio," which seems somehow to fit him perfectly. Work was the order of the day at 72 North Union, but there was hilarity too, many raucous good times, drunken parties, foolishness, irreverence. On occasion White managed to overcome his self-consciousness, indeed to dance and shout with joy. One evening in particular is remembered by several people who were there: during the afternoon a shooting session was held on the roof, and that night slides were projected on a drawn window shade, most of them nudes, some of them with no pretense whatsoever to art. At some point in the drunken to-do it was discovered that a crowd had gathered on the sidewalk outside: a growing audience of amazed upturned faces was watching the see-through backside of the second-story peep show with increasingly noisy delight. Not exactly the Creative Audience that was to preoccupy White in the years to come, but he appreciated it as much as anyone there. After working late at night on *Aperture*, he would drive friends home, especially if the weather was bad, and he loved to spin the vehicle around in the middle of the icy street. There was one particularly inviting spot on a bridge on the way to Bunnell's dorm room. White would speed up, then slam on the brakes and lock the wheels: and Bunnell would shut his eyes, listening as White's laughter deepened.

Extraordinary the energy at 72 North Union in those days, the controlled energy. Connections were being made: all kinds of things were coming together. The recipe for the soup stock that was always on the stove, it came from Beaumont Newhall, and some of White's most magnificent photographs from that period, they came from designs of condensation on the windowpanes caused by the steaming soup. Friendship, lack of money, food, the hated Rochester winters, belief in the idea that everything is always at hand for those enlightened enough to see it, the universe in a grain of sand—all of it came together in his art. Which is precisely what he wanted his art to be: where it all came together.

Paul Caponigro says, "The big thing that Minor did as a teacher—and the whole photography world owes him a debt for this—was to demonstrate, in word and deed, what a truly deep involvement in photography was. That was the space he let you into. He showed you what it was to have photography at the heart of your life. It was an inspiration and a challenge." Others describe the same thing in more general terms: he showed them what it was to take one's life seriously. They saw in Minor White not only an inspiring photographer and generous teacher and friend, however remote he seemed at times, but a man with a vision of a completely integrated life, his art his home, his home his art, both embodying his religion.

Everyone who knew him during the Rochester period, from the mid-1950's to the mid-1960's, testifies emphatically that he was then at the height of his powers. That in fact the Minor White of 1967 on—the Minor White who received so much attention—was a mere shadow of what he was at 72 North Union. Some of the decline is attributable to failing health; he was seriously ill in 1967 and never fully recovered. "His heart was the center of his being," Hoffman says. "He did everything with his heart—photographed, thought, everything. When his heart began to fail, everything went down with it." Surely that explains a lot, but there were other things involved in the decline as well.

In Rochester he was earning his maturity, discovering it all over again each day, laying claim to his full powers. For sustained intensity nothing can compare with that experience. Later he shared with his students what he had discovered in Rochester, but he could never again share with them the excitement of discovering it. In many ways he was only a few steps ahead of those around him at 72 North Union, and often a few steps behind, a situation that was as fruitful for him as it was for them. In later years there was no Beaumont and Nancy Newhall around, no Walter Chappell, no Nathan Lyons or Paul Caponigro, not often enough anyway. And the aura, the magic, got named: people started seeing him, as Bunnell put it, "with a mandala over his head like a halo." That is asking a lot of a weak heart, even of a strong one.

Today what was happening at 72 North Union—the interest in Gurdjieff and Zen and Taoism, in the techniques of meditation, in hypnosis and auto-suggestion and gestalt theory—would not seem nearly so aberrant to Americans as it did in the late 1950's and early 1960's. Despite *Aperture*, despite a growing appreciation of his photographs, few people at that time had the slightest idea what Minor White was up to. His description of sequencing photographs, taken from a letter to Bill Smith, can be read as a metaphor for the kind of life he was trying to live:

> This assembly period is always strange. It is intense, concentrated, yet I do not seem to pay much attention to what is going on. From long experience I know that forcing the spirit to do whatever it is she or it has decided to do, will not help. In my impatience I get a little anxious. But I have learned to watch the pictures arrange themselves according to the direction given. I merely lift them about. . . . It may seem that the music [*The Magic Flute*, which was on the radio while the sequence was occurring] caused my reaction, and helped heighten the mood. Doubtless it did. But that was the least of its services. It served still more as a way of not paying any attention to what I was doing with the photographs. . . . A mood that has been on for days, constantly and regardless of other work, concentrated somewhat. Not to a fine point, but somehow kept from being a fine point so that there was room to work. . . . During this kind of concentration something is needed to engage the conscious mind while the inner mind must look off to a distant landscape while the spirit works because if it looks at what the spirit is doing the work stops. Yet how great a love wells up!

> And the feeling has not gone. The great well gushing up from the earth is dramatic; the lake the waters form is calm in the glistening sun.

> As the sequence was sketched out and seen to be finished a fine surge of feeling swept over me. Joy yes, but as much of sorrow. My heart was laid bare once more. It is the love learned from the flesh turned to a love of God. That much was joy. I could foresee the misunderstanding—and that was the pain. If tears came, it was from an excess of emotion.

> A few will understand that this group of pictures is for the love of God. Such persons will already know what that means. Perhaps a few who are on the borderline will catch in a sidelong glance a love of spirit. If they have a lightening experience of you who are frequently in a state of communication [with spirit], then these pictures will be of use.

> I was repeating to myself, "It is beautiful! It is beautiful!" A phrase that has no meaning other than it is the words that come to my lips when some aspect of the visual world is so charged with meaning that you are at a loss what to do or say. These moments when the visual world is transparent. When the intangible is more solid than steel.

> And the feeling has not gone; the lake the waters form lies glistening in the moonlight.

Sound of One Hand Clapping

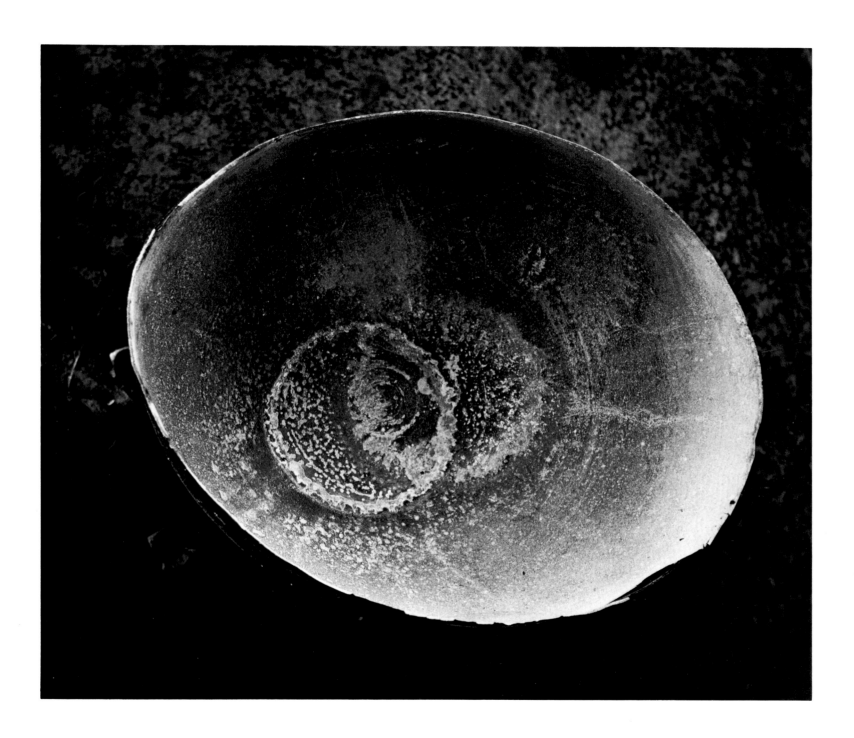

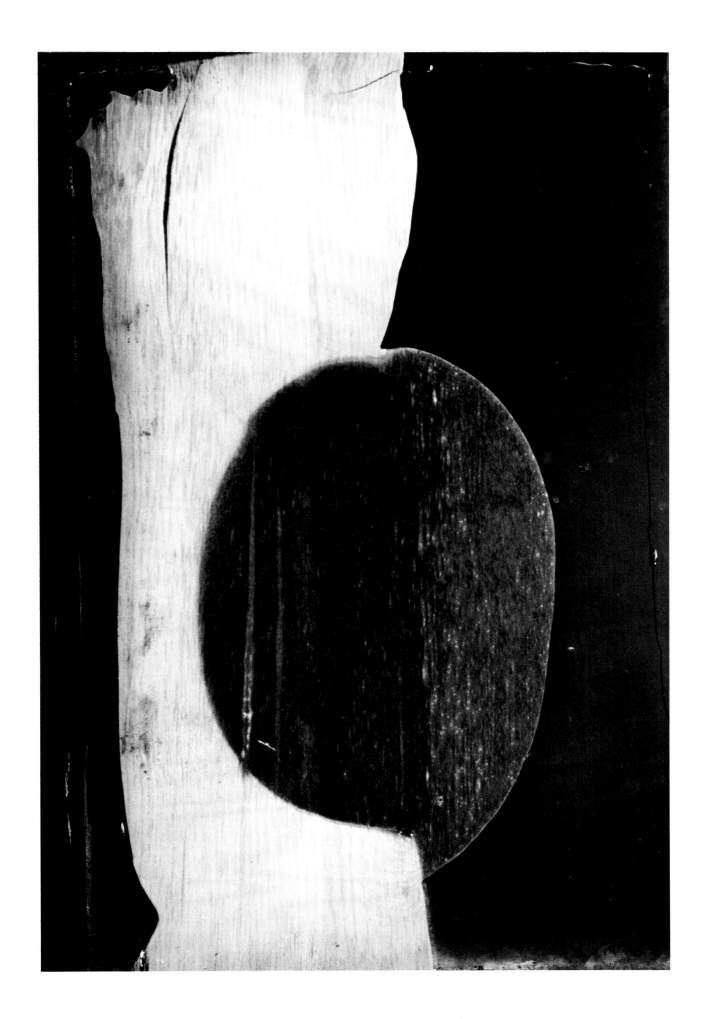

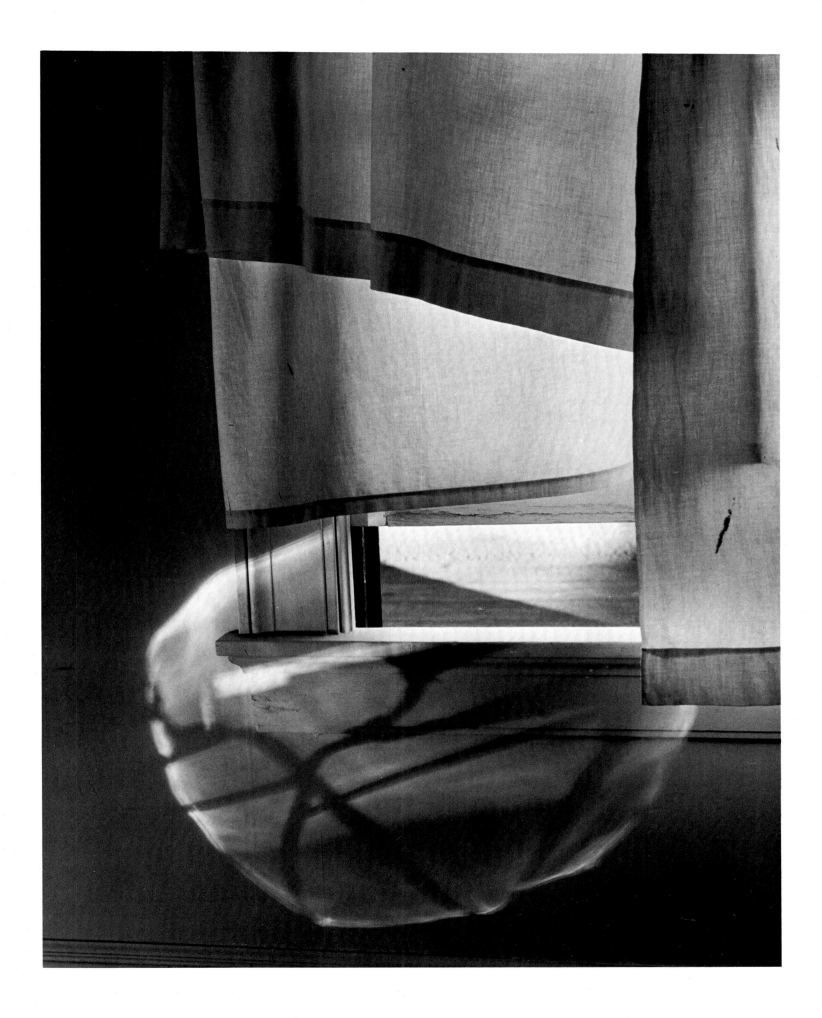

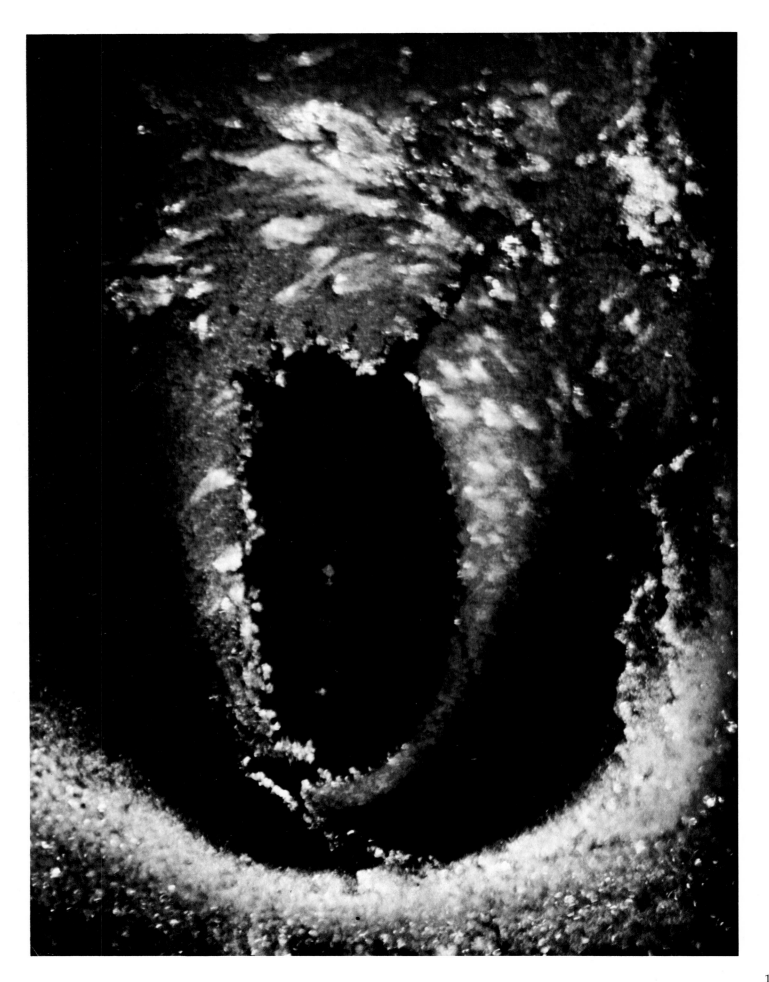

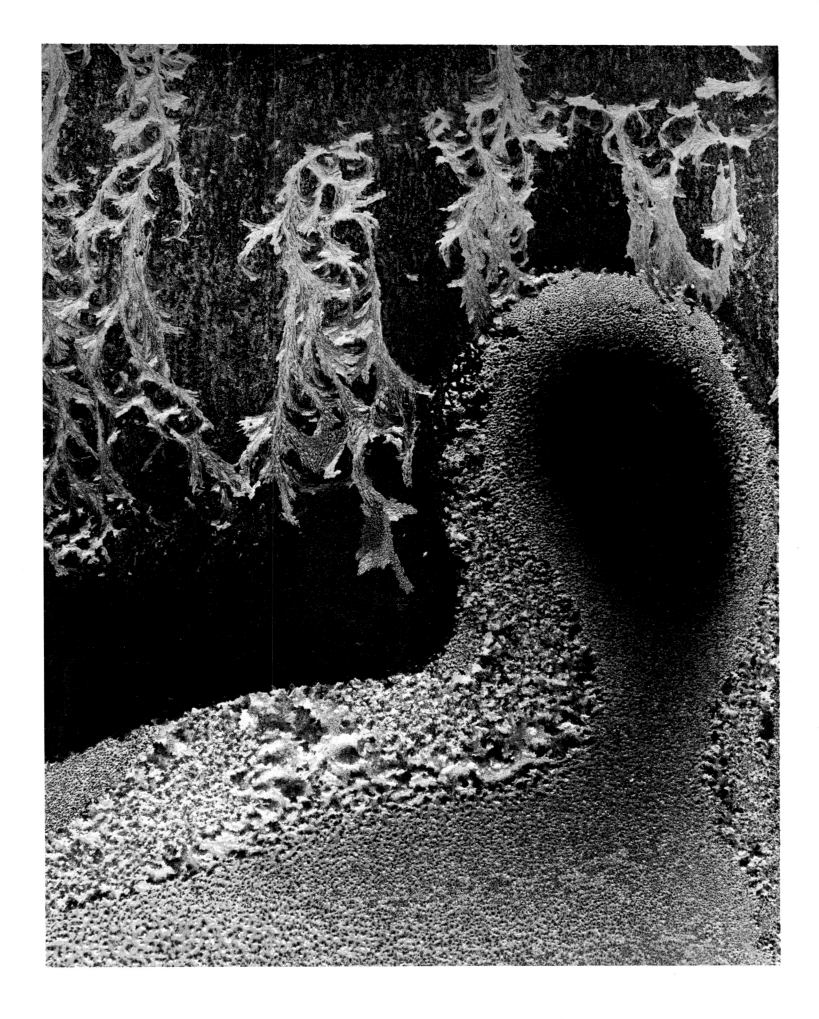

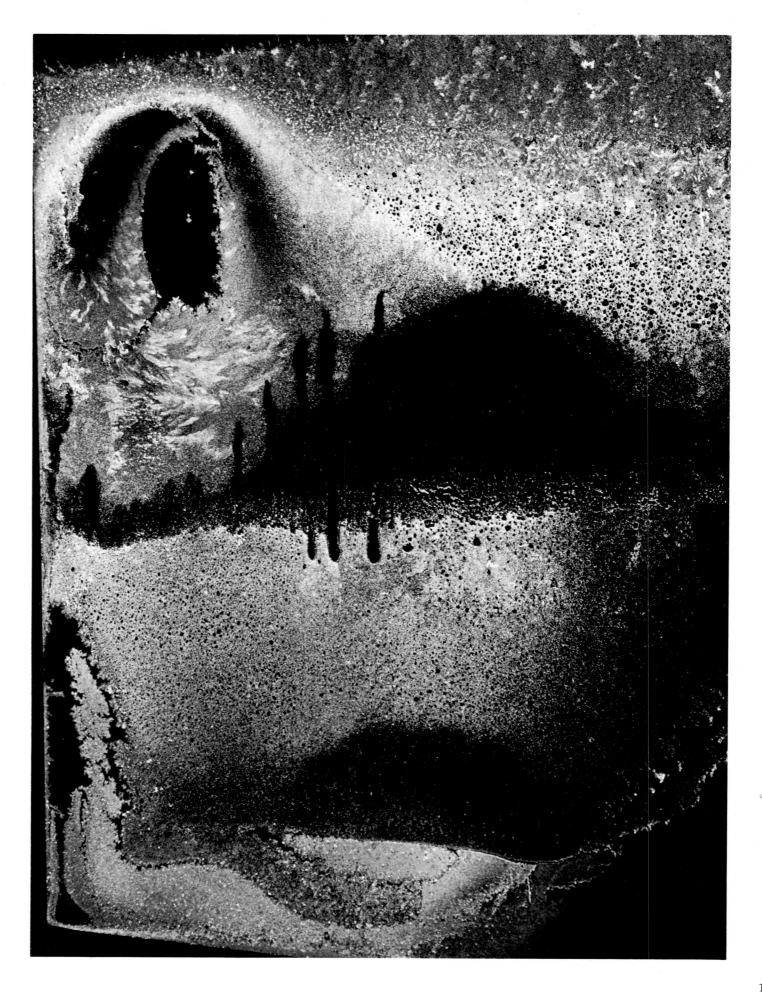

104

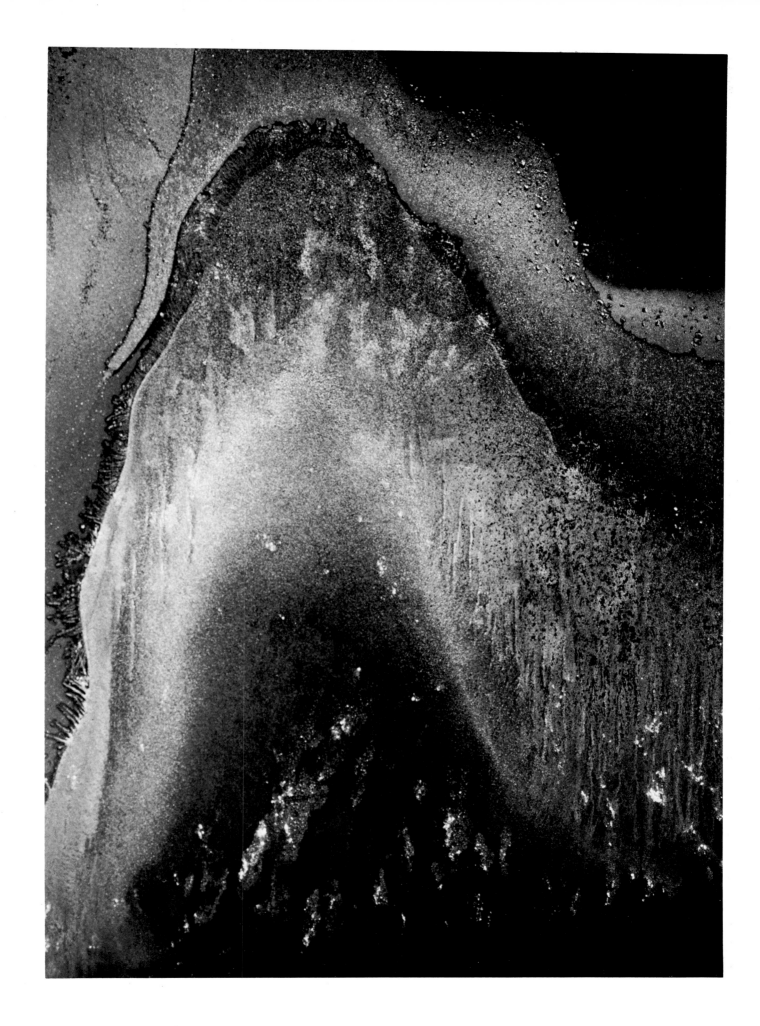

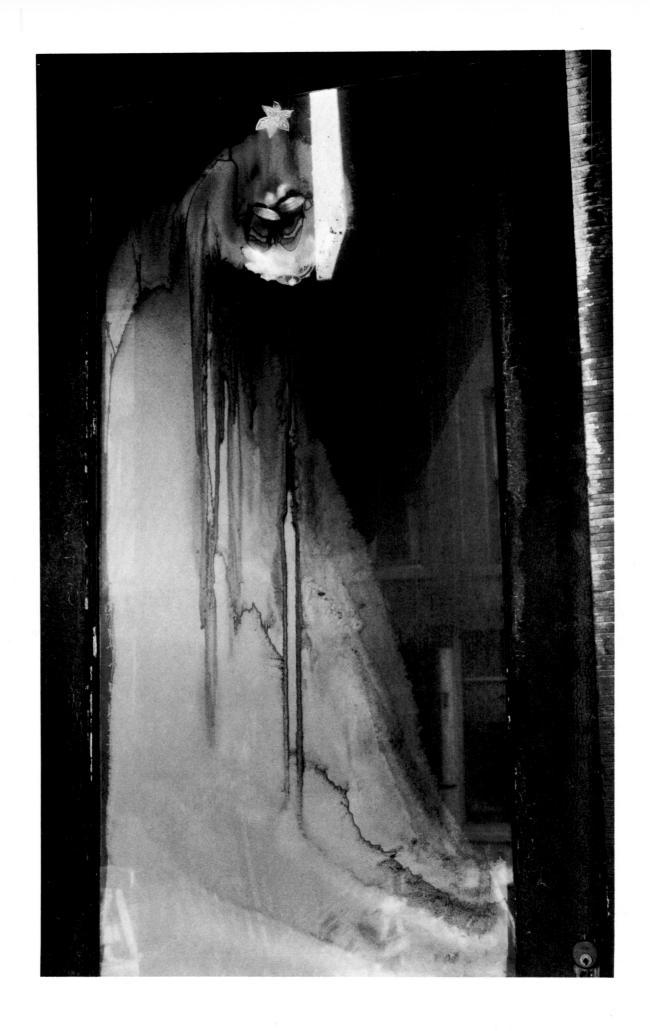

106

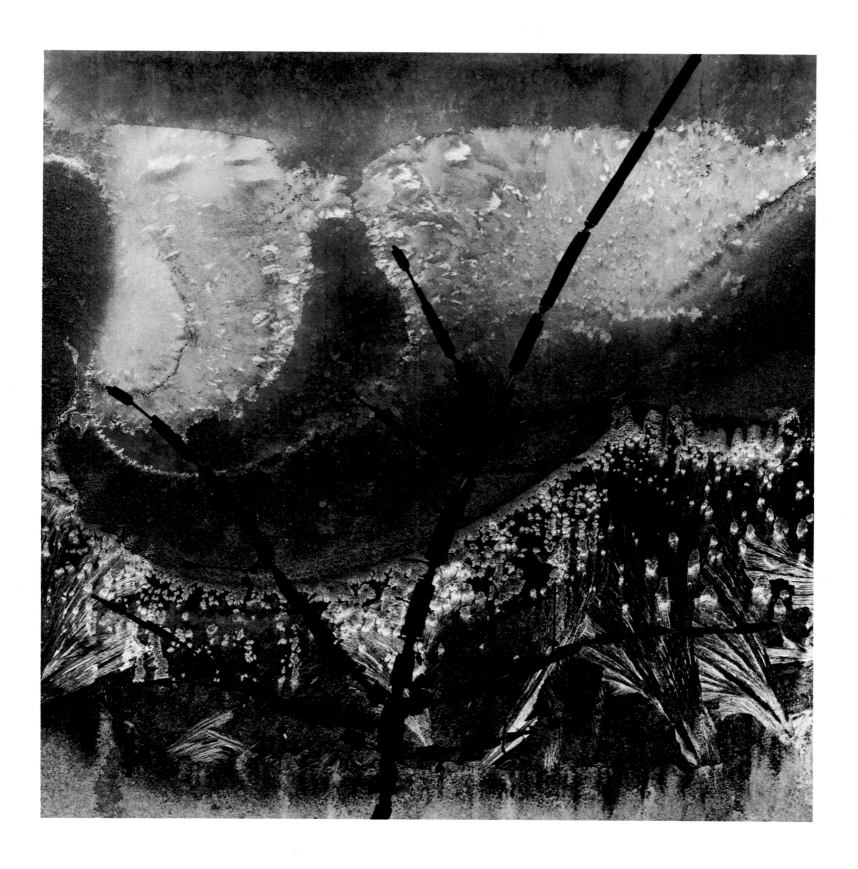

No matter how slow the film, Spirit always stands still long enough for the photographer It has chosen.

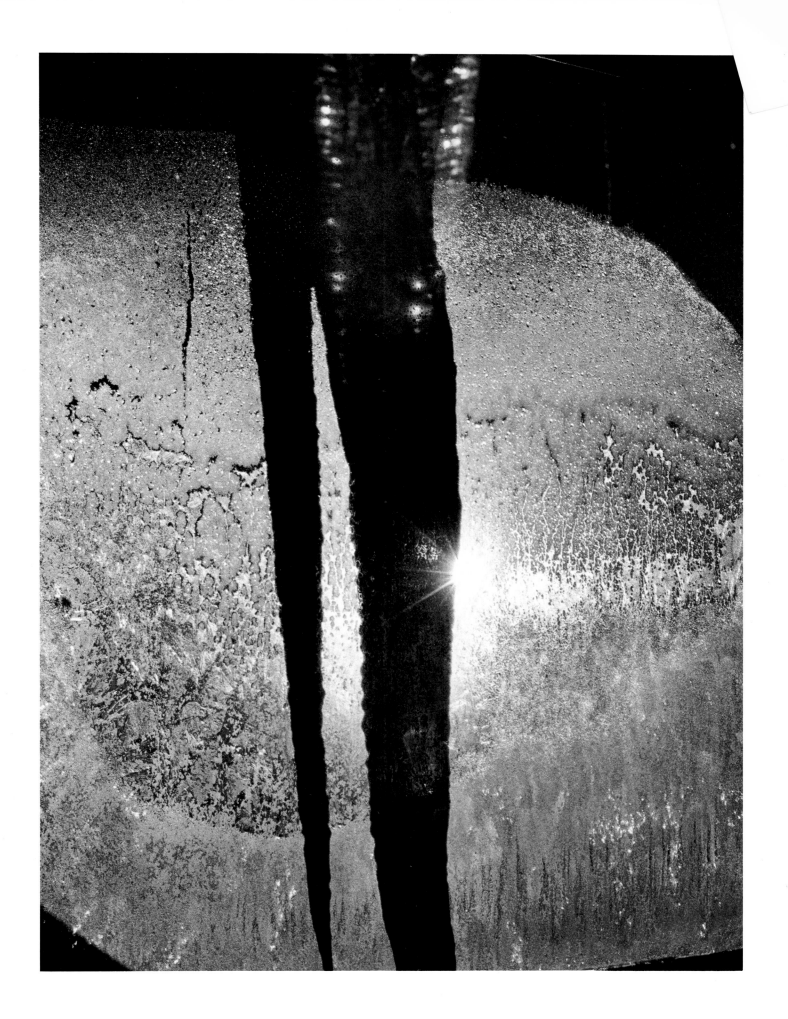

It is hardly surprising that I have concluded, after five years research, that camera is both a way of life and not enough to live by.... Glass between me and the world is both a channel and a barrier. To live through a lens, to live out my inner conflicts and brambles through a camera, to turn to the camera to help me return to the world was an experiment I set out to explore five years ago. I knew it was headed for failure in some way, but I persevered because little else was left open. Camera as a way of life, and this included teaching, especially teaching, is still the least impossible way for me to develop and to maintain a state that I can call mine.

When MIT approached Minor White in 1964 about coming there to start a photography program, he did not have clothes suitable to wear to the interview. Somewhere the money was found, and no one at 72 North Union was surprised when he returned from a shopping spree with what Hoffman describes as a "phosphorescent blue suit" that had struck his fancy—and an overcoat, which he promptly lost. That had not always been his way. Bunnell remembers a Minor White who, only a few years earlier, had dressed with studied, almost elegant casualness: fine white shirts, open at the neck, clean white socks and fine, hand-tooled sandals; the kind of man who made sure that his white hair was beautifully white, not the least bit yellow or blue. But all that began to change with his increasing otherworldliness. If there is one thing that everybody who knew him from the early 1960's on agrees about, it is what a dean at MIT once called "his marvelous carelessness about himself." When Hoffman first met him, at a Denver workshop in 1962, he thought, "Oh, that can't be Minor White, that's just some hanger-on. Minor White's the tall impressive-looking man over there with the big beard and the fine speech. But no. It turned out that Minor was the guy in the green pants who obviously didn't know what he had on, had just put on clothes because you had to put on clothes."

That sort of thing was, certainly for me, right at the heart of this gentle yet often commanding presence: a mixture of boyishness that was endearing and charming, especially in his shy smile, and otherworldliness. Tall, lanky, deep-voiced, he had a habit of clearing his throat, sometimes before each sentence, as if to say there was nothing casual for him about talk. He was balding, but you did not think of him that way: he had good reason to be vain about his hair, which he sometimes wore long. For all the carelessness about his appearance, that white hair made him look quite distinguished. He had the bearing of a man deeply confident in himself, or at least accustomed to being deferred to, and who was at the same time painfully self-conscious. That mixture of loftiness and social awkwardness made him someone you did not feel comfortable chitchatting with at any length. Nor was he a man easy to look at. There was something simian about his face, a hard, structural impishness that played against the dignity of his high forehead and white hair and stentorian voice which, taken together, never let you form too simple an impression of him. Or rest too comfortably with what you saw. There was something underneath that confidence, something deeper still. If you dealt with his presence, really let it into your eyes and nerves, it involved you somehow in the whole ongoing problem he had with his corporeality. His big hands and meaty handshake always came as a surprise, as I am sure his body often did to him.

The Rochester period came to an end in early 1965 when he moved to Arlington and became the first Professor of Photography at MIT. What the Institute wanted was a program that would expose their engineers and architects and scientists to creative work in a medium other than their own. It was a timely, productive coincidence of resources, a canny appointment of the sort that has made

MIT what it is. The Institute gave him a free hand, and within a few years he created one of the finest photography departments in the country, and surely the most inventive. At RIT he had been teaching students who hoped to make their living as photographers; he was eager now to work with amateurs—just how eager he had not known until MIT approached him.

Back in 1951 he wrote in a journal, "The genius requires little or no instruction, but his audience, if he is to have one, cannot exist without instruction, teaching, education." Having come to believe that photography as it was characteristically taught and practiced often kept people from seeing, he designed the curriculum at MIT around a course called "Creative Audience" that did not concern itself with picture-making at all. Using various techniques for heightening the sensitivity of the senses, he taught his students to probe the facts of their bodily experience in an effort to come to a deeper, more precise understanding of who and where they were and what

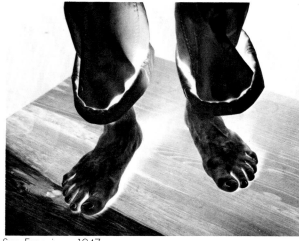

San Francisco, 1947

they were doing—and then to use that as a basis for learning how to see. As dancer Shirley Paukulis, his assistant in that course, says, "He shook the students up, destroyed their conventional way of seeing, of being. He made them run risks. We broke their stability down by making them *move*. We got them closer to the earth, where they could feel gravity, feel the energy that was flowing in them, through them. He had them read Ouspensky, Castaneda, *Zen in the Art of Archery*, the *I Ching*." Some students were offended—they had come to study photography, not crawl around on the floor—some were even infuriated, but few were indifferent; and many had experiences similar to those of Abe Frajndlich and Peter Laytin. Paukulis remembers one overwrought middle-aged businessman at a summer workshop who at the end of ten days danced off across an open field in a wild display of new life. One can imagine Minor White's delight, tinged perhaps with envy, at such a sight.

With his "Creative Audience" course surrounded by classes in basic and advanced technique, obsolete processes, criticism, the history of photography and others, his ambition as a teacher was, as he put it, "to bring the student, by way of a series of rightly conceived, perhaps infallible steps, to the point where he can 'see,' see profoundly the world around him, and he can recognize the relationship of his medium to his whole life, on any level he chooses to recognize it, emotional, intellectual, spiritual. And when he gets through, he would come at photography with control over the medium and a certain attitude: just as he asked the medium to serve him, something higher was asking him to serve it. Then he is in a 'right position' to use the medium as an art."

At MIT, White was much more aware than he had been in San Francisco and Rochester of the dynamics of his relationship with his students. In the earlier days he was often confused and hurt by the way some of them ended up turning against him, often in obscure ways. "At first I didn't understand it. I really had the sense that once I had the student, really had him, he was mine forever. When I first came into teaching, I really felt that without knowing that I was feeling it. I began to realize after a while that that's the way it was, and that that wasn't the way it ought to be. Now I realize that what I'm here for is to spread a lot of things out on the table, and let them take what they want. It doesn't make any difference to me what they take, or whether they take anything. Along with that attitude the ties aren't so great. *I* was tying them up myself, without realizing it."

Caponigro describes the same situation from the other side. He was at 72 North Union for a couple of months in the fall of 1957, then went back for a longer stay the next year, assisted in the 1959 summer workshop. After six months of intensive study, he felt the need to back off. "Minor was so generous and what he gave you so nourishing that it was especially hard to disagree, to separate yourself, to go your own way. Everybody around him shared the same assumptions—it was really difficult to call them into question. But after a while it was inescapable—there I was in another club. I had been in clubs before, the grand landscape club, the full-scale print club. I didn't want anything to do with clubs anymore.

"There was something in Minor straining always for a system, underpinnings for what he believed. First it was Zen, then it was hypnosis, then it was Esalen, then it was gestalt, then it was Gurdjieff, then it was Castaneda, then it was astrology. Essentially dynamic things were all the time being turned into rituals and exercises. I was always coming up against something static where I felt there should be movement, words where there should be work, exercises instead of photographs. I kept wanting to say,

111

What are we doing here talking, why aren't we out photographing? But it was hard to do, I didn't want to hurt him. There had to be a parting of the ways. He asked me to help again the next summer with the workshops, and I said *no*. Another student there said, How can you say *no?!* And I knew when I heard him that I had done the right thing. Minor accepted it finally—we ended up joking about it.''

Accepted it yes, but very much on his own terms—he took responsibility for the psychology involved in his role, granted Caponigro the son's need to declare independence, but not the philosophy. He never spoke to the ideas as ideas. He heard a lot of criticism in the same vein as Caponigro's—though none nearly so incisive—and the way he dealt with it is revealing.

''If he'd just make pictures,'' one teacher of photography said, ''and cut out all the mumbo jumbo! He's a great photographer, but he spends too much time contemplating his navel. He's supposed to be such a great teacher, but all his students are little imitation Minor Whites. Caponigro is the only one who's done anything. It's all a big ego trip.'' One hears that often, or some version of it—it is certainly the most common and, from a secular point of view, the most valid criticism levied against him. Ansel Adams, while granting the magnitude of his influence and much that was healthy in it, says that there was ''a great danger'' in the therapeutic aspects of it, a danger perceived also by Beaumont Newhall and others. ''Primarily, he was a *great* photographer,'' Adams says. ''In the end that is (for me) what counts. He was an important teacher. . . . [But] I do not feel assured he was a [purely] constructive influence. . . . When students or associates were at the borders of the rational, misplaced psychological approaches could be disastrous.''

And, as the journals suggest, they sometimes were; White himself noted several times ''the dangers of these methods'' and alluded to situations that seem to have gotten beyond his competence. He agreed also with the allegation that he promoted only versions of himself. When he started teaching at CSFA, he told his students that he wanted them to make their own pictures in their own way, and believed that that was where he stood, only to discover, as time passed, that he was teaching them ''to make the images I would have made had I been there.'' When school was out and he got into the field, he always found it difficult ''to photograph out of myself. I would be making the pictures I had been seeing my students make all year,'' imitating their imitations of him, at some crazy remove from the real thing. ''It usually took me a month or so of camera work to get back through all that to myself.'' With *Aperture*, too, he saw that he had done the same thing. ''It was a one-man show, an outlet for my own

photographs. . . . My own photographs, but other people did them.''

He dealt with all that quite openly, and without apology, for he knew it was neither the whole story nor the last word—nothing of the sort was possible from a secular point of view. The artist in him was often bored with the work he inspired in his students, as bored as any of us. ''Every time some kid comes through the door, I think well maybe this is the next Stieglitz or Cartier-Bresson. It never is, of course, but it's what one lives for.'' But the teacher in him had a different response. If there was spiritual growth, he was not troubled by imitative camera work, or even by no camera work at all. He was not teaching or even practicing photography per se, and he paid little attention to those who did not understand that.

But Caponigro not only understood it, he was (and still is) in basic sympathy with White's preoccupations and aspirations. He was not objecting, as so many have, to the fact that Minor White played the guru, but to the quality of the performance. As a man on the path himself, he was determined to see that it was not turned into a trip, what Chögyam Trungpa calls spiritual materialism. They had the same argument again nearly ten years later, this time over an introduction that White wrote for the Aperture monograph *Paul Caponigro*. Caponigro was offended by the glibness and emotionalism of it, and he said so in no uncertain terms. ''I didn't want anything to do with all that bullshit. He was dressing me up in all this masturbatory mysticism, relating my work to the Gurdjieff ideas. He was rowing his boat in this beautiful sea of symbols and calling that the reality of consciousness. Giddy is what it was! I was still struggling as a human being and as a photographer, and I was still struggling to understand Gurdjieff, and I didn't want to participate in that incredible dabbling.''

When I asked White about the dispute, he ducked all the issues by saying, ''Paul doesn't like to have his work talked about.''

Caponigro was objecting not to language, but to loose language; he wanted careful discrimination, precise observation, not self-indulgence, and much is revealed in Minor White's refusal or inability to hear what he was saying. Only toward the end of his life, in the caution with which he approached the Gurdjieff ideas in public, did he show any evidence of understanding what Caponigro meant by ''dabbling.''

Adams says, ''As far as I could observe, most of the people around him were his inferiors, not his peers.'' Hoffman puts it much more bluntly, ''Minor loved the idiots because they were no challenge.'' There is no question that White suffered, both emotionally and intellectually, from his patriarchal disposition. It was probably

more an effect of his isolation than a cause of it, another way of dealing with deep insecurities, but the result was the same: it perpetuated and deepened his psychological hermitage. The refreshing, healthy candor with which some of his old friends and peers dealt with him, the give-and-take of equals—Adams, Chappell, Hoffman, the Newhalls and a few others—was in stark contrast to the deference of people who surrounded him daily from the mid-1960's on. As his MIT colleague Jonathan Green says, "Minor was an aristocrat"—which means, among other things, that he understood authority, understood nothing better, in fact. He talked about his teachers in the Gurdjieff work in much the same way as his students talked about him. He understood how to be a teacher and how to be a student, he understood how to dominate and

203 Park Avenue, Arlington, c 1968

how to submit, but when something else was required—putting the two moves together in the same relationship, for instance, which redefines both—he often faltered. His principal relationship was with God: his intelligence was fundamentally hieratic and hierarchical. It moved with confidence up and down, between the sacred and the profane, but not with the same assurance sideways, among equals.

Surely one of the appeals of MIT for him was being in charge; the department, down to the last key, was his. He was in the photographs which the students made, he was in the talk you heard there, Minor this and Minor that, he was in the way the space was organized, he was in the colors that were chosen for the walls. I taught a course there once, and the first thing I saw when I walked in the door was a larger-than-life-size picture of the chairman smiling somewhat sheepishly down from up near the ceiling on the equipment cage wall—a student's witty comment on White's inescapable presence.

In addition to all that he was doing within the department, he hung four large and controversial shows over a six-year period in MIT's Hayden Gallery, *Light*[7], *Be-ing Without Clothes*, *Octave of Prayer* and *Celebrations*. Herbert Hamilton speaks here for legions: "I'll be damned if I know where the guy got the energy—he ran us all ragged." White had always been known as a highly disciplined worker, capable of long day after long day of hard, demanding work, and despite failing health he continued to inspire and often exhaust those around him with his schedule. While answering to all that both MIT and Aperture required of him, he expanded the life of his home, conducting live-in workshops now with not just one or two students in residence but as many as six; he continued to give summer workshops and lectures; he dealt with the increasing numbers of photographers and spiritual aspirants who walked in off the street, often with impossible uses for him; he worked on his own pictures, shows, portfolios and books (*The Zone System Manual*, *Mirrors Messages Manifestations* and two as yet unpublished volumes, *The Creative Audience* and *The Expressive Photographer*); he maintained the many friendships that his way of life created; he devoted himself to those aspects of his own spiritual development that were not accessible through camera work, editing and teaching; and he created and cultivated a house that objectified his inner life.

203 Park Avenue in Arlington was the Rochester place come of age, much larger, much more gracious, years of experience and a decent-paying job behind it. For all the many things that were going on there, the prevailing atmosphere was one of calm, as though you had walked from the busy world into a Rothko painting, large spaces floating within a frame. As one of his students put it, "That house is something special—it comes off the walls at you. The minute you go in it something takes hold of you. The outside world has no meaning there." The regulars entered not through the front but the side door, a sun porch full of potted plants, full of light. Some of the meals were taken there when the weather permitted.

The first time I visited 203 Park Avenue, in 1971 I think it was, in connection with a book I was preparing for Aperture, a live-in student made dinner for us—the tinkling of a bell signaled it was time to quit work—and served it on that sun porch. The three of us ate in silence, a monastic atmosphere that was my first real contact with White's life. The front room downstairs, what ordinarily would have been the living room, had been made into a

classroom, panels on the walls for displaying photographs, a baffle of gallery lights hung from the ceiling; and the dining room, with large tables made out of sawhorses and doors, was also workspace, for typing, editing, whatever, plenty of waist-high counters for laying things out. Only the spacious kitchen and the parlor, with its record player and Victorian chairs and couch, resembled a conventional home. On the walls all over the house, in polished aluminum frames, were photographs. Upstairs, one of the four bedrooms was given over to mounting, matting, spotting, editorial work and storage, with fine built-in cabinets. A big darkroom, with three enlargers, was in the basement. White's desk was in his bedroom, always set about with books, letters and manuscripts in progress. Except for the kitchen, which was cleaned and set to rights in detail after every meal, all the common rooms showed surface clutter, stacks of photographs, books, packing crates, all the stuff of the moment's projects or renovation; but the whole house had the feel of the important things being in place. The backyard, though small and full of trees and shrubs, had a fine sense of space, New England in scale; it was a marvelous place to read or think or just sit. On occasion meals were taken there too, on the flagstone terrace next to a piece of driftwood from Point Lobos. It was there, after a sumptuous chicken dinner with wine, that we had our final long talk about his life, continuing far past his bedtime. The last half an hour was spent in silence—it was, I am sure, the most important thing he wanted to say.

His live-in students rose early with him, they meditated for an hour or so, had breakfast, and the day's work was usually under way by seven or seven-thirty. Hired assistants did his processing and some of the printing, everything except exhibition prints, and all the busy work, both professional and domestic. An unlisted phone number helped now to keep his attention where he wanted it to be. Twice in the last years he was near death, and there was still a lot of unfinished work. When he retired from full-time teaching in 1975, he began working eight and ten hours a day, with breaks for lunch and an afternoon nap, on the two "teaching books," as he called them, "which have been sitting on my head for thirty years." When they were done, he wanted to spend the time that was left to him with a camera.

At noon the bell rang, people assembled in the kitchen from all over the house and yard to eat yogurt, fruit and salad, often in silence. Afterwards someone read from the manuscript he was working on; if there were questions or comments, there was a discussion; if not, they sat silently together for a while, then went back to work. And so the days went. The loneliness was no less profound than it had been in Portland, San Francisco and Rochester, but there was less anguish in it, considerably less. During the war he had imagined a time when the degradation of his body "by pain, hunger, privation, and annoyance" would be so great that his mind would stand aside "like a disembodied thing obedient only to its own ideals, rather than acknowledge the beastly thing it lives in." It was age finally, not suffering, that brought him to that. In his last years he was back again to that beginning he had imagined thirty years before, the "beginning of the love he would know when [he] was freed of his anchor of flesh."

Sometimes when White was not there, the students at 203 Park Avenue broke loose: they took the Bach off the turntable, put on the Rolling Stones, hauled in a case of beer, and the quiet floating spaces of the Rothko got overlaid for a while with a little Jackson Pollock. Things surfaced then that ordinarily were kept fairly well hidden.

Thomas Shuler

Minor White, Movement Demonstration, c 1972

On one such occasion, several of the live-ins were drinking wine and beer and listening to rock while they painted Minor's bedroom according to his instructions. Robin's-egg blue. Which was too much, they decided, robin's-egg blue was just too much. Soon their loud talk was full of jokes about him and his private life, "a real gutter trip," as one of them describes it. Right in the middle of the worst of it, they discovered that he had returned, was in fact standing at the bottom of the stairs, listening. He had given them a place to live and work, and many like them, he had fed them, he had given some of them pocket money, he had helped pay one of them out of his own salary (secretly, he thought) to work the equipment cage at MIT, he had helped them get jobs and

shows, he had published their pictures, and he had taught them, he had devoted a lot of his life to teaching them—and there they were scoring off the enema bag in his bathroom, off "the mystery woman" in his life. They did not know what to do. But he did. He acted as though nothing had happened. The next day, when they worked the conversation around to where they could apologize, they realized that he was telling them to forget it, that they all had better things to do. He was in a fine, ebullient mood, there was no problem. None, anyway, that they could do anything about.

Minor White died on June 24, 1976, in Boston. In that last talk I had with him on the flagstone terrace in the backyard he said, "I'm just a machine. When certain forces reach me I react in a certain way. When other forces reach me I react differently. And those forces change. I realize I'm just a little puppet out here, somebody else is pulling the strings. And it's interesting to become aware that that's what's happening. It's not a loss of ego, but to the ego it's a great loss. But another part of me is saying, gee, this is fascinating. Compared to this the ego is kind of dumb and dull. The ego is such a bore."

Beethoven was on the record player inside, the last movement of the *Ninth Symphony*, where human voices join the music of the spheres. Behind the Lobos driftwood two stepladders leaned against the house from roofwork that day, and above, a patch of the heavens was visible, a clear moonless night, the Pole Star standing over the house's dark shape. I could barely see him there in the dark, just a voice, a deep voice, with long silences in between. He had just shown me his quest fable, "The Diamond Lens Fable," and we were talking about Gilgamesh and the Fisher King. And about the stars, about astrology—he was telling me how he hoped to find time soon to pursue his deepening interest in the Sabian symbols of astrology.

Something told me that he would not live long and that he knew it and that it made no difference—he still had to talk that way, I still had to listen. I was being called into a strange old church, deserted except for the chastened spirit practicing its song: the prisoner was holding himself up by the bars so that he could sing, or perhaps he was trying to spread them, better to let the song out.

I pointed to the ladders and told him about a song I heard once in San Juan. *Para subir cielo, se necessita una escalera grande, una otra chiquita*—for climbing to the sky, all you need is a large ladder and a small one.

He laughed and said, "That's a hard song for most people to hear."

Indeed it is, especially hard for the modern ear to hear. It is the song Parsifal sang when he asked the Fisher King, Where is the Grail? The King's health was failing, all that was in his charge was failing, everything was going down, and no one knew what to do. The doctors fretted, the wise men scurried about in confusion, knights came daily only to reiterate the court customs that were imprisoning and killing the whole kingdom. It took the naive, somewhat foolish Parsifal to ask the obvious question—where is the sacred, where is the ultimate reality?—to remind the King that he had the answer, that salvation lay within him.

To see the sacred in the profane is to see the eternal in time: that was the controlling quest of Minor White's life, the search for an imagery that was in perfect register with the stillness of the still photograph, for a communication between people that was most articulate in silence.

A plane overhead descended into Logan Airport, the Pole Star momentarily at the apex of the flashing wing lights.

A little after midnight we shook hands in the dark. The last time I saw him he was climbing the stairs. The house plants, stirred ever so slightly by his passing, were returning to rest.

James Baker Hall

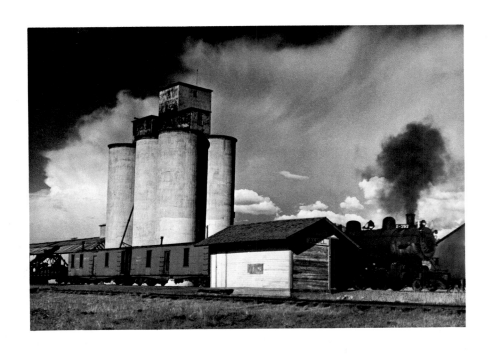

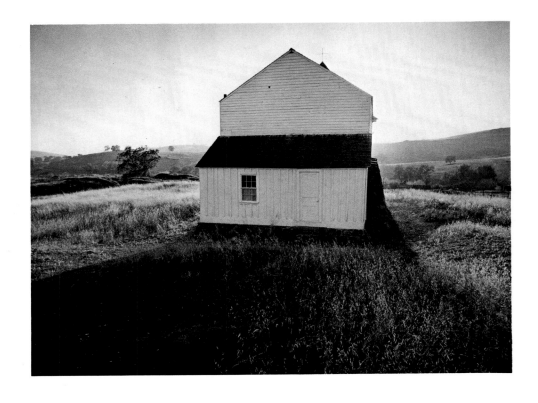

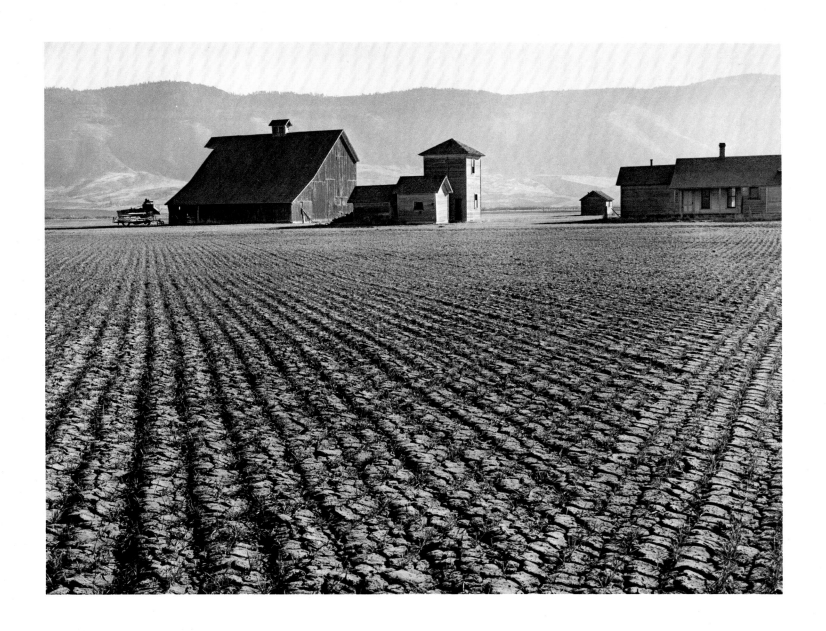

Let the subject generate its own photograph. Become a camera.

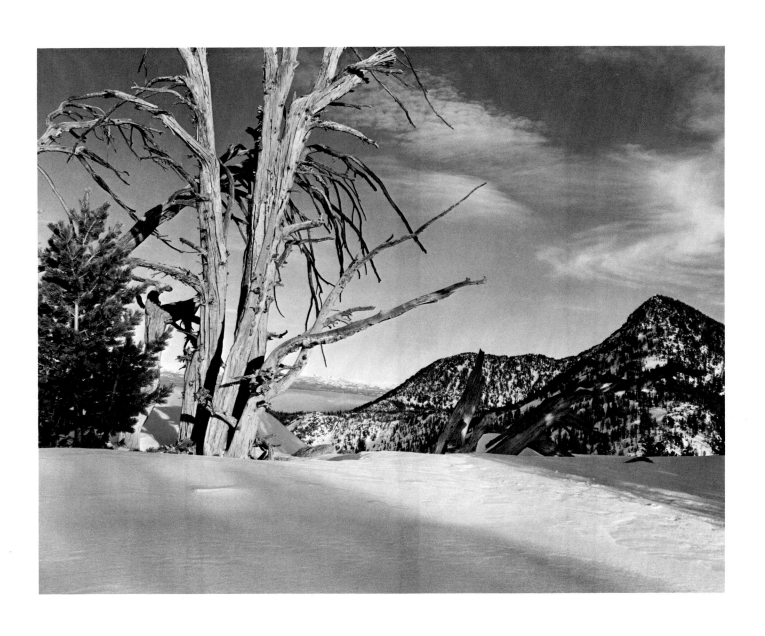

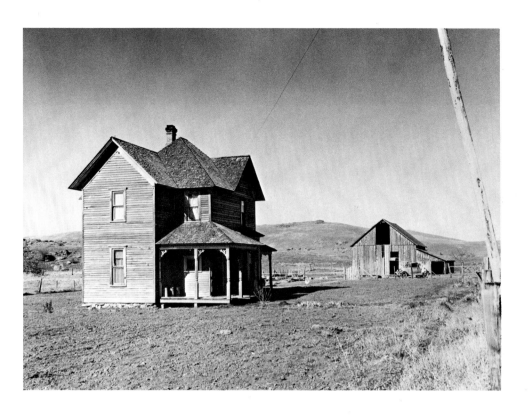

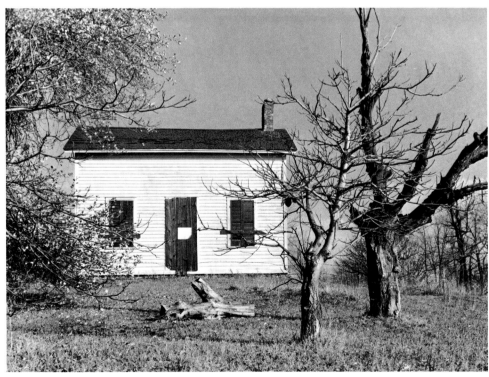

Be still with yourself
Until the object of your attention
Affirms your presence

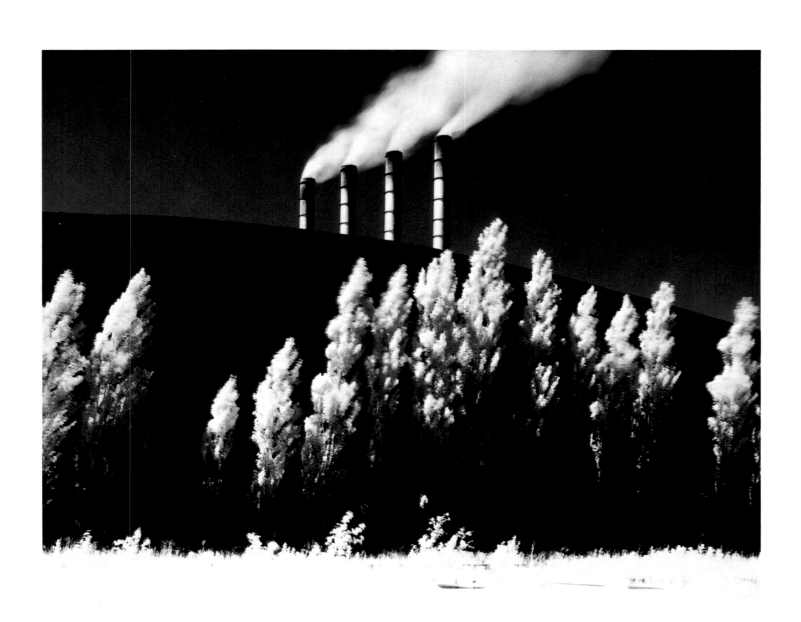

Postscript

To reduce *Aperture* to an item in a catalogue that includes the soup stock, which is all I really do with it in this essay, is fundamentally misleading.

When people wrote to Minor White asking him serious questions, he often answered, eloquently enough, by sending them a particular issue of the magazine. Anyone interested in more than scratching the surface of his thought, or in tracing its evolution, or in seeing precisely what it meant made manifest in photography, will find what he is looking for in *Aperture*— a lot of it, anyway. Until the mid-1960's, when Michael Hoffman began to take over, the magazine was right at the heart of White's life, very much a personal statement; and in more recent years certainly *Light⁷, Be-ing Without Clothes, Octave of Prayer* and *Celebrations* (exhibition catalogues which doubled as issues of the magazine) are indispensable to any detailed understanding of what Minor White was all about.

Peter Bunnell pointed out that *Aperture* belongs, in spirit, to the tradition of small literary magazines, a history rich with the romance of the avant-garde. Its influence now mocks its earlier reputation as an esoteric journal; not nearly so many books of fine photographs would be on the shelf today were it not for *Aperture*, nor would most of them look the way they do. The time, energy, talent, dedication and love that White and others put into the magazine is truly extraordinary. Each copy was addressed and stamped by hand, toted to the post office late at night, an armload at a time. There is a marvelous and important story there to be told, and I trust that someday it will be.

Further attention also needs to be paid to the influence of Gurdjieff's ideas. In discussing his life with me, helping in the preparation of this profile, White made only one explicit restriction: he did not want to talk or have me write in any detail about Gurdjieff or the Work. I assured him that, for reasons of my own, some of which were not unlike his, there was no problem. What many people call secrecy is a hallmark of the Work, one not well understood; curiosity, even the most genuine curiosity, is simply not enough: the kind of knowledge Gurdjieff has to offer cannot be bought that cheaply. White was not trying to hide anything, but rather, as I understand these matters, to protect his spiritual sources. That is not religious piety, but where religious piety comes from: an awareness of how easily such matters can be misused.

Even if I had had the time and space, I would have hesitated to go on at any length about the Work—I know little more than what I have read, which is not enough. The whole subject of Gurdjieff's influence not only on Minor White but on other photographers as well—Walter Chappell and Paul Caponigro come immediately to mind—needs to be taken on by someone who can speak with authority.

Access to private papers and many friends has given me something closer to the whole picture than has been available before, but that is all; it does not necessarily mean that this portrait is more penetrating. Study is often necessary to make sense of a human life, but it is never sufficient; there comes a time when only insight is to the point. Obviously my judgment has been involved every step of the way here, and obviously it is fallible. Nor is "the whole picture" necessarily truer, more essential, than a partial one; a great many of us spend most of our lives, I believe, distracted from our essence. It is perfectly conceivable to me that the right person at the right time could have seen in only a few minutes or a few days more than others saw of Minor White in a lifetime. I would be surprised to find reason to change the basic shape of this portrait—I would not have written it now had I thought otherwise—but surprises are built into the process of knowing anyone. What is at stake is the story of an important man and a great photographer; it is up to those of us who were nourished by his life to preserve an understanding worthy of it.

For a fuller account of the ideas in this essay concerning myth, one should read the work of Joseph Campbell, especially *The Hero with a Thousand Faces*, to which I am particularly indebted. And also the work of Mircea Eliade, beginning with *The Sacred and the Profane*.

In addition to the many sources of information and insight acknowledged in the text, I want to thank Nata Piakowski, Gus Kayafas, Richard Benson, Lynn Strong, Barry Spacks and especially Joan Joffe Hall. Her help and support have been, as always, invaluable.

J.B.H.

Photographs

Cover: Ivy, Portland, Oregon, 1964
Frontispiece: Peeled Paint, Rochester, New York, 1959

Sequence 17

Chronology

1908

Minor Martin White born July 9, Minneapolis, Minnesota; only child of Charles and Florence White.

1913–1928

Develops interest in photography through grandfather, amateur who conducts "slide evenings." Given hand camera at age seven or eight; considers beginning of own photography to be at age twelve when grandfather moves to California, leaving him photographic equipment and knowledge of its use. Attends public schools.

1928–1933

Enters University of Minnesota to study botany; begins to write. Fails to accumulate sufficient science credits to graduate and gives up regular classes in 1931.

Attends university at night to obtain necessary credits, meanwhile studying English and botany on graduate level. Develops serious interest in writing and embarks on one-year program of writing verse.

Graduates from university in 1933 with B.S. degree in botany, minor in English.

1933–1938

Continues to write verse. In 1937 turns once again to photography but first completes 100-verse "sonnet sequence," representing initial attempt with sequence form.

Purchases Argus 35mm camera. Travels west by bus and is stranded in Portland, Oregon. Works as night clerk in small hotel and briefly with photofinisher to earn money for photographic equipment. Joins Oregon Camera Club.

Makes first photographs in central city. Improves basics of technique at Oregon Camera Club. Exhibits frequently at YMCA; teaches photography there and lectures on composition at another Portland camera club. Knows work of photographers like Ansel Adams, Berenice Abbott, Alfred Stieglitz and Edward Weston from published sources only. In popular photographic press follows continuing controversies like that surrounding F/64 Group.

1938–1939

Obtains eight-month position as secretary with People's Power League.

Through friends in League is appointed "creative photographer" for Works Progress Administration. Assigned first to photograph iron-front buildings in Portland, then, in 1939, Portland waterfront.

Begins to produce publicity photographs for Portland Civic Theater of such plays as *The Death of Tintagiles* and *Our Town*.

1940–1941

Appointed teacher of photography, then director at La Grande Art Center, small WPA center in eastern Oregon. Teaches photography three nights a week. Spends weekends photographing for personal aims, notably series of approximately seventy-five photographs of Grande Ronde–Wallowa Mountain area in northeast Oregon.

Produces regular fifteen-minute broadcasts for La Grande radio station on activities of Center.

Completes first article on photography: "When Is Photography Creative?" published in *American Photography* (January, 1943).

1941

Exhibits first photographs in national exhibition: *Image of Freedom* at Museum of Modern Art.

Returns to Portland; obtains miscellaneous employment as photographer and, at Christmas, as Santa Claus while waiting to be drafted.

Continues photographing for Civic Theater.

1942

First sequence of photographs: a series, or "story," on YMCA ski trip to Mt. Saint Helens, Washington.

First one-man museum exhibition: Portland Art Museum.

First photographs published: *Fair Is Our Land*, edited by Samuel Chamberlain.

Receives draft notice from U.S. Army.

1942–1945

Undergoes basic training in Hawaii. Assigned to Army Intelligence Corps. Sees limited combat in Leyte invasion.

Photographs little. Tries instead to write way through photography. "Eight Lessons in Photography," manuscript stemming from Boleslavsky's *Acting: The First Six Lessons*, is completed but unpublished, though incorporated into later writings.

Baptized into Catholic Church by army chaplain about 1943.

1945

Discharged from army. Goes to New York with purpose of learning what occurred in photography during the war. Seeks out Beaumont and Nancy Newhall at Museum of Modern Art.

Encouraged to undertake graduate studies in art history and aesthetics at Columbia University Extension Division. Under Meyer Schapiro submits paper on Edward Weston retrospective at Museum of Modern Art, representing first writing on how to "read" a photograph.

Studies museum methods with Newhalls and finds employment as photographer at Museum of Modern Art.

1946

Meets and experiences profound, liberating influence of Alfred Stieglitz. Creative thinking along psychological lines also influenced by Meyer Schapiro. Meets Edward Weston, Harry Callahan, Paul Strand, Edward Steichen, Todd Webb and Brett Weston.

Accepts appointment to photography faculty of California School of Fine Arts (now San Francisco Art Institute) headed by Ansel Adams. Arrives in California and resides first at Adams' home, then next-door in house owned by Adams; develops close personal rapport.

Adopts metaphorical approach to photography.

Visits Edward Weston at Point Lobos; begins deep attachment to Weston and locale.

1947

Instrumental in development of three-year photographic program at CSFA. Gradually assumes major teaching responsibility from Ansel Adams.

Second Sequence/Amputations completed, representing first grouping of photographs without literary or "story" content and, as with all subsequent ones, designed primarily for wall exhibition.

1948

First postwar exhibition: *Song Without Words* sequence at San Francisco Museum of Art.

1949

Begins photographing such plays as *Dear Judas, Family Reunion, Lady from the Sea, No Exit* and *Well of the Saints* for Interplayers group; continues for nearly four years. Also directs several CSFA students in theater photography with Interplayers.

1951

Judges, with Ansel Adams and Rene Weaver, exhibition *Oregon 1950* at Portland Art Museum. Directs exhibition *Focus Unlimited*.

Participates in Camera and Reality seminars at Aspen, Colorado; also exhibits *Sequence 6*. Idea for Aperture develops from one of seminars.

1952

With Dorothea Lange, Nancy Newhall, Ansel Adams, Beaumont Newhall, Barbara Morgan, Ernest Louie, Melton Ferris and Dody Warren founds *Aperture,* quarterly publication of photography, in San Francisco. Chosen editor and production manager. First issue appears in April.

1953

Directs exhibition *How to Read a Photograph* for San Francisco Museum of Art Extension Division.

In November joins staff of George Eastman House in Rochester, New York; Beaumont Newhall then curator. Responsible for exhibitions (1953–1957) and editor of *Image* (1956–1957).

1954

Editorial offices of *Aperture* relocated in Rochester with production in San Francisco.

Directs portraiture exhibition *Camera Consciousness* for George Eastman House.

1955

Directs exhibition *The Pictorial Image* for George Eastman House.

Joins faculty of Rochester Institute of Technology. Teaches, for one year only, course in photo-journalism.

Produces first body of photographs

relating to specific landscape of the eastern United States: *Sequence 10/Rural Cathedrals*. Distinct shift of emphasis from portraiture to landscape. Begins making 35mm transparencies in color; continues this work until his death.

Begins readings particularly in comparative religion. Period of intense personal study related to writing verse.

1956

Directs exhibition to define straight photography: *Lyrical and Accurate* for George Eastman House.

Conducts workshop at Indiana University and in Long Beach, California.

Resigns position of assistant curator at George Eastman House in order to devote greater energy to personal work.

Accepts appointment to faculty of Rochester Institute of Technology as part-time instructor. Begins biweekly evening workshops for undergraduate students; workshops continue intermittently for three years.

Develops deep interest in Oriental way of life.

1957

During summer begins preliminary work on autobiographical sequence of photographs: *Ashes Are for Burning*.

Introduced to Gurdjieff philosophy. Puts into practice "concentration-attention" and meditation techniques in looking at photographs and at subjects to be photographed. Develops these ideas in teaching and in workshops.

1959

Opening of largest exhibition to date: *Sequence 13/Return to the Bud* at George Eastman House.

First road trip across United States; travels with Paul Caponigro. Purchases Leica for use in color photography.

Oregon Centennial Commission sponsors workshop and exhibition *Sequence 13/Return to the Bud* in Portland. Workshop at California School of Fine Arts.

First full-time three-month resident workshop. Introduces hypnosis techniques into concentration of reading photographs.

1960

Second cross-country trip; travels with

Jack Franks.

Second Portland workshop. Weekend workshops at Horizon Northwest, Salem, Oregon, and Long Beach, California.

Production of *Aperture* relocated in Rochester beginning with Volume 7, Number 3.

Continued involvement with Gurdjieff movement in Rochester.

1961

Works on manuscript "The Canons of Camerawork" and continues exploration in techniques of concentration.

Third Portland workshop. Workshop at Isomata Foundation, Idyllwild, California; observation of dance group there effects introduction of rhythm and movement into teaching techniques.

1962

First Denver workshop. Documentation and description published: *A Notebook Resume* by Arnold Gassan.

Second Idyllwild workshop and fourth Portland workshop. Interest in movement and dance intensified.

Becomes founding member of Society for Photographic Education.

1963

First of seven Cleveland workshops. Weekend workshops in New York, Boston and Chicago.

"The Canons of Camerawork" completed but not published.

Second Denver workshop. San Francisco Art Institute workshop and fifth Portland workshop.

Lectures at second conference of Society for Photographic Education: "Is There a Place for a Functional Criticism in Camera Image Making?"

Three weekend workshops (third in 1964) at St. Lawrence University, Canton, New York.

Aperture, Inc., established as nonprofit corporation.

1964

Boston and New York workshops.

Commissioned by architect Louis I. Kahn to photograph First Unitarian Church in Rochester.

Millbrook workshop. Third Colorado workshop. San Francisco Art Institute workshop. Sixth Portland workshop.

Accepts appointment as Visiting Professor in Department of Architecture at Massachusetts Institute of Technology. Purchases house at 203 Park Avenue, Arlington, Massachusetts. By 1968 program consists of five courses; permanent exhibition space set aside as part of teaching facilities.

Directs *Exhibition One*, work of twenty-two greater Boston area photographers, for MIT.

Workshops in Arlington, Portland and Coos Bay, Cape Arago, Oregon.

Accepts temporary editorship of *Sensorium*, magazine of photography and arts of communication; magazine fails to reach publication.

First spring resident workshop held in Arlington.

Michael Hoffman becomes publisher of *Aperture*.

1966

Workshop in Arlington. Final cross-country trip by motor; travels with Huebert Hogh. Workshops in Albuquerque and Portland.

Production of *Aperture* moves to New York beginning with Volume 12, Number 4.

1967

Begins work on monograph *Mirrors Messages Manifestations*, first conceived in 1947. *Sequence 13/Return to the Bud* is another version in 1959. Workshop, "Vision and the Man Behind the Camera," sponsored by Project, Inc., of

1968

Mirrors Messages Manifestations completed.

Summer resident workshop in Arlington.

Fall workshop, "Design," sponsored by Project, Inc. Exhibition of work of sixteen photographers, many from various workshops, held at Worcester Craft Center.

Directs exhibition *Light*[7] for Hayden Gallery, MIT. Establishes permanent collection of photographs for Institute, with first to be drawn from *Light*[7].

Begins time of intensive self-education, again in part through reading. Period comparable to that of 1955 but more urgent. Studies brought on by illness diagnosed as angina. Illness has

profound effect on life-style: distinct psychological changes occur relative to total personal and public environment; observable in new priorities of interest and approach including increased meditation and strict food regimen.

Undertakes study of astrology. Increased emphasis on personal photography.

1969

Mirrors Messages Manifestations published.

Critique: Light[7] televised over National Educational Television; includes on-camera interview.

Travels to Cape Breton, Nova Scotia, to photograph; first of two visits.

Promoted to tenured professorship, MIT.

Lecture at Princeton University: "Photography and Inner Growth."

1970

Major one-man exhibition opens at Philadelphia Museum of Art. Subsequently tours United States.

Directs exhibition *Be-ing Without Clothes* for MIT.

Participates in Society for Photographic Education National Conference, University of Iowa.

First Creative Photography workshop, Hotchkiss School, Lakeville, Connecticut. Summer workshops continue here and elsewhere through 1974.

Begins to teach "Creative Audience" course at MIT.

Awarded Guggenheim Fellowship.

1971

Travels to Virgin Islands and Puerto Rico.

Spends considerable time writing. Participates in founding of Imageworks, Cambridge.

Aperture offices move to Millerton, New York.

1972

Directs exhibition *Octave of Prayer* for MIT.

With Jerry Uelsmann organizes and participates in Sippewisset (Cape Cod) Conference.

MIT advertises for successor; position never filled.

1973

Lectures at University of Massachusetts, Boston, in rebuttal to A. D. Coleman's criticism of *Octave of Prayer* exhibition. Lecture, prepared with Jonathan Green, subsequently published.

Takes group of MIT students to Rome for photographic work.

Travels to Puerto Rico to photograph; first of two trips in these years.

Visit to Zen Center at Tassajara, California.

Travels to Peru to give photography workshop.

1974

Directs exhibition *Celebrations* for MIT.

Retires from faculty of MIT; continues to teach Creative Audience course.

Travels to Peru for second time.

Directs exhibition *1,000 Photographers* with Jonathan Green for MIT Creative Photography Galleries.

Contracts with Light Gallery, New York, to be co-publisher of forthcoming *Jupiter Portfolio* and to represent him in New York.

1975

Publication of *Jupiter Portfolio* of twelve original photographs.

Appointed Senior Lecturer at MIT. For academic year 1975-76 made Fellow of MIT Council for the Arts.

Ceases editorship of *Aperture* with Volume 19, Number 1. Credited henceforth as Founding Editor.

Participates on Committee on the Future of the Friends of Photography, Carmel, California.

First substantial exhibition of photographs in Europe circulated by U.S.I.A., Paris.

Travels to England in November and returns to participate in Ansel Adams Gallery/University of Arizona Photography Workshop.

Is interviewed on videotape by Harold Jones for Center for Creative Photography.

Visits Cleveland for brief workshop before returning to Boston.

Suffers heart attack on December 1; hospitalized.

1976

Personal photography continues, including work with SX-70.

Becomes consulting editor for newly founded magazine *Parabola*.

Receives Honorary Doctorate of Fine Arts from San Francisco Art Institute; accepted by Walter Chappell.

Dies June 24 in Massachusetts General Hospital. Private wake held in Arlington. Graveside service at Mt. Auburn Cemetery, June 26.

Bequeaths personal photographic archives, papers, library and collection of original photographs to Princeton University.

Bibliography

This bibliography is selective. It is intended to present the range of Minor White's writing and the chronological development of his concerns. Through the year 1969 it contains only entries for works by Minor White; from 1942 through 1969 few substantive articles about White were published. Following the publication of *Mirrors Messages Manifestations* in 1969, however, a considerable literature about Minor White appeared; therefore, beginning with 1970 works about him are preceded by an asterisk. The bibliography has been extended one year past White's death to include the numerous obituaries and appraisals which appeared.

A comprehensive bibliography of works by Minor White, 1942–1968, including extensive bibliographic notes, together with a detailed chronology of his life and work, appears in *Mirrors Messages Manifestations*. In addition to those credited with assistance in that publication, I would like to thank Jonathan Green, Abe Frajndlich and Carole Kismaric for their assistance with the present bibliography and chronology.

Peter C. Bunnell

1943

"When Is Photography Creative?" *American Photography*, 37:16–17 (January). Reprinted *Exposure*, 14:7–8 (October, 1976).

1947

"Photography Is an Art." *Design*, 49:6–8, 20 (December).

1948

"What Is Photography?" *Photo Notes* (Spring), 16, 19. Reprinted *Exposure*, 14:8–9 (October, 1976).

1949

"Photography in an Art School." *U.S. Camera*, 12:49–51 (July).

1951

"Are Your Prints Transparent?" *American Photography*, 45:674–76 (November).
"How Concepts Differ for Two Cameras." *American Photography*, 45:546–51 (September).
"How to Find Your Own Approach to Photography." *American Photography*, 45:406–10 (July).
"Your Concepts Are Showing: How to Judge Your Own Photographs." *American Photography*, 45:290–97 (May).

1952

"About Aperture." *Aperture*, 1, 1:3.
"The Camera Mind and Eye." *Magazine of Art*, 45:16–19 (January). Reprinted *Photographers on Photography*, Nathan Lyons, ed. Englewood Cliffs, N.J.: Prentice-Hall, Inc., 1966, pp. 163–68.
"Exploratory Camera: A Rationale for the Miniature Camera." *Aperture*, 1, 1:5–16.

1953

"The Age of Photography." *Aperture*, 1, 4:3.
"The Creative Approach." *Aperture*, 2, 2:2.
"Criticism." *Aperture*, 2, 2:27–33.
"The Educated Audience." *Aperture*, 2, 1:3.

1954

"New Developments and the Creative Photographer." *Aperture*, 2, 4:3.
"Oscar Rejlander and the Model." *Image*, 3, 4:26–28.

1955

"A Name for It." *Aperture*, 3, 4:35–36.
"Applications of the Zone System." *Aperture*, 3, 3:11–29.
"The Myth of the Soulless Black Box." *Aperture*, 3, 1:3.
"Towards Camera." *Photography*, 10:26–31 (October).
"The Zone System of Planned Photography." *Aperture*, 3, 1:15–30.

1956

"A Motivation for American Photographers." *Aperture*, 4, 4:123.
"The Education of Picture Minded Photographers." *Aperture*, 4, 3:86.
"Eugene Atget." *Image*, 5, 4:76–83.
Exposure with the Zone System. New York: Morgan & Morgan, Inc.
"The 4 R's and the Cave Man." *Aperture*, 4, 3:83–85.
"Happenstance and How It Involves the Photographer." *Photography*, 11:40–45, 73 (October). Variant *Aperture*, 5, 1:7–10 (1957).
"Lyrical and Accurate." *Image*, 5, 8: 172–81.
"Of People and for People." *Aperture*, 4, 4:134–41.
"The Pursuit of Personal Vision." *Aperture*, 4, 1:3.
"Putting History to Work." *Image*, 5, 8:171.
"Ten Books for Creative Photographers." *Aperture*, 4, 2:58–67.
"When a Student Asks." *Aperture*, 4, 2:47–48.
"The Whiff of a New Trend." *Image*, 5, 5:99.

1957

"The Ambiguous Expressive/Creative Photograph." *Aperture*, 5, 1:3.
"An Experiment in Reading Photographs." *Aperture*, 5, 2:51–75.
"Ansel Adams: Musician to Photographer." *Image*, 6, 2:28–35.
"The Experience of Photographs." *Aperture*, 5, 3:112–30.
"How Creative Is Color Photography?" *1957 Popular Photography Color Annual*. New York: Ziff-Davis Publishing Co., pp. 17, 169–70.
"More Books for the Creative Photographer." *Aperture*, 5, 1:11–13.
"On the Neglect of Visual Literacy." *Aperture*, 5, 4:135.
"Pilot Project RIT." *Aperture*, 5, 3:107–11.
"Some Methods for Experiencing Photographs." *Aperture*, 5, 4:156–71. Written with Walter Chappell.

"What Is Meant by 'Reading' Photographs." *Aperture*, 5, 2:48–50.

1958

"On the Strength of a Mirage." *Art in America*, 46:52–55 (Spring). Reprinted as "The Light Sensitive Mirage." *Aperture*, 6, 2:74–83.
"Substance and Spirit of Architectural Photography." *Aperture*, 6, 4:143–82.
"To Recapture the Innocence of Vision." *Aperture*, 6, 2:55.

1959

"Minor White." *Camera*, 38:5–25 (August).
"Photographs in Boxes." *Aperture*, 7, 1:22–24.
"Polaroid Land Photography and the Photographic 'Feed Back' Employed with Informal Portraits." *Aperture*, 7, 1:26–30.
"That Old Question Again." *Aperture*, 7, 1:32.
"The Way Through Camera Work." *Aperture*, 7, 2:46–84.

1960

"A Gathering of Forces." *Aperture*, 7, 4:173.
"Call for Critics." *Infinity*, 9:4–5 (November). Reprinted *Exposure*, 14:9–10 (October, 1976).
"The Craftsmanship of Feeling." *Infinity*, 9:6–8, 14 (February).
"Editorial." *Aperture*, 7, 3:91.

1961

"Beyond Art." *Aperture*, 10, 2:48–49, 60–61.
"Ducks and Decoys." *Aperture*, 8, 4:171–73.
"The Formulas for Depth Photography." *Aperture*, 9, 3:94–95.
"Who Owns the Photograph." *Aperture*, 10, 1:3.
"With Nothing Between You." *Aperture*, 8, 4:186–87.
"With Two Hands." *Aperture*, 9, 1:3.
Zone System Manual. New York: Morgan & Morgan, Inc.

1962

"Frederick Sommer." *Aperture*, 10, 4.
Gassan, Arnold, *A Notebook Resume*. Denver: Arnold Gassan. Description of Denver Workshop, edited by Minor White.
"Photography: An UNdefinition." *Popular Photography*, 50:36, 74–75, 76–77 (April).
"Varities of Responses to Photographs." *Aperture*, 10, 3:116–28.
"When Competition Is the Order of the Day." *Aperture*, 9, 4:139.
"The Workshop Idea in Photography." *Aperture*, 9, 4:143–44, 148–54. Reprinted *Exposure*, 14:10–12 (October, 1976).

1963

"Equivalence: The Perennial Trend." *PSA Journal*, 29: 17–21 (July). Reprinted *Photographers on Photography*. Nathan Lyons, ed. Englewood Cliffs, N.J.: Prentice-Hall, Inc., 1966, pp. 168–75.

1964

"Amateur Photocriticism." *Aperture*, 11, 2:62–72.
"Critiphotocisms from Sam Tung Wu." *Aperture*, 11, 2:55, 61, 72, 83.
Editorial. *Aperture*, 11, 3:90.
"Pictorial Photography," in *The Encyclopedia of Photography*. New York: Greystone Press, pp. 2869–80.
"Te Deum Zeitgeist Drift." *Aperture*, 11, 2:47–48.

1965

"Dorothea Lange, 1895–1965." *Aperture*, 12, 3:132.
Zone System Manual. Hastings-on-Hudson, N.Y.: Morgan & Morgan, Inc. Second edition.

1967

"Futures." *Aperture*, 13, 2.
Zone System Manual. Hastings-on-Hudson, N.Y.: Morgan & Morgan, Inc. Third edition.

1968

"A Balance for Violence." *Aperture*, 13, 4:1.
"Could the Critic in Photography Be Passé." *Aperture*, 13, 3.
"Extended Perception Through Photography and Suggestion," in *Ways of Growth*, Herbert Otto and John Mann, eds. New York: Grossman.
"Light[7]." *Aperture*, 14, 1:1–74. Also *Light[7]*. Cambridge, Mass.: M.I.T. Press.
"A Meeting of the Portland Interim Workshop." *Aperture*, 13, 3.

1969

Mirrors Messages Manifestations. New York: Aperture, Inc. Accompanying brochure includes essays by Beaumont Newhall, Meyer Schapiro, Peter Bunnell, Jonathan Green, Barbara Morgan, Ansel Adams.

1970

"Be-ing Without Clothes." *Aperture*, 15, 3:1–96. Also *Be-ing Without Clothes*. New York: Aperture, Inc.
*Coleman, A. D., "Latent Image: Smith/White." *Village Voice* (April 2), pp. 16, 18.
"French Primitive Photography." *Aperture*, 15, 1. Also *French Primitive Photography*. New York: Aperture, Inc.
*Mann, Margery, "View from the Bay." *Popular Photography*, 66:22, 166 (February).
*Szarkowski, John, "Mirrors, Messages, Manifestations . . ." *New York Times Book Review* (March 8), pp. 6–7, 33, 34, 35.
"The Tale of Peter Rasun Gould: An Experiment in Fiction." *Aperture*, 15, 2.

1971

*Coleman, A. D., "Without Clothes, but Not Naked." *New York Times* (April 25), p. D28.
"The Secret of Looking." *New York Times* (November 21), pp. D31–32.
"Tides of Man and Nature," in *Penrose Annual 64*, Herbert Spencer, ed. London: Lund Humphries, pp. 128–35.

1972

"Exercises to Meet and Deflate Your Ego By." *New York Times* (September 3), p. D15.
Foreword, in *Ansel Adams*, Liliane DeCock (ed). Hastings-on-Hudson, N.Y.: Morgan & Morgan, Inc.
"Octave of Prayer." *Aperture*, 17, 1:1–91. Also *Octave of Prayer*. New York: Aperture, Inc.
*Porter, Allan, "Minor White." *Camera*, 51:14–23 (January).

1973

"Debate: A. D. Coleman vs. Minor White." *Camera 35*, 17:38–40, 45, 76, 78 (November).
Preface, in *In Front of St. Patrick's Cathedral*, Donald Blumberg. Cambridge, Mass.: Flower Mountain Press.
*Bratman, Stan, "High Priest Under Siege: Minor White at Columbia [Col-

lege]." *New Art Examiner* (November), p. 9.

*Coleman, A. D., "Latent Image: Scattered Shot and Gathered Prints." *Village Voice* (February 22), pp. 20–21.

*"Debate: A. D. Coleman vs. Minor White." *Camera 35*, 17:34–38 (November).

*"Latent Image: Sticky-Sweet Hour of Prayer." *Village Voice* (March 15), p. 24.

*Thornton, Gene, "From Minor White: A Choice Collection." *New York Times* (October 14), p. 34.

1974

"Celebrations." *Aperture*, 18, 2:1–83. Written with Jonathan Green. Also *Celebrations*. New York: Aperture, Inc.

"Introduction," in *Photography in America*, Robert Doty, ed. New York: Random House, Inc., pp. 7–9.

*Klink Walter, "Viewpoint: Clout and Metaphysics." *Camera 35*, 18:28–29, 75 (February/March).

*Kramer, Hilton, "Minor White Gathers Final M.I.T. Show." *New York Times* (March 1), p. 14.

*Rossell, Deac, "Minor White's 'Celebrations.'" *Boston Sunday Globe* (March 17), p. A14.

1975

*Baures, Mary, "Photography as Mysticism/Minor White." *Bosarts*, 1:3–6 (January). Reprinted as "Minor White Portfolio." *New Age Journal*, 10:21–29 (January, 1976).

*Porter, Allan, "Photography: A Contemporary Compendium." *Camera*, 54:23, 42 (November).

*Sekula, Alan, "On the Invention of Photographic Meaning." *Artforum*, 13:36–45 (January).

"Silence of Seeing," in *One Hundred Years of Photographic History*, Van Deren Coke, ed. Albuquerque: University of New Mexico Press, pp. 170–73.

*"Tribute from Minor White (Celebrations)," in *Photography Year 1975*, Fred R. Smith, ed. New York: Time-Life Books, pp. 34–45.

1976

*Buerger, Janet E., "Minor White (1908–1976): The Significance of Formal Quality in His Photographs." *Image*, 19, 3:20–32.

"The Diamond Lens of Fable." *Parabola*, 1:74–77 (Winter). Reprint of unsigned introductory essay from *Jupiter Portfolio* (1975).

*Kneeland, Paul F., "Minor White, Artist in Photography, 67." *Boston Globe* (June 26), p. 27.

*Kramer, Hilton, "Remembering Cunningham and White." *New York Times* (August 1), p. D24.

*"Milestones: Died. Minor White, 67 . . ." *Time*, 108:74 (July 5).

*"Minor White and Imogen Cunningham, Photographers Are Dead." *New York Times* (June 26), p. 26.

*"Minor White: Imaginative World Photographer." *The Times* (London) (July 2), p. 18.

The New Zone System Manual. Dobbs Ferry, N.Y.: Morgan Press, Inc. Written with Richard Zakia and Peter Lorenz.

*"Rite of Passage: For Minor White, June 21–24, 1976." *Parabola*, 1:56–65 (Fall).

*"Transition: Minor White . . ." *Newsweek*, 88:107 (July 4).

*Untitled Obituary. *Parabola*, 1:5 (Summer).

*Vestal, David, "Minor White, 1908–1976." *Popular Photography*, 79:13 (October).

1977

*Hill, Paul, and Cooper, Tom, "Camera Interview—Minor White, 1908–1976." *Camera*, 56:36–41 (January); 56:36–40 (February); 56:34–38 (March).

*"Minor White," in *Interviews with Master Photographers*, James Danziger and Barnaby Conrad, III. New York: Paddington Press, Ltd., pp. 14–35.

*"Minor White—Mystic and Mentor," in *Photography Year 1977*, Sheldon Cotler, ed. Alexandria, Va.: Time-Life Books, pp. 206–13.

Selected Books from Minor White's Library

Adal, *The Evidence of Things Not Seen*, 1975

Allegro, John, *The Sacred Mushroom and the Cross*, 1971

Aries Press, *The Degrees of the Zodiac Symbolized*, 1968

Armstrong, Margaret, *Field Book of Western Wild Flowers*, 1915

Arnheim, Rudolph, *Art and Visual Perception*, 1960

Art Club of Chicago, *Photographer as Poet*, 1973

Aurobindo, Sri, *The Riddle of This World*, 1969

Baynes, Cary (trans.), *The I Ching* (Vols. I and II), 1952

Benoit, Hubert, *The Supreme Doctrine* (2 copies), 1959/1960

Berger, Charles, *Image Tibet*, 1973

Boas, George, *Wingless Pegasus*, 1950

Boleslavsky, Richard, *Acting: The First Six Lessons*, 1956

Breler, Henry, *Food Is Your Best Medicine*, 1968

Brown, Norman O., *Love's Body*, 1966

Browne, Edward, *Tassajara Cooking*, 1973

Buechner, Frederick, and Boltin, Lee, *Faces of Jesus*, 1974

Capra, Fritjof, *The Tao of Physics*, 1975

Carter, C. E. O., *Encyclopedia of Psychological Astrology*, 1963

Castaneda, Carlos, *A Separate Reality*, 1971

———, *Tales of Power*, 1974

———, *The Teachings of Don Juan*, 1968

———, *Journey to Ixtlan*, 1972

Chen, Joyce, *Joyce Chen Cook Book*, 1962

Chung-yuan, Chang, *Creativity and Taoism*, 1963

Coamaraswamy, Ananda K., *The Transformation of Nature in Art*, 1964

Collin, Rodney, *The Theory of Celestial Influence*, 1958

———, *The Theory of Conscious Harmony*, 1958

———, *The Theory of Eternal Life*, 1956

Collingwood, R. G., *Principles of Art*, 1958

Crebo, Anna, *Creativity, Psychology, and the Cosmos*

Davis, Adelle, *Let's Cook It Right*, 1962

deHartmann, Thomas, *Our Life with Mr. Gurdjieff*, 1964

De Ropp, Robert S., *The Master Game*, 1968

Dooling, Dorothea, *Conversations with Don Juan* (pamphlet), 1972

Eliade, Mircea, *Death, Afterlife, and Eschatology*, 1974

———, *Myth and Reality*, 1968

Eliot, T. S., *Collected Poems (1909–34)*, 1936

Erikson, Erik, *Insight and Responsibility*, 1964

Fagan, John, and Shepherd, Irma Lee, *Gestalt Therapy Now* (2 copies), 1970

Feng, Gia-Fu, and English, Jane, *Chuang Tsu*, 1974

———, *Chuang Tsu—Inner Chapters*, 1974

———, and Kirk, Jerome, *Tai Chi—A Way of Centering*, 1970

Franck, Frederick, *Zen of Seeing*, 1973

Fromm, Erich, *Man for Himself*, 1968

Fujimoto, Rindo, *The Way of Zen*, 1961

Gauquelin, Michel, *The Scientific Basis of Astrology*, 1969

George, Llewellyn, *A to Z Horoscope Maker and Delineator*, 1967

Guillaumont, A., *The Gospel According to Thomas*, 1959

Gunther, Bernard, *Sense Relaxation Below Your Mind*, 1968

Gurdjieff, George Ivanovitch, *All and Everything: Beelzebub's Tales to His Grandson*, 1950; *Meetings with Remarkable Men*, 1963; *Life Is Real Only Then, When "I Am,"* 1975

Guru Bawa, M. R., *Divine Luminous Wisdom*, 1972

———, *Songs of God's Grace*, 1973

Hall, Manly, *Astrological Keywords*, 1958

Harris, Pamela, *Another Way of Being*

Heckt, Frederick, *Above and Beyond*, 1971

Heindel, Max, *The Message of the Stars*, 1940

Held, Richard (ed.), *Image, Object and Illusion*, 1972

Herrigel, Eugen, *Zen*, 1964

———, *Zen in the Art of Archery*, 1971

Herron, Matt, *Voyage of Aquarius*, 1974

Hesse, Hermann, *Demian*, 1968

———, *Narcissus and Goldmund*, 1969

———, *Steppenwolf*, 1963

Hickey, Isabel, *Astrology—A Cosmic Science*.

Hilgard, Ernest R., *Experience of Hypnosis*, 1968

Hone, Margaret, *The Modern Text Book of Astrology*, 1968

Housman, A. E., *The Name and Nature of Poetry*, 1933

Howe, E. D., *Human Possibility*, 1968

Hsieh, Tekyi, *Chinese Epigrams Inside Out and Proverbs*, 1948

Hughes, Dorothy Beach, *The Basic Elements of Astrology*, 1961

Hunter, Beatrice, *The Natural Food Cookbook* (2 copies), 1975

Ishimoto, Tatsuo, *Art of the Japanese Garden*, 1958

James, William, *The Varieties of Religious Experience*, 1958

Jocelyn, John, *Meditations on the Signs of the Zodiac*, 1966

Jourard, Sidney M., *The Transparent Self*, 1964

Jung, C. G., *Memories, Dreams, Reflections*, 1963

———, *The Undiscovered Self*, 1961

Keeler, W. Frederick, *The Practice of Concentration*, 1936

Kempis, Thomas, *Of the Imitation of Christ*, 1882

Kennett, Jiyu, *Selling Water by the River*, 1972

Kepes, Gyorgy, *Education of Vision*, 1965

———, *Language of Vision*, 1944

———, *Nature and Art of Motion*, 1965

Kubie, Lawrence S., *Neurotic Distortion of the Creative Process*, 1958

Lefebre, Dom Gaspar, *St. Andrew Daily Missal*, 1940

Leverant, Robert, *Zen in the Art of Photography*, 1969

Levi, *The Aquarian Gospel of Jesus the Christ*, 1964

Leydet, François, *Time and the River Flowing*, 1964

Li, Chu-tsing, *Liu, Kuo-sung: The Growth of a Modern Chinese Artist*, 1969

Liu, Da, *I Ching Coin Prediction*, 1975

Lubicz, Isha, *Her-bak, Egyptian Initiate*, 1967

Luce, Gay Gaer, *Body Time*, 1971

Luntz, Charles E., *Vocational Guide by Astrology*, 1962

McLuhan, Marshall, *The Gutenberg Galaxy*, 1966

Maslow, Abraham H., *Farther Reaches of Human Nature*, 1971

———, *Religions, Values, and Peak-Experiences*, 1970

Merton, Thomas, *Contemplative Prayer*, 1971

Misko, Karin, *Longevity Cookery Cookbook*, 1973

Naranjo, Claudio, and Ornstein, Robert E., *On the Psychology of Meditation*, 1972

Nasr, S. H., *The Encounter of Man and Nature*, 1968

Needleman, Jacob, *The New Religions* (2 copies), 1970

New Era Laboratories, *The Biochemic Handbook*, 1966

Nicoll, Maurice, Index to Vols. IV and V of *Psychological Commentaries on the Teachings of Gurdjieff and Ouspensky*, 1934

———, *Living Time*, 1953

———, *The New Man*, 1950

———, *Psychological Commentaries*, 1957

Orage, A. R., *On Love*, 1957

Otto, H., and Mann, J., *Ways of Growth*, 1968

Ouspensky, P. D., *The Fourth Way*, 1957

———, *In Search of the Miraculous*, 1949

———, *The Psychology of Man's Possible Evolution*, 1974

———, *Tertium Organum*, 1931

Perls, Frederick S., *Gestalt Therapy Verbatim*, 1969

———, *In and Out of the Garbage Pail*, 1969

Perls, F., Hefferline, Ralph, and Goodman, Paul, *Gestalt Therapy* (3 copies), 1965

Peters, Fritz, *Gurdjieff Remembered*, 1965

Peterson, Severin, *A Catalogue of the Way People Grow*, 1971

Reich, Wilheim, *Listen, Little Man*, 1965

Reps, Paul, *Zen Flesh, Zen Bones* (2 copies), 1958/1961

Rilke, Rainer Maria, *Stories of God*, 1963

Robson, Vivian, *An Astrological Guide to Your Sex Life*, 1967

Rosenfeld, Edward, *Book of Highs*, 1973

Rosicrucian Fellowship, *Ephemeris* (2 copies), 1972

———, *Studies in Astrology*, Vols. I–IX, 1965/1968

Rudhyar, Dane, *An Astrological Mandala*, 1973

———, *The Lunation Cycle*, 1967

Sakoian, Frances, and Acker, Louis S., *The Astrologer's Handbook*, 1973

Saraswati and Yogashakti, *Dynamics of Yoga*, 1966

Schiffman, Muriel, *Gestalt Self Therapy*, 1971

Serrano, Miguel, *C. G. Jung & Hermann Hesse*, 1966

Shah, Idries, *Nasrudin*, 1972

Simmons, Leo W. (ed.), *Sun Chief*, 1974

Siu, K. G. H., *The Man of Many Qualities*

(2 copies), 1968

Storm, Hyemeyohsts, *Seven Arrows*, 1972

Suzuki, Daiseth T., *The Chain of Compassion*, 1966

———, *The Way of Compassion*, 1966

Szekely, Edmond Bordeaux, *The Essene Gospel of Peace*, 1970

Tagore, Rabindranath, *Gitanjali*, 1913

Trungpa, Chogyam, *Meditation in Action*, 1974

Tsu, Lau (Feng and English, trans.), *Tao Te Ching*, 1972

Underhill, Evelyn, *Mysticism*, 1955

Ut-Tair, Mantig, *The Conference of the Birds*, 1964

Waltham, Clae, *I Ching*, 1969

White, John, *What Is Meditation?*, 1974

Whitman, Walt, *Leaves of Grass*, 1897

Wicksteed, Joseph, *Blake's Vision of the Book of Job*, 1910

Wilhelm, Richard, *The Secret of the Golden Flower*, 1962

Woener, Norbert, *The Human Use of Human Beings*, 1954

Wolberg, Lewis R., *Hypnoanalysis*, 1960

Wolters, Clifton (trans.), *The Cloud of Unknowing*, 1967

Yogananda, Paramahansa, *Autobiography of a Yogi*, 1968

Zimmer, Heinrich, *Philosophies of India*, 1956

Like the bell broken from its boat drops upon a ledge where its rope is rotted away, then is swept off into the endless ocean, loses the light of day, sinking deeper forever, sounding its drowned note deeper and deeper… it sinks away into new water.…

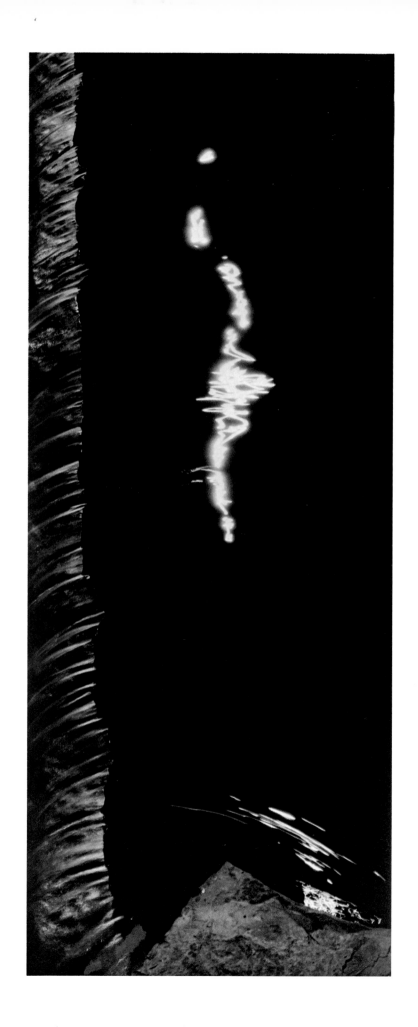